THE BOOK OF
SPECIAL
EFFECTS
Photography

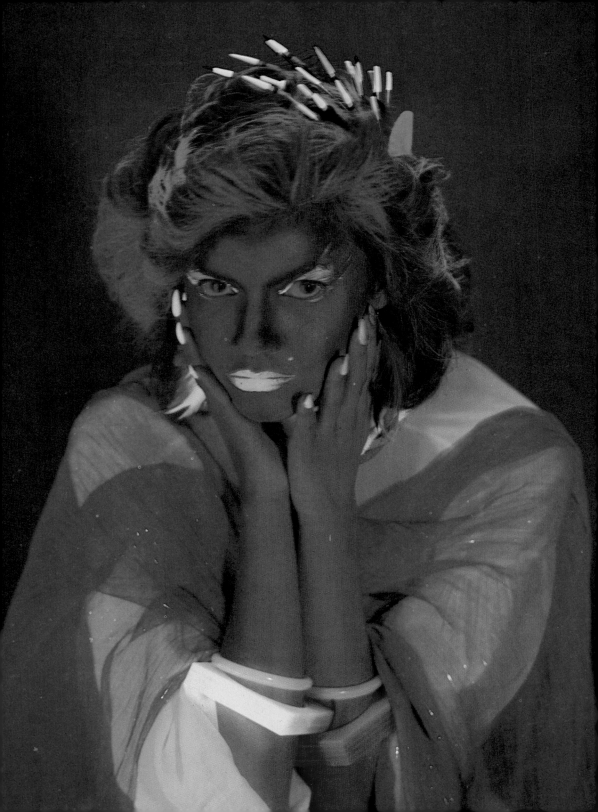

To the very best and dearest sister in the world—

The special effects of friendship add color and beauty and excitement to otherwise dull and ordinary black and white lives.

Thank you for the magical artistry, the expertise which fills my life with softly blended rainbows.

Your forever sister,
Sammi

THE BOOK OF
SPECIAL EFFECTS
Photography

Michael Langford

Alfred A. Knopf, New York 1981

The Book of Special Effects Photography was
conceived, edited and designed by
Dorling Kindersley Limited,
9 Henrietta Street, London WC2

Project Editor
Judith More
Art Editor
Neville Graham
Managing Editor
Joss Pearson
Art Director
Stuart Jackman

Picture Research
Elly Beintema
Modern Media Consultant
Tim Stephens

Staff Photographer
Andrew de Lory

This is a Borzoi Book
Published by Alfred A. Knopf Inc.

Library of Congress Catalog Card Number:
81-82591

ISBN 0 394-52107-2

Typesetting by MS Filmsetting, Frome, Somerset
Reproduction by F. E. Burman Limited, London
Printed and bound in Italy by A. Mondadori, Verona

Contents

Introduction

Special effects photography is concerned with manipulating reality – to form an eye-catching image, or to create a dream-like, even nightmarish visual situation. It is visual theater – generally larger than life, sometimes subtle, but often outrageous.

Oddly, photography still has the reputation of being truthful and objective. The misconception that photography is accurate began with its invention 150 years ago. At that time, people were in awe of a process which drew pictures "by the action of light itself". Surely nothing could be more proof against manipulation? In fact, photography is no more objective than the printed word, but both are taken as accurate representations of reality because they *appear* to be definitive and sound. Photography is a medium of expression and communication, and you can use it with the same freedom of imagination as any other type of medium.

Most books and courses on photography have sections that tell you how to avoid mistakes. This book will encourage you to make them. To become a good special effects photographer you must experiment – be prepared to waste some materials, and in the process you will discover new kinds of image. You need to be a good technician in order to get the most out of tools and processes, and devise new gadgets. And you must be flexible and inquisitive – before you throw away a "spoiled" image, consider how you could take that type of image further or turn it in a different direction for an interesting result. Also, you must be able to recognize visual qualities in subjects and situations which you can strengthen by using a special effect.

Use the examples in this book as a visual guide to the sort of images you can achieve with each technique. In practice, you will find that subjects and ideas lead you into using mixtures of methods. Never limit yourself to the manufacturer's official uses of any product – use this as a starting point to work out ways in which you can "abuse" material. As new equipment in fields like home video and color copiers appear, and new types of regular and instant films are introduced, you should test products for their manipulative possibilities.

The earliest photographic manipulations were photograms – made by pressing objects in contact with light-sensitive material. These pre-date true camera photography by 30 years.

False color scene by Erik Steen △
You can manipulate color in a great many ways to produce special effects. For example, you can use a mis-matched process, or strong color filters, or infrared film, or solarization. For this picture, the photographer copied a shot taken on Ektacolor duplicating film and gave reversal processing instead of the recommended negative processing.

◁ **"Abstract" by Alfred Gescheidt**
Double exposure – the combination of two different images on one frame – is an effective way of producing startling, often surrealist pictures. Here, a simple double mask attachment was used.

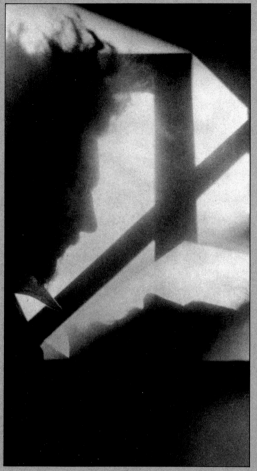

Portrait of Ezra Pound by A. L. Coburn △
For this "Vortograph" picture, taken in 1917, Coburn used kaleidoscope-type mirrors in front of his lens — a system he called the Vortoscope. The image plays on Pound's many-sided character.

"Two ways of life" by Oscar Rejlander ▷
Rejlander was a famous early 'high-art' photographer. This 1857 composition was printed from over 30 negatives. It recounts the choices open to a young man — from gambling, drink and sex (left half) to education and hard work (right half).

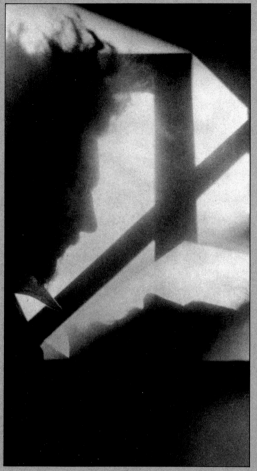

But most early photography was preoccupied with obtaining results which were "true to nature". Blur, double images, and distortions were avoided – they were regarded as barriers to truth.

In the mid-nineteenth century, artistically-minded photographers would often follow the examples of painters, choosing themes that called for elaborate staged tableaux. They would build fake scenes as studio sets, often with ludicrous results. The arrival of glass negatives in 1851 allowed photographers – like painters – to plan and separately image each figure or part of a setting for a composition. To create the whole picture they would mask unwanted parts of these negatives, and then contact print them one at a time by sunlight in planned positions on a single sheet of photographic paper. This laborious combination printing technique was carried out with immense technical skill.

By the 1880's, photographers such as Edweard Muybridge and Etienne Marey were able to use brief exposure shutters to record fast-moving subjects in great detail. Muybridge produced sequences of individual pictures to analyze human and animal movements. Marey worked with similar subjects, but exposed his sequences mostly on one frame to give overlapping, flowing images that resembled today's stroboscopic sequences (see p. 84). All these new effects excited the interest of the art world. Objective, realistic painters found that frozen-image photography proved that many fast actions, such as a horse's gallop, had been drawn incorrectly for centuries. The more revolutionary members of twentieth century art movements – Cubism and Dadaism – saw the strange image effects that photography could create as sources of new forms.

Modern painting movements, in turn, influenced some photographers, who turned to special techniques as an alternative to pictorialism (see p. 10), aiming for increasingly abstract results. They took pictures of modern buildings from extremely high or low viewpoints, or photographed through kaleidoscopes (see p. 58) to make angular patterns. Dadaists turned to photograms and montage as methods of presenting familiar subjects in unusual forms. Visual artists like Man Ray discovered ways of creating part-positive, part-negative photographs (see Solarization, p. 128). Laszlo Moholy Nagy, and other teachers at Germany's Bauhaus during the 1920's, mixed manipulated photographs with painting and graphic design to explore new ways of expressing space and movement.

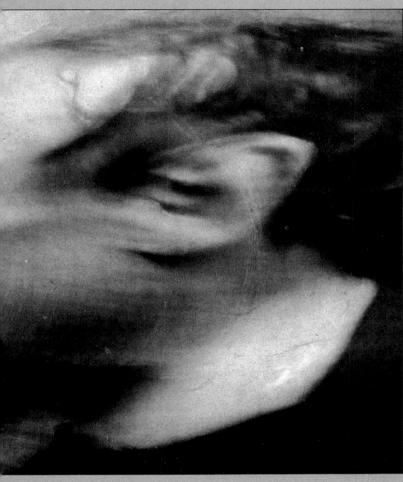

Self-portrait by Louis Ducos du Hauron △
This 1890 special effect was taken with a distorting camera fitted with two crossed slits in front of the shutter. Du Hauron was a notable early experimenter in photography – he invented one of the first color processes.

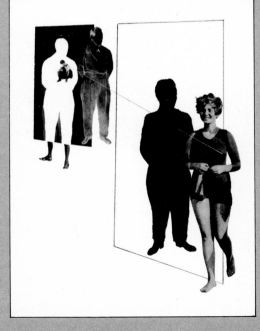

"Jealousy" by Lazlo Moholy Nagy ▷
Moholy Nagy produced this mixture of montaged positive and negative photographs, drawing and artwork, at the Bauhaus in 1930. The early twentieth century was a great period of experiment in the combination of realism and fantasy in imagery.

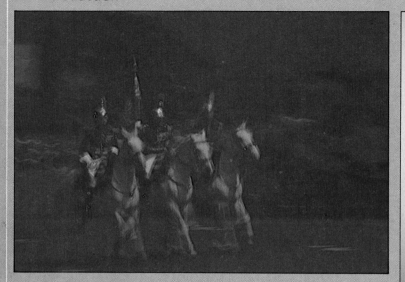

Not all past movements in photography were so revolutionary. The mainstream movement was, and still is, pictorialism – pictures in which beauty, atmosphere and mood are more important than subject or message. From the 1880's to the First World War, at the height of the Pictorialist movement, great controversy raged over the type and amount of image manipulation that was acceptable in giving a pictorial impression of a scene. Some photographers, like P. H. Emerson, maintained that the eye concentrates on one central part of a view, and sees detail away from this zone indistinctly. Diffusion and soft focus attachments (see p. 48) were therefore acceptable, whereas studio sets and montaged images were not. Soon these photographers began to use overall diffusion, and their work came to resemble another new art movement at that time – Impressionism. Other leading Pictorialists insisted that the camera side of image-making should be straightforward, but allowed manipulation of the print itself.

Today, no such rules or schools of thought exist to tell you how much or in what way you should simplify or abstract normal photographic detail. Lens attachments allow you to spread lightest parts of the image, giving a luminous quality, and softening shadow contrast. Screens, reflective surfaces and filters between the camera and subject extend this effect. Single lens reflex cameras allow you to preview image changes, and modern color film enables you to record the subtleties of spread colors and tones. You can choose to work on infra-red, tungsten or daylight color film stock, and process negative film as a positive, or vice versa (see p. 100). Movement

Impressionistic scenes by Francisco Hidalgo
For the picture of the Empire State building in New York, right, and the shot of Republican guards in Paris, above, Hidalgo used slow shutter speeds and camera movement to capture flow. And he employed lenses, filters and attachments to enhance color and mood.

Dancer by David Buckland ▽
For this impressionistic photograph David Buckland used a panoramic camera and fast-panned in the opposite direction to the sweep of its lens, distorting the dancer's movement in a dramatic manner.

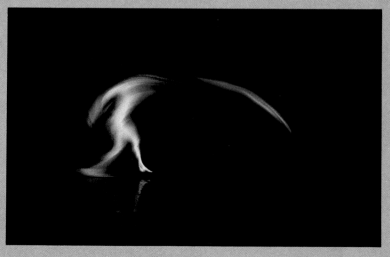

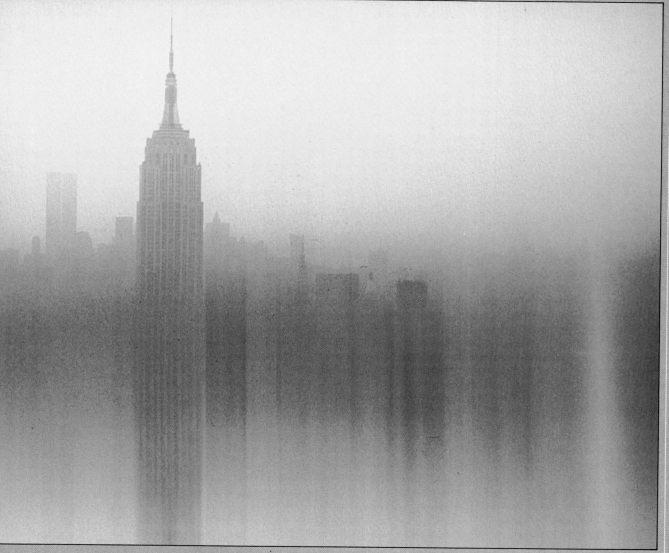

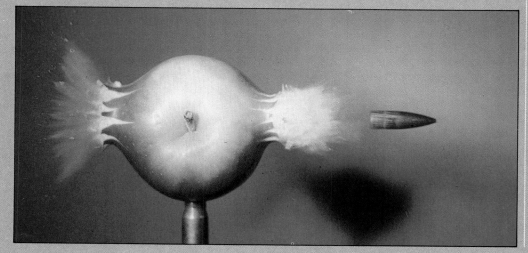

"Bullet and Apple" by Harold Edgerton ▷
Despite their undoubted accuracy, high-speed studies of movement can appear just as unreal as image distortions. Dr. Edgerton developed stroboscopic and high-speed flash equipment for his scientific studies. He took many high-speed shots of objects moving at speeds up to 15,000 miles per hour, like this early color example.

of the camera or subject during exposure forms shapes and blurs which can reveal the pattern of movement better than sharp detail frozen by flash.

At the opposite extreme from pictorialism, montage is a special effects technique that is based heavily on subject and statement. Montage is the combination of two or more images, usually performed by cutting out elements and attaching them to a single background (see p. 118). This manipulation interested Dadaist painters – for example, George Groz and Hannah Höch – because it fitted in well with their use of machine-made art.

The detail that photography gives makes montage results appear extremely realistic, no matter how fantastic the scene they portray. Photo-montage is therefore an obvious choice for political satirists, who have employed it to caricature and ridicule their opponents. One of the most famous satirists who used montage to put over his political views was John Heartfield, who worked in Germany in the 1930's. He produced forceful anti-Nazi posters and covers for the radical magazine *AIZ*. Heartfield's visual attacks on the Nazi party were directed at a wide public, making use of montage to show Nazi leaders as blood-stained butchers, or to picture them accepting bribes or squandering public funds.

Although the 1920s and 1930s period in Europe was the greatest for political use of photo-montage, the technique continued to be used to great effect. British photographer Angus McBean produced photo-montages, and similar results using studio sets, to create images of theatrical personalities for *The Sketch* magazine in the late 1930s. Unlike Heartfield's somber themes, McBean's work had a stylish, romantic approach. He placed well-known faces in surreal settings related to the stage show in which they were currently appearing. The tradition has continued to the present day – montage has been widely used for record covers from the 1960s onward. In this field you will find the most innovative contemporary examples of applied montage, airbrushing and other artwork.

Today consumer products of every kind are shown photo-montaged in magical, unworldly settings. Nobody is deceived by these fake, fantasy situations – they are accepted as part of show-business, salesmanship and packaging. Indeed, in the 1960s and 1970s pop art painters such as Richard Hamilton and Andy Warhol brought this commercial use of an art technique full circle by using photographs and other mass-media images as raw material for their own creative compositions.

Photographers today make most use of special effects to create surreal images – pictures with themes based on the irrational subconscious. This surrealism can take the form of either pure dream-like fantasy shots, or pictures which at first seem normal, but contain some impossible juxtapositioning of structure or subject. For typical examples of each of these approaches look at paintings by Salvador Dali and Rene Magritte. The extreme detail and realism that is a constant feature of surrealist images makes photography an ideal medium for them. You can change natural scenes into fantasy settings by using the wrong film, colored lights, filters, or distorting lenses. Or use special sets or projected backgrounds in the studio. And you can create juxtapositions of the impossible by

Surreal portrait by Angus McBean ▷
McBean used specially constructed studio sets, double printing and photo-montage techniques to create his fantasy portraits, like this 1938 picture.

Adolf the Superman by John Heartfield ▽
This powerful poster, captioned "Adolf swallows gold and spouts junk," was made in 1932. Heartfield used photo-montage to campaign against the Nazis as they rose to power.

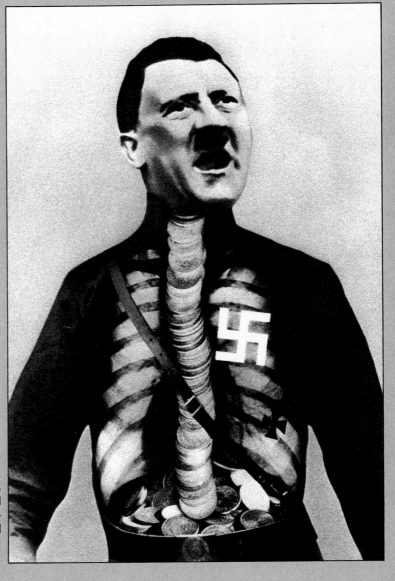

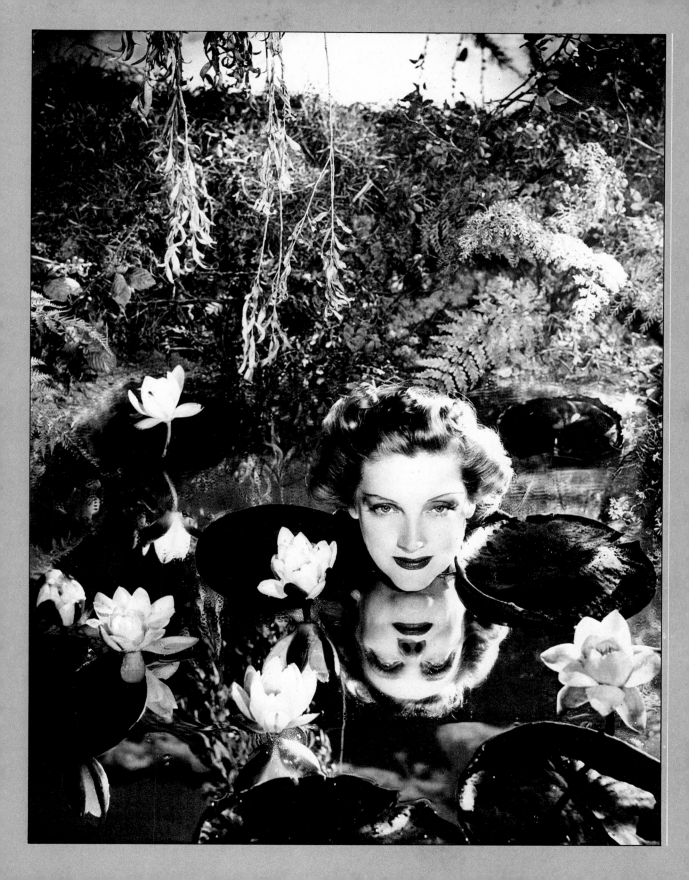

Nude by John Knights △
This graphic effect was made by combining the image of the girl with a shot of basket work. Knights uses a large format camera, and plans his elements very carefully when shooting, in order to produce his high quality sandwiched images.

Multiple print by Bob Carlos Clarke ▷
Two elements – the man and the eye – make up this picture. Clarke printed the man, then burned in the eye to add a surreal touch to the image, designed for an album cover.

◁ Nude by Sam Haskins
Haskins trained at art school, and he uses his design background to create graphic images. Before taking a photograph he makes sketch plans of the final image he visualizes. Here, he has sandwiched a black and white and a color original.

either sandwiching, double exposing, montaging, or double printing scenes. The strongest, most effective pictures result from good visual ideas carried out to high technical standards. This does not mean that you need complicated themes and elaborate processes. Often, the best ideas are extremely simple, and you can carry them out without any special facilities.

This book has two main functions. First, its pictures provide a survey of the unusual images that contemporary materials and equipment make possible. These pictures should help you to find solutions to visual problems –

suggesting, perhaps, a method that might suit your particular idea. The range of images is far from exhaustive – visual permutations of the subjects and techniques are endless. Second, the book is designed to offer a source of technical projects. Since it is structured mostly in terms of equipment and processes, you should use it to widen the range of results you can obtain from your equipment.

The five main sections cover camera handling manipulations, optical attachments, lighting, film effects, and post-camera workroom and darkroom effects. You can work from the first three sections even if you do not have access to a darkroom. You can also try several of the post-camera techniques such as sandwiching slides, hand-coloring, photocopy manipulations or montage. However, when you use outside laboratory services, limit yourself to color slide materials. The laboratory may "correct" results on color negative stock to a normal color print.

If you are a beginner in this field, first experiment with simple camera techniques such as panning, the use of slow shutter speeds, and improvised optics. Diffusion, the use of reflections, and sandwiching slides are also simple, interesting effects to try. In the darkroom, photograms and solarized images are good starting points.

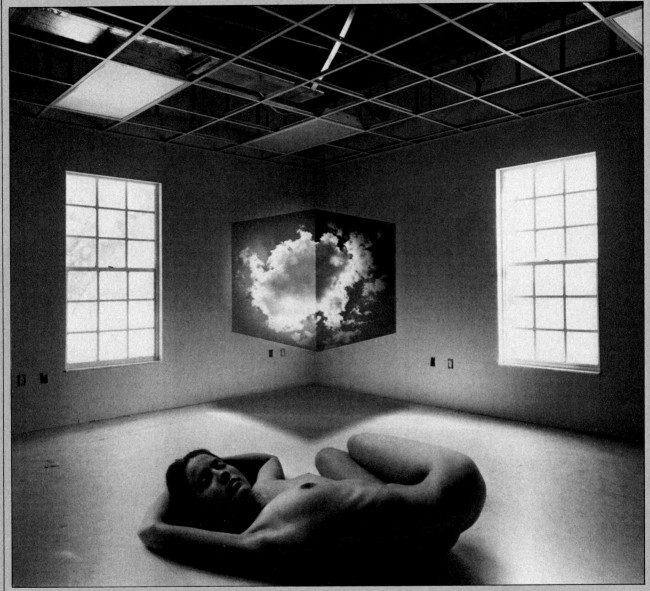

Multiple print by Jerry Uelsmann △
Uelsmann is a master of the technique of printing several negatives on one sheet of paper. He works from a stock of film images, combining them under the enlarger – a method he calls "in process discovery".

The most challenging special effects in this book are slit shutter work, multiple exposure, front projection and airbrushing. These techniques are for more experienced photographers, and usually require some extra equipment. With every subject you will find practical advice on each picture page. For additional background information you should turn to the Appendix at the back of the book (see pp. 145–64).

If your main aim is to experiment and explore in order to discover what variations are possible, make sure you adopt a methodical approach and keep notes. With camera work you should record exposure details, or the way you use an attachment, against each frame number. If you are using a new type of film or changing the processing, you should bracket your exposures as well as recording details of technique. And the same advice applies when you make copy manipulations or two related exposures for solarizing.

Finally, the best way to learn about special effects photography is to go out and practice it. Most people find that it is far easier to produce unusual and interesting images than they expected. You should be adventurous, accept the fact that you are likely to waste some material, and then follow your own visual preferences.

CAMERA AND LENS CONTROLS

This first group of special effects centers on the camera itself, especially its shutter and lens system. It begins with the various ways you can express movement impressionistically through the use of blur. Movement of the subject, movement of the camera, or movement of both subject and camera will give static and moving parts of the scene an unusual appearance. And if you have a zoom lens you can use it to engineer movement so that scenes appear to explode, or step up in size or distort. Sport or dance, night-time lights and illuminated signs are ideal subjects for these techniques.

Other special effects in this section involve ways of exploiting light and lenses. You can create a magical radiance by removing your lens hood and shooting into the light to produce flare. Use improvised optics, or put your lens out of focus deliberately for softened images. And fisheye lenses, long telephoto or anamorphic lenses will change an image dramatically. These techniques provide a fresh approach to familiar subjects like landscapes and portraits.

Finally, you can interfere with the shutter mechanism itself to influence images. Keep the shutter open and move film through the camera past a slit to produce a distorted strip image. Or create composite scenes by shooting several pictures on one frame of film.

Slow shutter

Photographers who study movement use slow shutter speed to capture its flow and sway. Ernst Haas, for example, uses long exposures and rich colors for his brilliant impressions of action. To achieve blur, keep the camera's shutter open while the subject is moving. A light-toned subject against a plain, dark background will create the clearest patterns. Movement against a pale background will often burn out the subject (use this technique to "clear" pedestrians and traffic from a busy street). Try to include a still element that will provide a sharp contrast to the blurred action. You need a tripod and slow film, and in bright light use neutral density filters. A lens that stops down well allows a long exposure time.

Blur and color ▷
For this photograph of dancers from the London Contemporary Dance Theater company, David Buckland used a 1/2 sec. exposure and slow film, pushed two stops. The warm, rich colors are the effect of the stage lighting on the tungsten film.

Stillness and movement △
Slow film and an exposure of 1/8 sec. caused this image of a passer-by to blur. The richly patterned blue tiles on a nearby wall in this Morroccan street contrast with the ethereal impression left by the pedestrian.

Light trails ▷
For a result similar to the image shown right you will need medium speed film, a red filter and a tripod. Set the shutter to B, stop down and make an accumulated exposure (45 sec. here) of the traffic tail-lights, capping the lens between each burst of traffic to minimize the effect of street lighting.

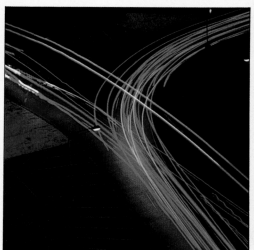

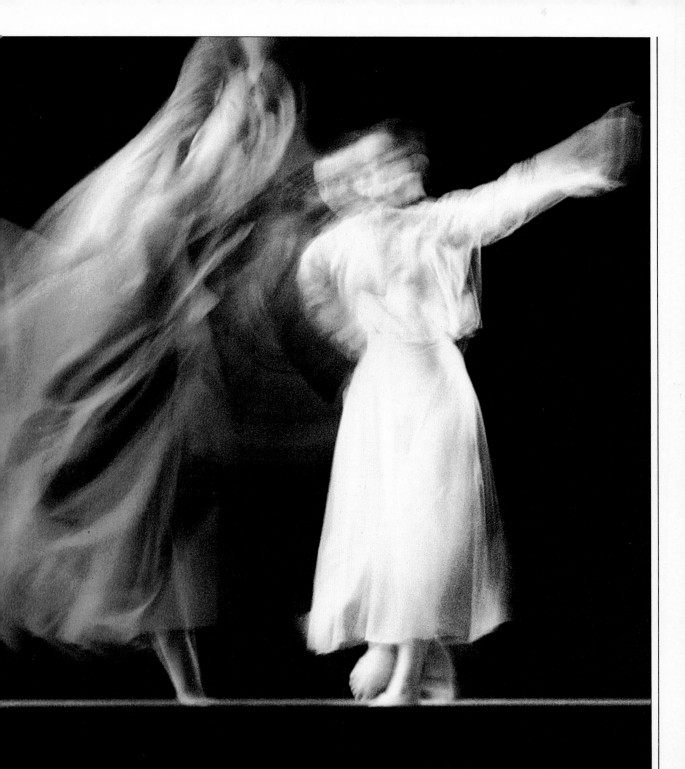

Camera movement

Moving the camera while the shutter is open is a simple way of creating blurred, impressionistic images. This technique draws out subject highlights, turning them into streaks that trace the movement of the camera. Smooth vertical or horizontal movements give straight lines, whereas rough jogging produces irregular blur. Rotation gives a swirling effect, with the greatest blur at picture edges (this is especially evident if you use a wide-angle lens). Study photographs by experts like Ernst Haas, who move the camera to create shapes that suit the mood and content of a picture. Overall blur decreases contrast, so choose a contrasty scene such as lights at night or glistening water, set against a dark or plain background.

You can move the camera while standing still or walking along, or hold it from a moving automobile or carnival ride. You can move it mechanically by cranking the tripod column during exposure. Try exposure times between 1/8 and 10 sec., depending on subject and situation. Use a slow film and small aperture, and, if necessary, a neutral density filter. You cannot see through an SLR viewfinder during a time exposure, so follow the subject by looking over the top of your camera.

◁ **Camera and subject movement**
In order to emphasize the speed of a tennis serve, left, the photographer set a slow shutter speed (1/30 sec.), and used a 300 mm lens and then moved the camera diagonally during the exposure. For this type of shot make your camera movement echo the subject's movement.

Camera rotation ▽
To create the tunnel effect in this picture, the photographer rotated his camera, turning it in a circle during a 1/15 sec. exposure. Although the result has an abstract quality, certain elements of the original composition — like the automobile in the background — are still recognizable.

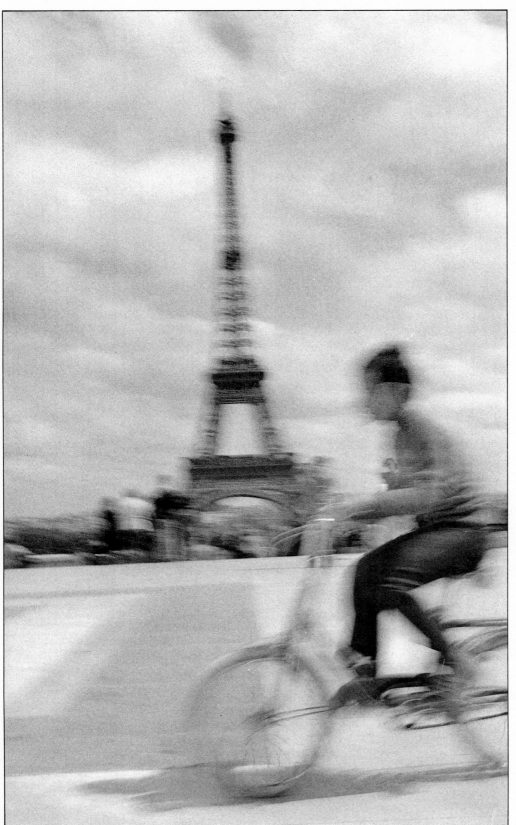

◁ **Walking with the subject**
To shoot this photograph,
Ricardo Gomez-Perez
set a shutter speed of
1/8 sec. and walked along
with the cyclist, following
the movement with his
camera. He used fill-in flash
to add some frozen detail.
The blur caused by camera
and subject movement has
heightened the impression
of action.

Panning

The technique of panning involves swinging the camera in a horizontal direction, whilst keeping a moving subject still in the viewfinder so that it records clearly. When combined with a slow shutter speed, it turns static objects in the foreground or background into blurred streaks of light. Panning gives a strong sense of movement and action, and is therefore widely used by sports photographers. It also enlivens subjects where a sense of movement is more important than surrounding detail – shots of children, animals or traffic for example.

For a good result choose a viewpoint where your subject is set against a many-colored background. Prefocus on a spot the subject will pass, then start panning smoothly with the action – releasing your shutter when the subject reaches the prefocused position; but continuing to pan. Use shutter speeds between 1/60 and 1/8 sec. – this allows the background to blur while keeping the subject fairly sharp. If you set a longer exposure, or pan faster than the speed of your subject, you will blur it too.

Panning for action ▷
To express the speed and energy of this runner, Gerry Cranham panned with a telephoto lens, at 1/30 sec. (see diagram below). First, he prefocused on the track, then panned with the movement of the race, pressing the shutter release when the athlete reached the prefocused point. Some parts of the subject are less sharp than others because the speed and direction of movement differs.

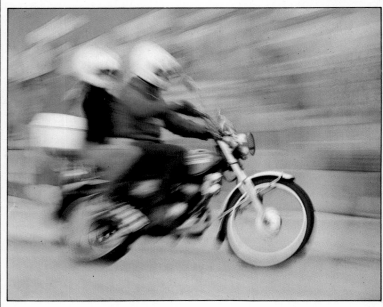

Pan and zoom △
For dynamic background blur, as in this shot of a motorbike, use a zoom lens. Prefocus with the lens at maximum focal length, then zoom in a little as you pan. Try a shutter speed of about 1/8 sec. and mount your camera on a tripod.

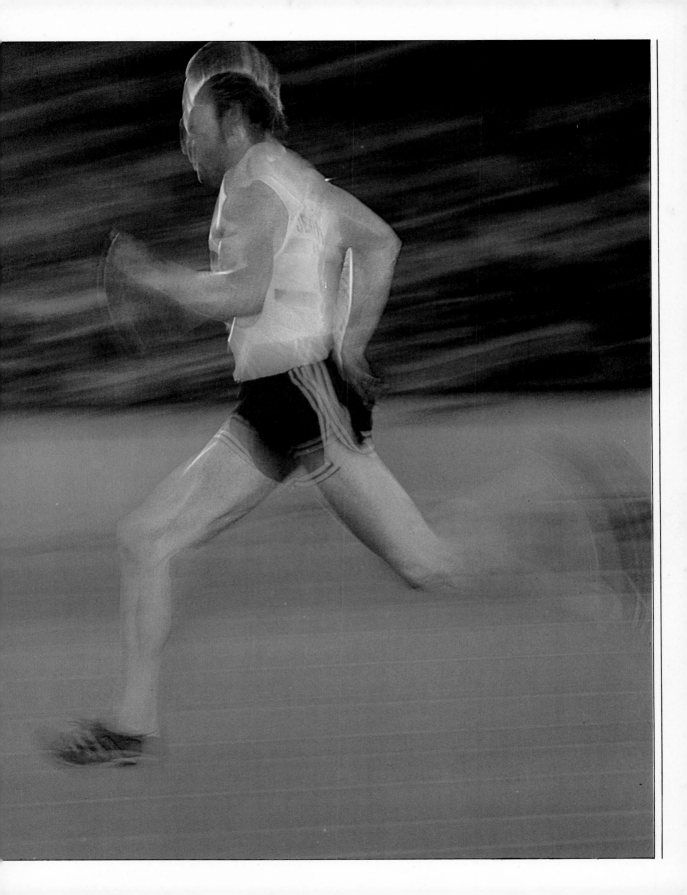

Focus

Another blur effect – softening of image outline and detail – involves de-focusing the camera lens. Out-of-focus images are generally thought of as errors; yet the plastic qualities of these images, and the way colors blend and subject appearance simplifies, are attractive.

Use a telephoto lens set at wide aperture for shallow depth of field. Subjects should have plenty of mixed colors against a plain dark or light background, which will not blur

noticeably. Focus the image sharply, then shift the lens to further and nearer settings and compare results – they may differ in quality. Circular highlights will spread into "beads" in the shape of your lens diaphragm.

As a variation, use selective focus to draw attention to one element in a picture. Exploit factors which give minimal depth of field – wide aperture, close-working, and long rather than short focal length.

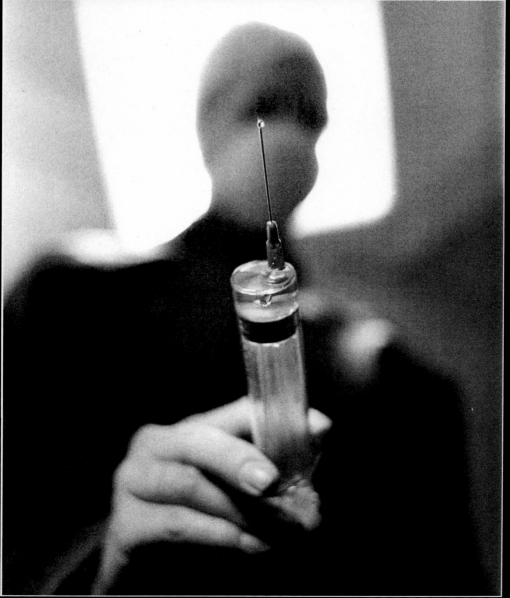

◁ **Dramatic selective focus**
The photographer shot from an angle which spaced out elements at varying distances. He used a telephoto lens at wide aperture to limit depth of field to a narrow zone, so that only the needle in the foreground is in sharp focus. Choice of viewpoint has dramatized the image, placing emphasis on the hypodermic and producing a patient's-eye view.

De-focusing for effect ▷
For this shot Andrew de Lory focused his 500 mm mirror lens, see diagram below, on the balloon seller, then shifted his focus control until he saw a pleasing de-focused image in the viewfinder. The photograph was taken on a bright day – the photo-grapher shot on slow film with a neutral density filter so that he could use a wide aperture.

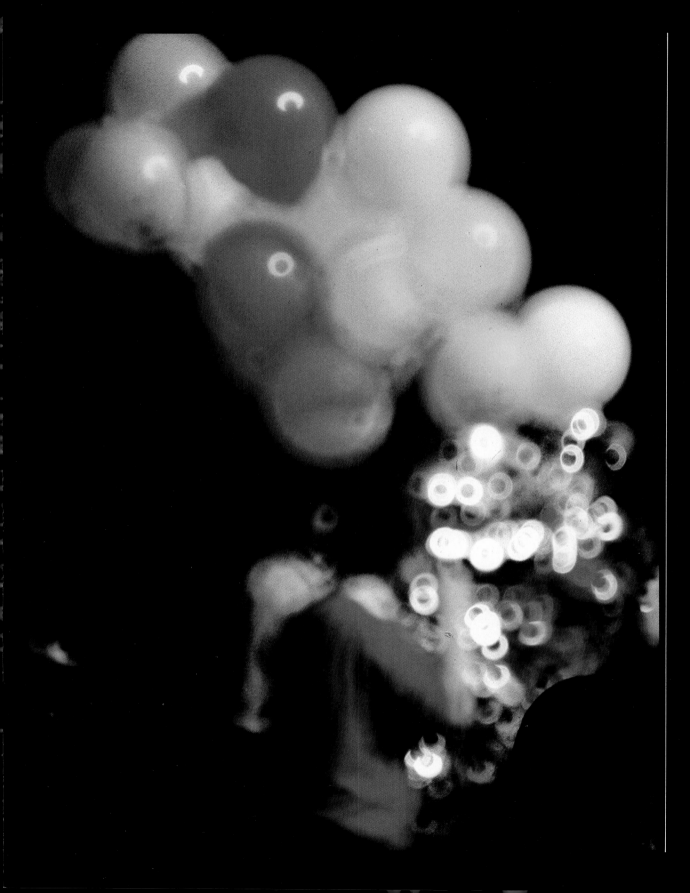

Zoom

A zoom lens can create an exploding image – even still objects will appear to be rushing outward. Many sports photographers use zoom – often head-on to the subject – for dynamic action shots. Choose subjects with plenty of isolated highlights and a generally dark background. Put your camera on a tripod, center your subject and set an exposure of 1/4 sec. or longer (p. 18). Focus the lens at its longest focal length, then zoom from long to short while the shutter is open. Results are difficult to predict, so make several shots at different shutter speeds and zooming rates.

For a different zoom effect, divide up exposure into several shorter times, and re-set the zoom to a different focal length between each exposure. This stepped technique produces several sharp images of the subject, diminishing in size and set one inside the other.

When you have mastered zooming with a static camera, combine zoom with panning (p. 22) or tilting. Panning while zooming is not easy – you will have to alter focus and zoom controls, fire the shutter and keep a moving subject in frame all at once. Results show lines radiating from the center of the subject, while the background blurs into horizontal streaks. When you tilt the tripod during zooming static subjects turn into swooping shapes – use this on point source lights with a dark background.

Sport and zoom ▷
For this shot of a cycle race, Gerry Cranham used a one-touch control 80–200 mm zoom lens; this is a good focal length to use for exploding zoom pictures. Here, blur radiates from the center of the frame, and is greatest at the edges of the image, giving an impression of speed to the photograph.

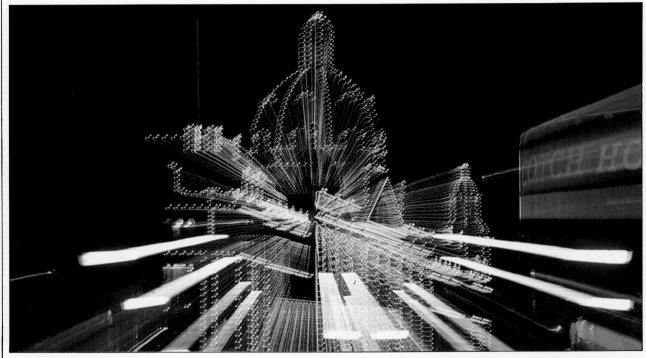

Zoom at night △
Night-time neon illuminations are interesting subjects for zoom. The photograph of a store front, above, was taken with an 80–200 mm lens fitted with a magenta filter. The photographer placed his camera on a tripod, and composed his image with the store front centered in the frame. And then he zoomed smoothly down through the focal settings on his lens during a 1 sec. exposure.

Stepped zoom ▷
For the shot shown far right, the photographer cut out shapes from a piece of black cardboard, near right. He put diffusing material over the craft shape and a green gel over the planet, then he masked out the planet. Next, using an 80–200 mm lens, with the camera on a tripod he exposed the same frame of film three times. First he exposed the image through a deep red filter with the lens set at 80 mm, then through a deep blue filter at

a setting of 135 mm. For the third exposure he removed the mask from the planet, fitted a cyan filter, and set his lens to 200 mm.

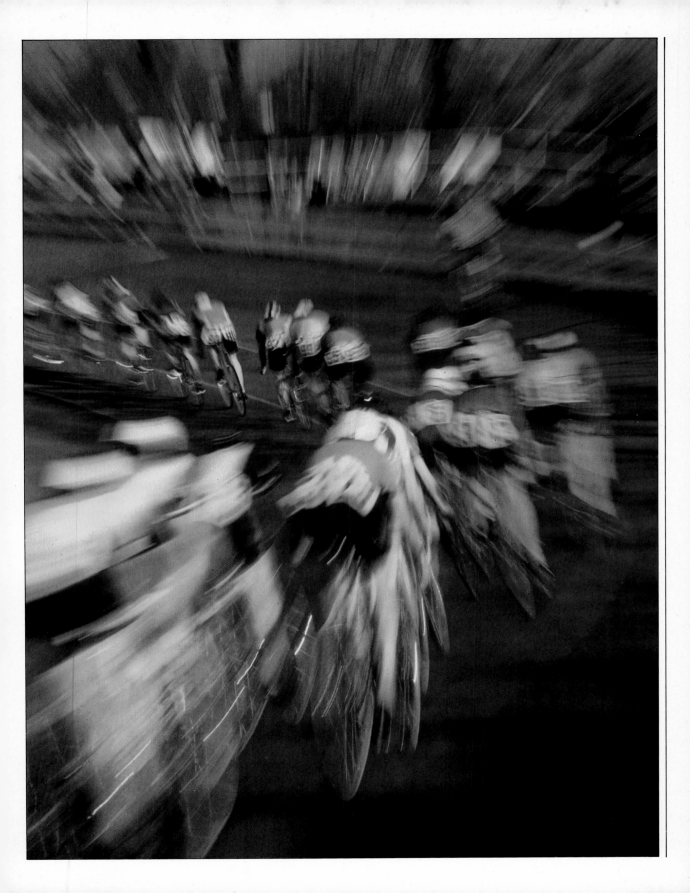

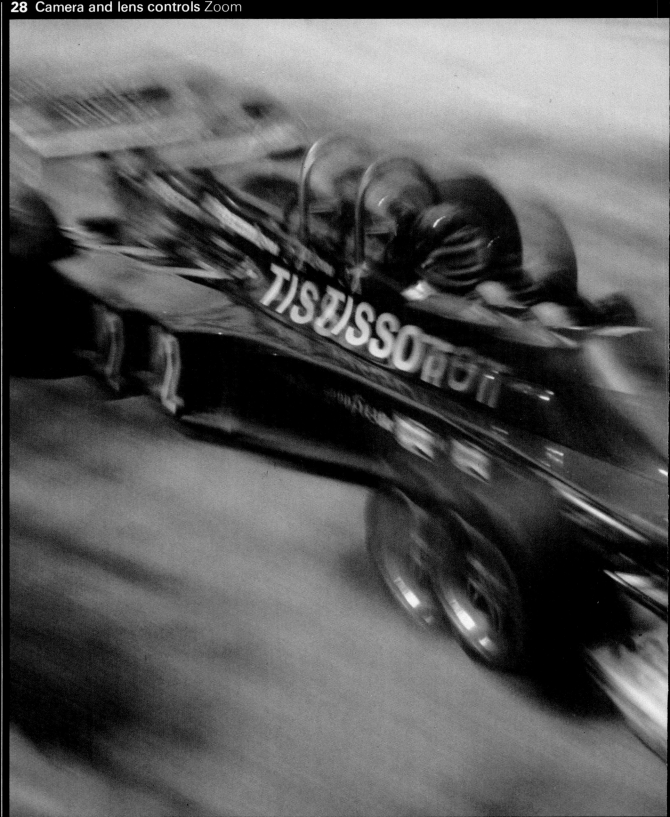

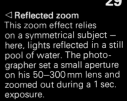

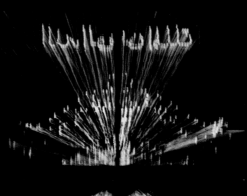

◁ **Reflected zoom**
This zoom effect relies
on a symmetrical subject —
here, lights reflected in a still
pool of water. The photo-
grapher set a small aperture
on his 50–300 mm lens and
zoomed out during a 1 sec.
exposure.

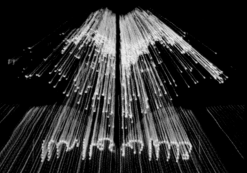

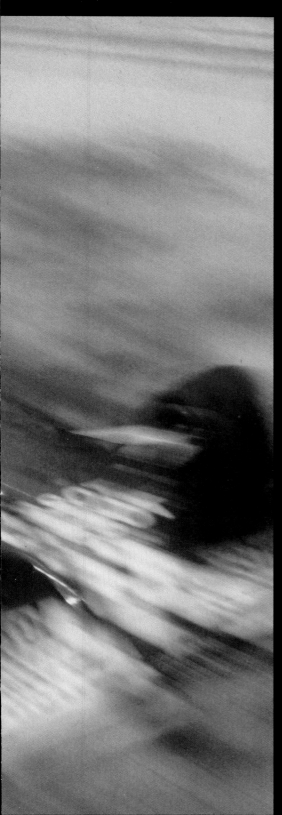

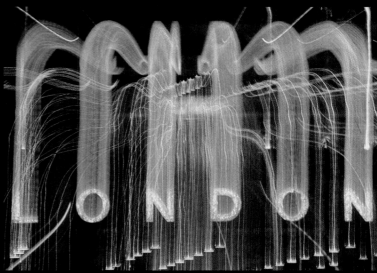

◁ **Zoom and prism**
For this photograph of a
racing car, Gerry Cranham
fitted a clear parallel multi-
image attachment (see p.
54) to his zoom lens. This
produced three overlapping
images of the racing car
which, combined with blur
from zooming give an
impression of accelerating
movement.

Zoom and tilt △
Decide on the amount of tilt
you need to shift your
subject down the frame, and
fit appropriate stops to your
tripod head. Hold the cable
release between thumb and
index finger, and use your
little finger to operate the
head, right. Begin your
exposure, zooming out as
you smoothly tilt the head
down. Finish the movement
before the end of the expo-
sure, for a final sharp image.

Flare

Used creatively to dramatize landscape, flare will produce evocative, romantic pictures or give a science fiction atmosphere to an image. Flare occurs when scattered light is added to the image – usually when shooting toward the light source. Scattered light degrades color and dilutes blacks, giving a misty effect. Unlike atmospheric pictures taken with a fog filter (see pp. 48–9), flare shots usually contain additional patches of light that are either formed by the lens diaphragm or reflected from shiny parts of the lens surround.

For greater overall flare remove your lens hood, and shoot through glass or use an old lens without an anti-flare coating. Try to include areas of black in the picture as this will help to emphasize the light scatter. Flare is more difficult to produce with modern coated lenses, but you can still form star-like patterns and chains of light patches if you include the light source in your composition.

For all controlled flare pictures it is vital to check the image through the lens at actual working aperture – use the preview button. Read the exposure from the sky – not the sun – and then make bracketed exposures. Each f number alters the size and shape of every flare spot, and even very small shifts of viewpoint will radically alter both the position and the appearance of flare chains.

Creating flare spots ▷
If you compose your shot to include the sun in an off-center position it will reflect ghost diaphragm shapes from each internal lens element, setting up oblique chains of flare spots. The number and size of these patches vary with lens design. They are most effective when they are large and dramatic, as in this fisheye shot by John Cleare.

Flare and background ▷
Circular flare, combined with a warm color cast, highlights the golden mood of this sunrise, taken at Masai Mara in Kenya. In sunrise or sunset photographs the rest of the scene generally turns into a silhouette, providing an ideal background for flare patterns.

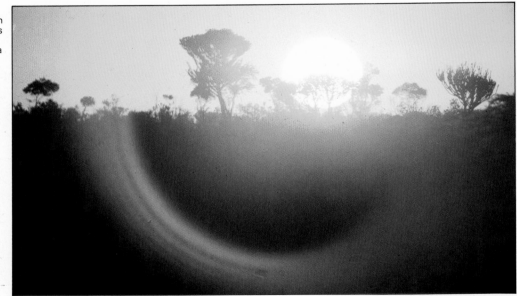

Making a natural starburst image ▷
If you place the sun in the middle of the frame, diffraction at each tiny angle of the lens diaphragm blades will form short, radiant lines. The effect is more contrasty and dramatic if you restrict the sun's size, using a gap between leaves for example, as in this shot.

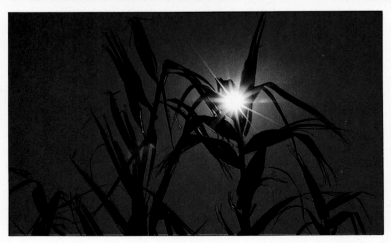

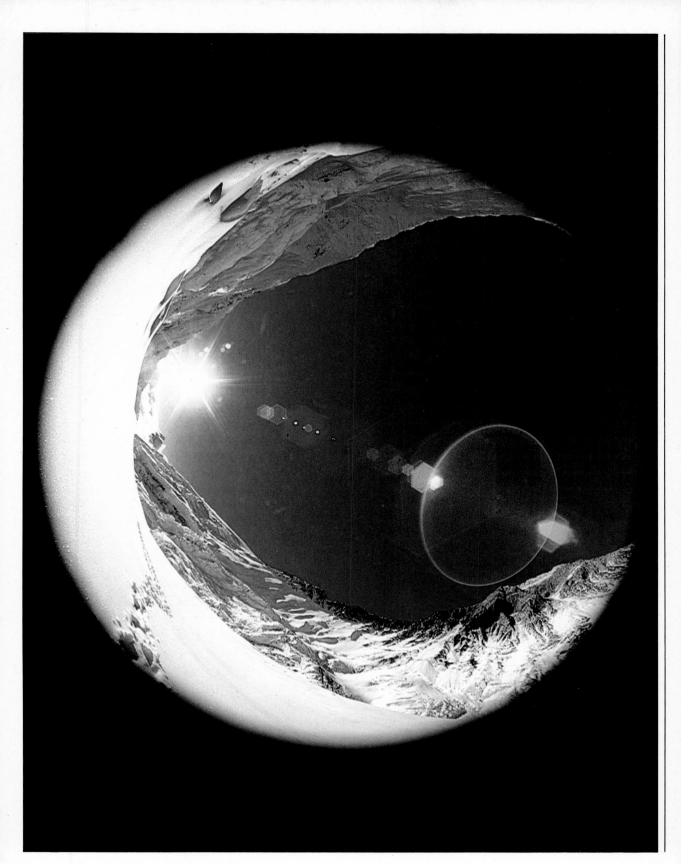

Simple optics

Low-grade optics can create a soft image quality impossible to achieve with a photographic camera lens, even with a diffuser (see p. 48). Cheap plastic or glass magnifying glasses, toy cameras, or a pinhole, all give slight softness of detail and spread of light.

It is possible to replace the normal lens in most cameras with a simple magnifier. With an SLR camera, you can measure exposure using its TTL meter, but you may have to position the lens at the right focusing distance using a cardboard tube and tape.

Pinholes also give a soft image, with very great depth of field. Because extremely long exposures are often necessary, even slow moving objects such as clouds or flowing water may record as featureless blur. You can fit a pinhole to an SLR body by taping aluminum foil over the lens seating, and making a tiny needle hole in the center of the foil. You will be able to see the image dimly on the focusing screen. You should increase exposure time to allow for reciprocity failure. You can also make improvised pinhole cameras from boxes of printing paper, cans or developing tanks. Both magnifying glasses and pinholes give low-contrast images, so push-process your results.

Using a plastic lens
To produce soft results with spreading highlights, like the images left and above, you must replace your lens with a large diameter plastic reading glass. Tape the glass to the front of your camera body on a cardboard tube, positioning the lens at the right focusing distance for your subject. You can measure exposure from your hand meter or TTL meter.

Making a pinhole result △
To create this image, Tim Stephens removed his lens and made a pinhole lens with aluminum foil and his camera body cap. He drilled one hole in the body cap and pierced three holes in the foil. He covered the first foil hole with red, the second with blue, and the third with green gelatin, see diagram right. Then he replaced the cap, with the foil inside, and gave an exposure three stops over the TTL meter reading (6¾ min in total). Each pinhole gives a separate, offset filtered image. Where these images overlap, composite colors form.

Wide-angle and telephoto

The scale of near to far objects in a scene alters with change of distance and lens focal length. A close viewpoint and wide-angle lens produces steep perspective, and brings the viewer close to the scene. Most extreme wide-angle lenses abandon normal rectilinear optics for a fisheye image. All lines except those which pass through the picture center curve, and the scene seems to bulge toward you. Fisheye lenses give a wildly distorted sense of depth and distance in cramped interiors. They produce caricature portraits, and exaggerate actions in sports. For accurate exposure take a spot reading or use a hand meter.

Extremely long focal length lenses allow a distant viewpoint. They minimize scale change – objects appear to be mostly on one plane, and seem remote and detached from the viewer. Long lenses have very shallow depth of field, giving circles of confusion from out-of-focus highlights. You can alter the shape of circles using shaped diaphragms, see below.

Extreme wide-angle and viewpoint ▽
For this picture Erik Steen used a 20 mm lens at f16 and chose a low, close viewpoint. As a result, the sunglasses at the near end of the plank appear out of scale to the girl standing at the other end.

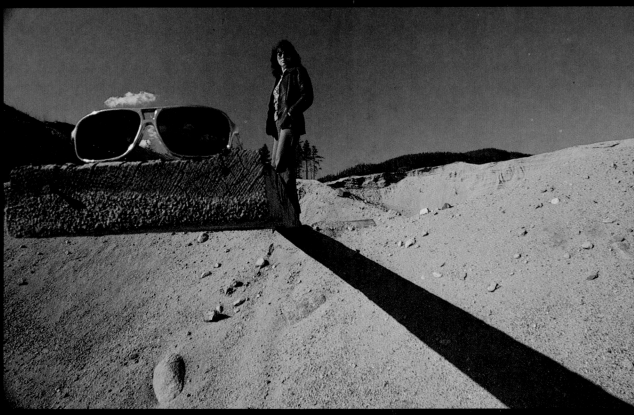

Aperture masks ▷
For a result like the photograph on the right, take black cardboard and cut out a single shape such as a star, diamond, letter, leaf (as here) to suit your subject. Place the mask in front of your telephoto lens (close-focusing 200 mm here) and focus carefully on your subject. In the resulting image all the out-of-focus background or foreground highlights (circles of confusion) will take on your chosen shape.

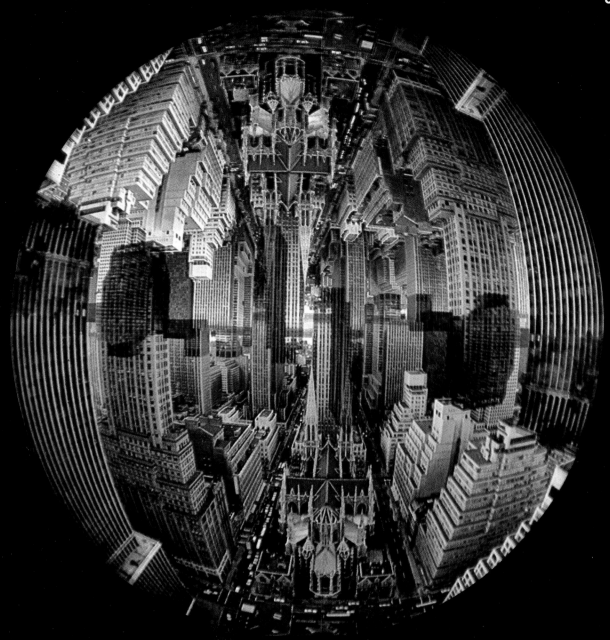

Fisheye for effect △
To create this circular view
of New York, Francisco
Hidalgo cut the lens cap of
his 8 mm fisheye lens in half.
Then he made two ex-
posures, reversing the
camera (and cap position)
to obtain the second image.
The barrel distortion of
fisheye has curved the
skyscrapers outward,
forming a frame for the
double image of the
cathedral.

Image distortion

In addition to zoom and fisheye lenses, several other special camera or lens systems can produce strikingly distorted image shapes. You can use them for caricatures, to distort lettering and other formal shapes, or to create strange images that look like optical illusions.

Anamorphic lenses or lens attachments are designed for movie cameras. They squeeze the image horizontally, recording a wide-screen view. Lens surfaces are cylindrical instead of spherical. On a still camera, placing the flat part of the cylinder vertically will compress the picture left to right, making objects tall and thin (see p. 49); rotating it by 90 degrees gives a fat, squat image. Halfway between these positions gives a 45 degree slanting effect.

Panoramic cameras give an expanded angle of view (180 degrees or more) in a horizontal dimension. During exposure the lens partially rotates, scanning the scene and recording it on film through a moving slit. A straight, horizontal line will record in a curve, whereas a curved line will appear straight. If you photograph a standing figure, using the camera vertically, the resulting image has a tiny head at the top, broadens at the middle, and converges again to tiny feet at the bottom. A sudden shift of subject or camera during a long exposure, as the camera scans in an arc, can give strange shape compression and expansion.

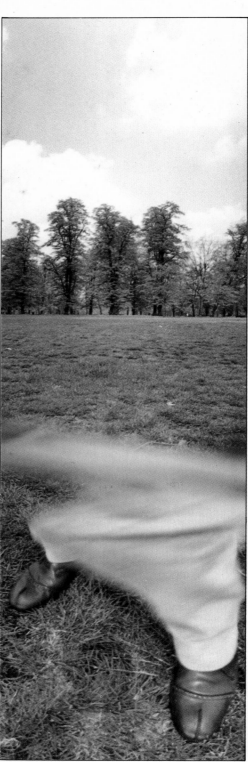

Panoramic distortion ▷
To create this headless figure, Wilf Nicholson used a panoramic camera vertically, see diagram, giving a long exposure. He set up a tripod in a low position and stood in front of it. As the lens began to scan the bottom of the picture, he jumped over the camera. His legs record as a sharp image, then the waist blurs, and finally the lens photographs grass and sky because he is out of view.

Anamorphic distortion △
Andrew de Lory used an
anamorphic lens, right, to
produce the askew image,
above. He set the cylinder at
a 45° angle. You can rotate
an anamorphic lens or
attachment until you see the
amount of distortion that
you want in the viewfinder.

Slit shutter

The technique of narrowing down the picture format to produce compressed or expanded distortions of moving images is commonly known as linear or slit shutter. To achieve this effect you must narrow the image seen by the film to a vertical slit about $\frac{1}{16}$ in (1mm) wide. Either tape foil in the focal plane of your camera or place a piece of slit cardboard over the front of your lens hood.

On 35 mm cameras start by covering the lens and advancing the entire film on the take-up spool. Then tape down the rewind button, lock the shutter open, and expose by turning the rewind handle steadily. With a peel-apart Polaroid camera fit a slit over the film pack and expose the film by pulling the tab. Always set your camera on a tripod, and position it so that passing subjects move in the opposite direction to the film. Turn the handle steadily – try $1\frac{1}{2}$ rotations per sec. for city traffic about 25 ft (7.5 m) away. Objects which move by at the right speed for the film record as a normal shape against a blurred background, but if they travel at other speeds or angles, or move unevenly, you will get strange curved or stretched images.

Slit images ▽
Slit shutter results are in long strips without frame divisions, like the pictures below. You can select any segment and cut it out for printing or projecting. The vertical bar patterned background in all slit pictures is a result of uneven film winding.

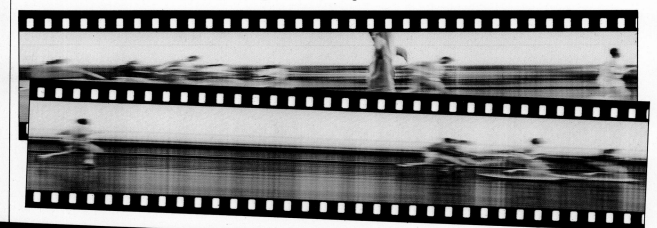

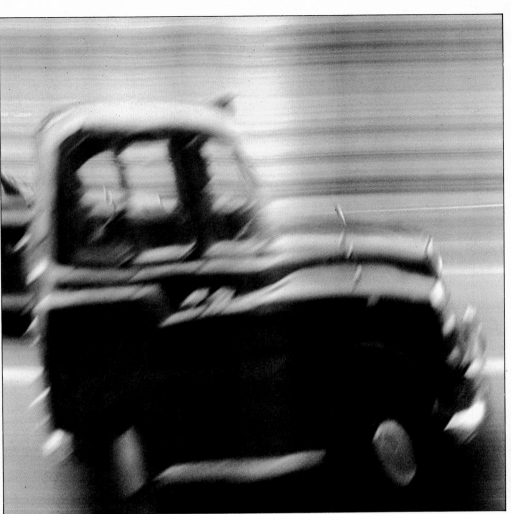

◁ **Compressing movement**
The speed of subject and film, and angle and direction of subject movement will compress shape, as here, or expand it, see below. In this picture, compression is a result of a film wind that is slower than the speed of the subject.

Distorting shape ▽
My original subject was a figure striding to the left. Parts of the body are undistorted because they matched film movement, slower-moving parts have stretched. I used a purchased slit shutter attachment on my camera, see diagram below.

Multiple exposure

Two or more exposures on one frame of film can combine wide-ranging subjects, structures, and moments in time in the same picture. Photographers such as Mitchell Funk, Sam Haskins, and Francisco Hidalgo frequently exploit this technique to create mood and atmosphere, form composite abstract images, or give surreal effects.

In a multiple exposure, details of one image will appear most strongly in the darker areas of the other, and areas of overlap become progressively lighter with each exposure. It is best to select dark-toned backgrounds for each of your component images, and make a preliminary sketch or mark the focusing screen to make sure that they match up successfully. If the medium or light tones of one image substantially overlap those of another, give each element half its correct exposure time. With images that do not overlap, and have dark backgrounds, you can give each part the TTL meter exposure.

Multiple exposure will combine images that differ in viewpoint or scale. To alter size or perspective quickly it is a good idea to use a zoom lens (see pp. 26–9). You can also try changing colored filters for each exposure (see p. 46), or shooting one image blurred, or out of focus, in order to enhance your effect.

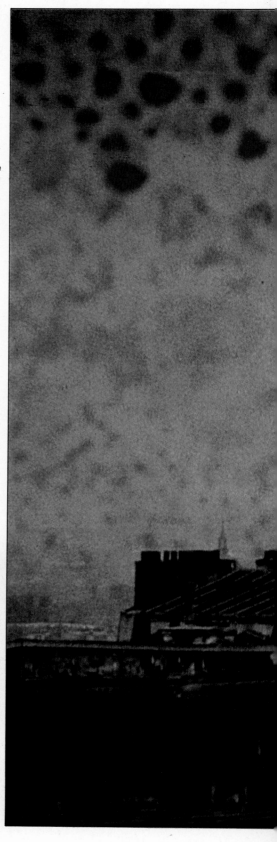

Multiple exposure for mood ▷
For this moody picture Francisco Hidalgo used color slide film to take a first weak exposure of flowers, setting his lens out-of-focus. Then he took another exposure — this time of Monmartre at sunset. The blurred flowers have turned into a dapple of color spots over the sky, giving the effect of an Impressionist painting. This mood is ideally suited to the subject.

Filling the sky ▽
You can use multiple exposure to introduce a moon, sun or stars to an empty sky, as in this picture by Chris Alan Wilton. One way to do this is to expose a roll of film, shooting the moon, say, against a dark sky, and using a long lens (200–500 mm) so that the image is a good size. Then rewind the film, restarting it at the same position so that you can photograph your main image.

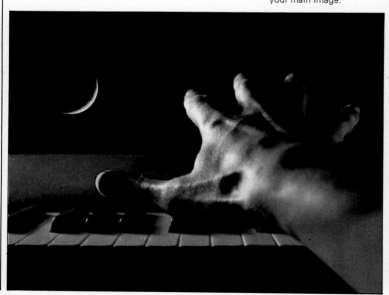

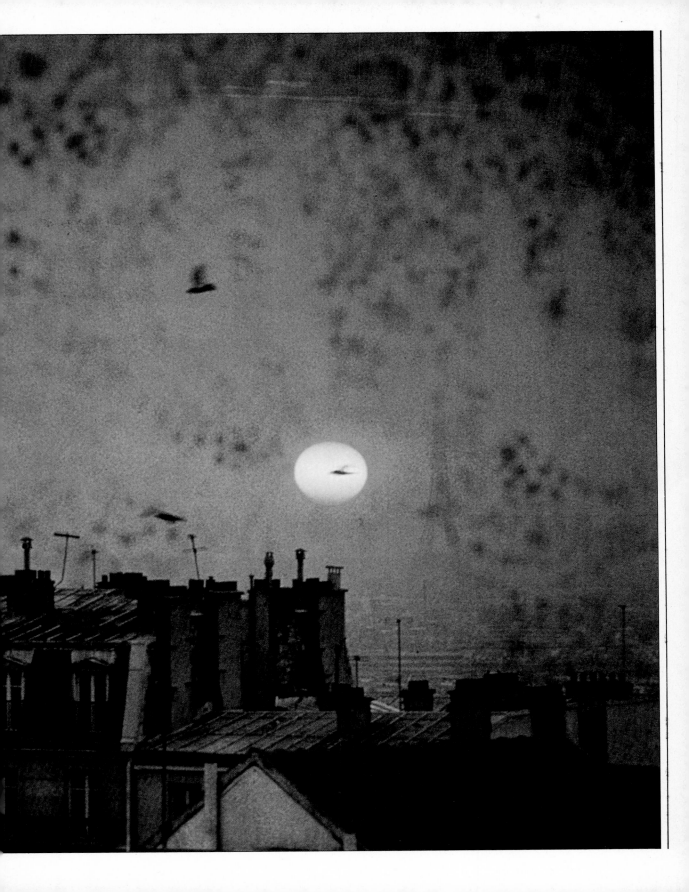

Multiple abstract ▷
To create this colorful
impression of a New York
skyscraper, Mitchell Funk
made five cumulative
exposures on a single frame
of color slide film, through
five different colored filters.
With his camera on a tripod,
he shot a close-up of the
building. Then, for each of
four exposures, he shifted
his camera slightly toward
the right and changed the
filter. Finally, he man-
ipulated the image still
further by processing the
slide film in chemicals
intended for color negative
stock (see p. 100).

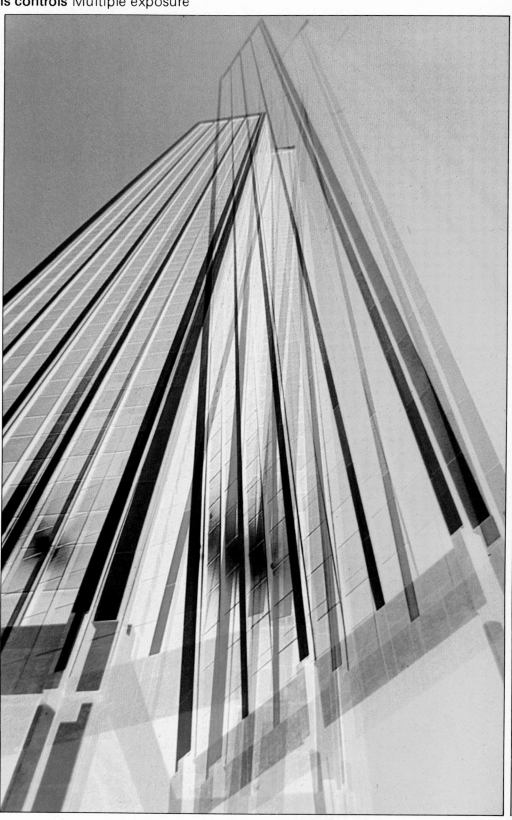

ATTACHMENTS AND REFLECTIONS

This section shows you how you can use the most popular lens attachments to produce special effects. It begins simply with colored filters to gently tint or totally dominate subject colors. Center-spot or graduated filters color part of the picture only, and with a split-field attachment you can focus a close-up in one half of the picture and keep the distant half sharp.

Sometimes you will want to create a soft, romantic image from a scene. Instead of using simplified optics (see p. 32), fit a diffuser to your regular lens to spread the highlights and lower contrast and image detail. Take manipulation a step further with prism, starburst or diffraction attachments that split up the image into a pattern of offset repeats, or turn intense highlights into pointed stars.

Reflections are an interesting source of optical distortions. Exploit reflective surfaces in the scene itself to give a double view of the subject. For more complicated images, hold a mirror close to the lens, or else explore the formal designs a kaleidoscope produces. Screens and masks allow you to add pattern or shape to an image. And a double mask enables you to expose two separate images side-by-side on one frame.

Do not waste money on equipment you will hardly ever use. Best buys are the least assertive attachments, because you can use them in many subject situations. You can use several different attachments at once, but you will find that both image sharpness and contrast suffer.

Single color filters

Filters that affect image color are basic ingredients in many successful photographs. In general, pale filters are subtle and realistic in effect – they warm up or cool down the mood of an image – whereas strong color filters give bold, unnatural results. When choosing a filter consider the color quality that will suit your composition best – warm reds and yellows, or cold blues and greens – and use the filter to increase the color harmony of your result.

Photographic filters work by removing certain elements of the light that passes through them. A blue filter, for example, will subtract most wavelengths of light from the image except for blue. You can exploit this property if you use a deep filter and shoot directly toward an extremely contrasty image such as the sun. You will overexpose the light source itself; this will allow sufficient wavelengths of other hues to reach the film, burning out the sun's image so that it records as a white shape. Other objects will appear as a few stark tones rather than a range of colors, so compose your shot as you would a silhouette (see p. 68). Because deep filters may affect the accuracy of your TTL meter; you should measure exposure from the sky alone (without the filter), then increase it by the factor recommended for your filter.

Strong color filter ▷
This evocative desert scene was shot by Pete Turner, using a long lens and a deep orange filter.

Turner carries about 100 filters with him on assignment. Sometimes he exposes his subject through a deep filter, using mismatched film (see p. 100). More often he creates his vivid, color-saturated results by introducing filters when using a slide copying attachment (see p. 114).

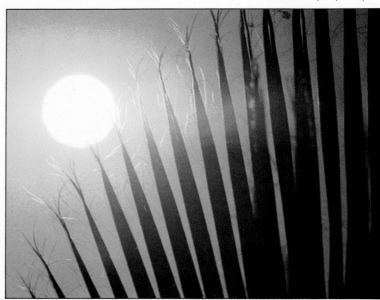

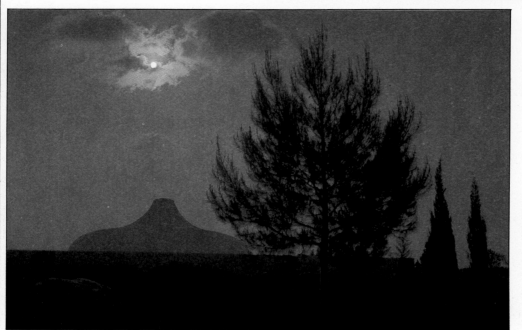

Filtering the sun △
To create this large, pale sun, the photographer used a deep amber filter with a 200 mm lens at full aperture. Because he shot into the sun, the foreground tree that frames the image has become a silhouette.

◁ **Day for night**
To produce a moonlit effect from a daytime scene, as in this photograph, you should underexpose your subject by two stops through a deep blue filter. You can include or exclude your main light source.

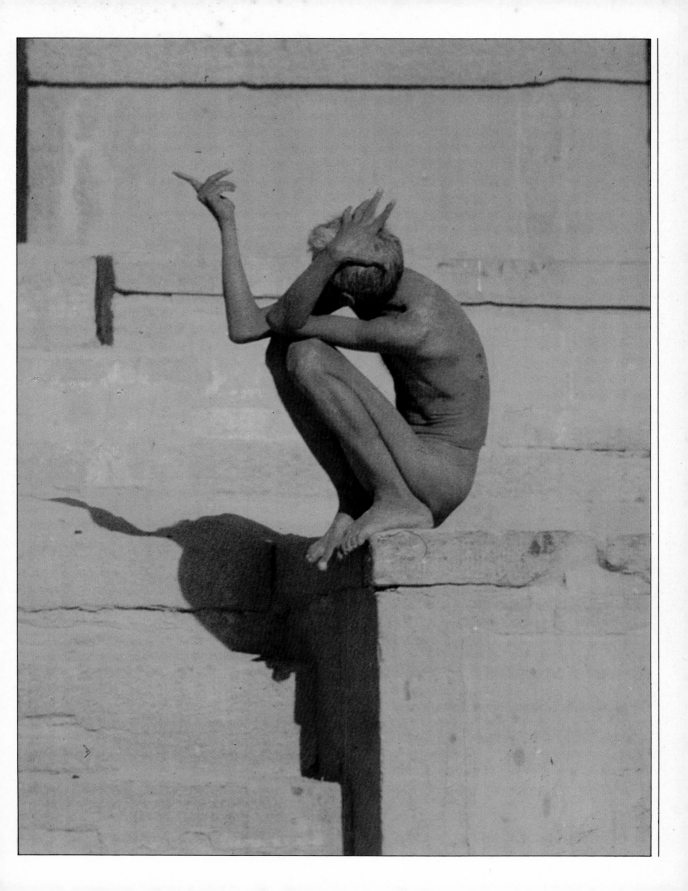

Color combinations

Dual-color, center-spot and graduated filters suit a variety of subjects. Most landscape photographers use graduated (half colored, half clear) filters to tint dull skies, adding mood. A dark gray filter, for example, gives an ordinary, cloudy sky a stormy appearance. Center-spot filters tint picture edges – portrait photographers often use them to frame a face with a soft vignette of color.

Dual-color or split filters give dramatic, surreal results. For best effect use them on simple, uncluttered subjects. The filter colors sharply divide, but you can create a gradual change if you use a wide aperture, especially with a telephoto lens. A small aperture gives an abrupt division – this works best when you align the split with a strong horizontal or vertical line.

Another way of making multi-color images is to give a moving subject three exposures through separation filters. The static elements accumulate a white light exposure and appear normal. Moving elements, on the other hand, are speckled with color.

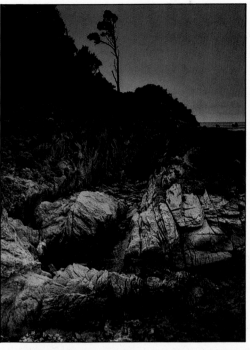

◁ **Enhancing a dull sky**
For this shot of Point Lobos in California, the photographer used a graduated tobacco filter. He positioned it at an angle in order to color only the gray, overcast sky, leaving the rocks in the foreground unfiltered. Read exposure before positioning the filter, so that it does not alter the TTL meter reading.

Color for mood ▷
To add delicate color to this shot of Japanese kites, Andrew de Lory used a yellow and magenta dual-color filter on a 200 mm lens. He set a wide aperture to soften the split between the colors.

Rainbow effect ▷
For a result like this fountain shot, first expose your image through a green, then a blue, and finally a red density-balanced tri-color filter. For a correct exposure multiply the film ASA (200 ASA here) by three and set the dial at the nearest rating (640 ASA here). Then give the metered exposure for each step. A tripod is essential to keep framing exact so that white light areas appear normal.

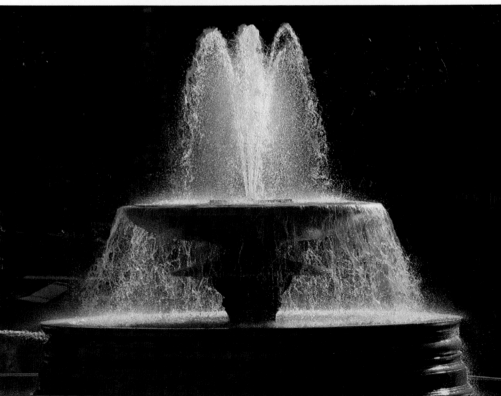

Diffusion

Diffusion – slight spreading of the lightest parts of a picture – softens detail and gives a misty, romantic effect. The technique was first used by the Pictorialists – impressionist photographers in the nineteenth century. In this century, the creators of Hollywood glamor portraits made use of its flattering effect to erase facial wrinkles and blemishes. Today, leading exponents are David Hamilton, who produces soft, pretty photographs of nudes, and Sarah Moon, who creates innovative fashion pictures in delicate, muted colors.

The simplest and most adaptable diffuser is a UV or clear glass filter smeared with a little petroleum jelly – you can treat only one half of the image, or diffuse the edges more than the center. Another method involves stretching some 15 denier nylon just in front of the lens. You can buy a glass disk diffuser or a fog filter, or a lens with variable soft focus settings. With all these devices you should preview results at your chosen aperture – diffusion lessens as you stop down. For best results, choose subjects with strong highlights and contrasty tones.

Selective diffusion ▽
To produce this image the photographer smeared petroleum jelly on a clear filter. He treated the lower half of the filter most heavily, in order to scatter the highlights from the water in the stream, and set a wide aperture for maximum diffusion.

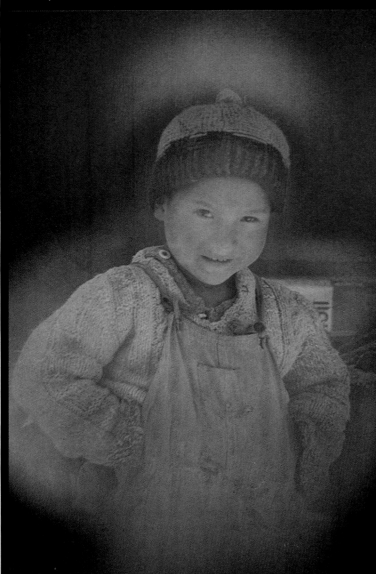

◁ **Soft focus portrait**
If you shoot a diffuse image on color film the result will often be very effective – your picture will have soft, muted, harmonious hues. This technique is especially suited to portraiture, as in this picture by Francisco Hidalgo.

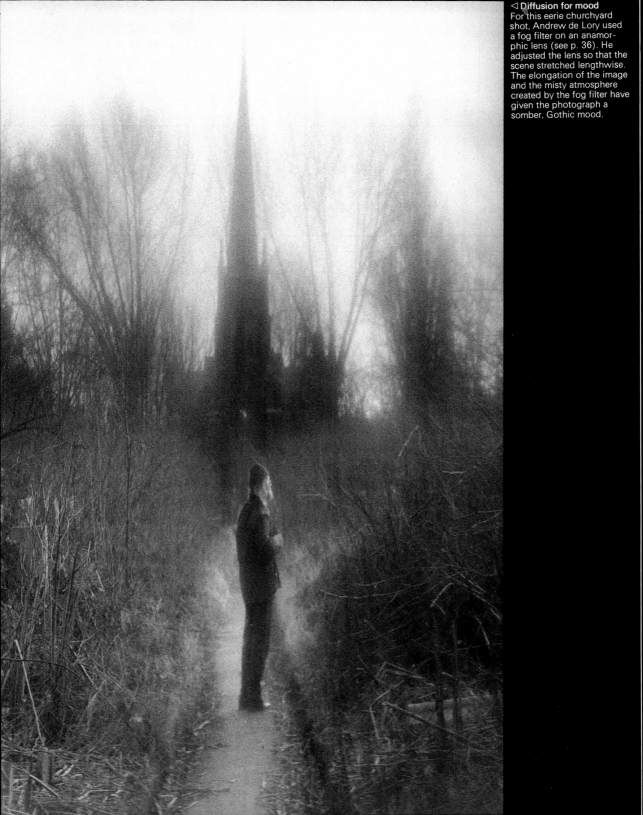

(see p. 36).

◁ **Diffusion for mood**
For this eerie churchyard
shot, Andrew de Lory used
a fog filter on an anamor-
phic lens (see p. 36). He
adjusted the lens so that the
scene stretched lengthwise.
The elongation of the image
and the misty atmosphere
created by the fog filter have
given the photograph a
somber, Gothic mood.

Diffraction and starburst

Starburst and diffraction attachments are colorless glass or plastic disks which work by breaking up the light. Commercial photographers use starburst attachments to give glamorous, theatrical effects on subjects that contain small, but intense light sources. City lights, candles, and highlights on water, chrome or glass are all good sources for starburst shots. Outdoors, a starburst on the sun suggests glare and heat, and fills an otherwise plain sky. A starburst filter consists of a grid of fine lines on a single disk, or two disks with parallel lines which you rotate against each other to form cross lines at any angle.

Diffraction or rainbow attachments reduce image contrast, and slightly soften focus. Diffractors have a very fine pattern of parallel grooves, which break up white light into some of its component colors. Highlights split into blue, green and red, while light-toned areas appear as offset repeats in pale hues. Starburst and diffraction disks do not affect exposure.

Diffraction rainbows ▷
Andrew de Lory used an inexpensive plastic rainbow-making disk from a toy store. The plastic diffractor has turned the tungsten strip lights into blurred, rainbow-like stripes.

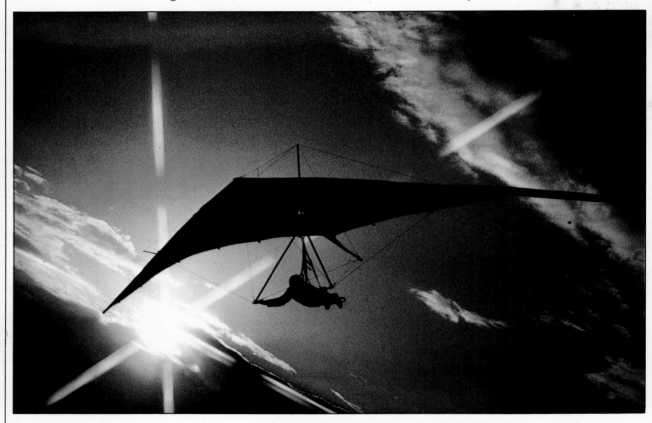

Dramatizing skies △
You add sparkle to a picture like this shot of a hang glider, where the subject is set against sky, by using a starburst to spread highlights from the sun. Here, a six-pointed diffracting attachment was used on a standard lens at a small aperture.

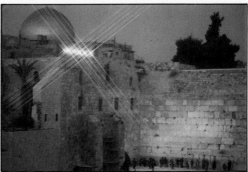

◁ Using a starburst
For this image taken in Jerusalem at dusk, the photographer used a 135 mm lens and a wide aperture. He fitted a four-pointed starburst attachment to turn the bank of spotlights in the foreground into a series of four-rayed stars.

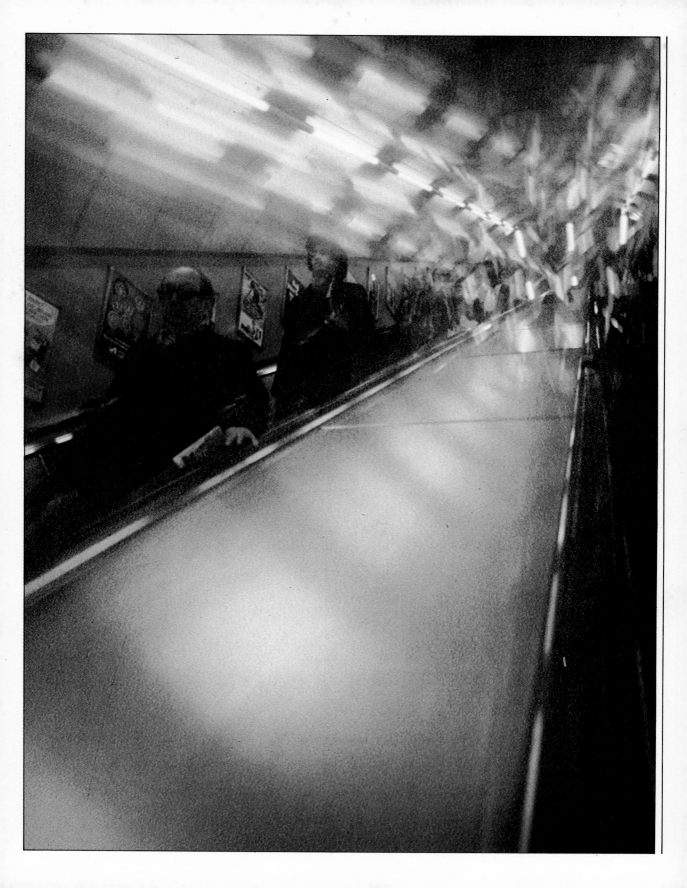

Supplementary lenses

Additional lenses for special effect purposes distort or enlarge the part of the image they are placed in front of. Improvised lenses – such as magnifying glasses or pieces of molded glass – are useful to distort or limit the area of sharp focus. And you can use a close-up lens so that it affects only one section of the image. This makes it possible to create an extensive depth of field that is impossible with normal lenses.

A split-field attachment is a half-circular close-up lens which you place over the regular camera lens. Set the main lens to focus on a distant subject, then arrange the split lens to cover and bring into focus some nearby foreground object. A small lens aperture gives the most abrupt change of sharp focus. For a more gradual change use a wider aperture, but take care that the foreground and background are in a continuous level plane – the split may produce an out-of-focus band in the center.

You can achieve the opposite effect – localized sharpness across a subject which is all at one distance from the camera – by holding a supplementary lens some distance from the camera lens. Focus the camera lens on the part seen through the supplementary, then control the sharpness of the rest by choice of aperture.

Split field ▷
For this surreal effect, Michael De Camp placed a close-up lens over the bottom half of the picture. As a result both the clock in the foreground and lake in the background are sharp.

Using molded glass △
Any sort of molded glass, like the bottle used in this photograph, will distort any part of the subject that is viewed through it. Faces are good subjects for this type of distortion – note the size of the nose and mouth in relation to the hands.

◁ **Using a supplementary lens**
Try taking a humorous shot like this picture, using a magnifying glass to distort one part of an image out of proportion to the rest.

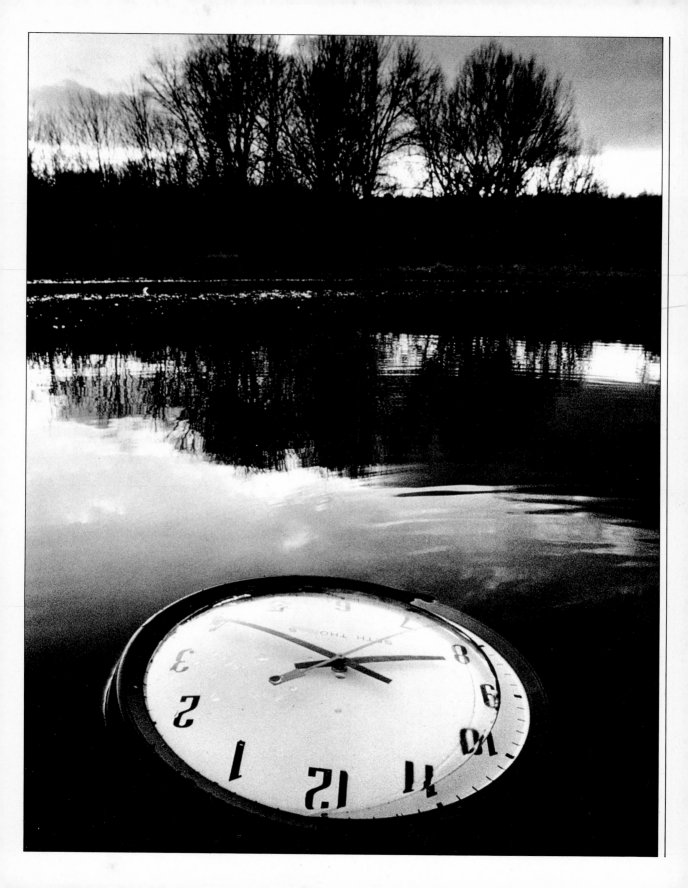

Multiple-image filters

Improvized pattern-making devices such as multi-faceted mirrors and cut glass first became popular with the development of Cubism as a painting style early this century. Today many special effects photographers use special faceted glass lens attachments originally developed for the movie industry. Some give one normal image plus overlapping parallel repeats, others produce a central image encircled by repeats. Some attachments have facets tinted so that each repeat image is a different color.

The best subjects for multi-image filters have a simple, but distinctive shape. Choose a plain background, and bear in mind that a pale background will tend to flatten image contrast because of the overlap of light. You can make the repeat images almost as sharp as the direct image if you use a small lens aperture.

When you turn the mount of a multi-image filter, the position of the refracted images rotates within the frame – if you do this slowly and carefully you will create attractive circular blur effects. To split up part of a scene only – to form several heads on one body for example – hold a circular filter about 6 ins (15 cm) in front of a normal lens, set at wide aperture.

Color effects ▷
The photographer used a circular, colored multi-image filter to heighten the beauty of a stained glass window in the cathedral of Notre Dame. He used a shallow depth of field, focusing on the window so that the candles in the foreground became blurred spots of light.

Simple images ▽
For a successful multi-image result you should use your circular attachment to photograph a single, simple object against a clear background. You do not have to adjust exposure if you are using a clear attachment.

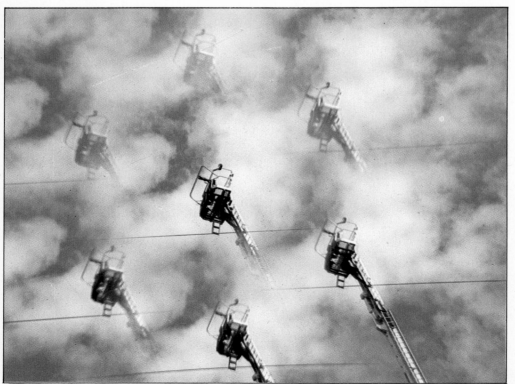

Illustrating movement ▷
John Starr used a clear parallel attachment to take this photograph of a dancer at the height of her leap. The repeat effect echoes the dancer's movement, and a long exposure has blurred the subject's legs, implying action. The mood of the image is enhanced by the soft muted colors of the stage lighting.

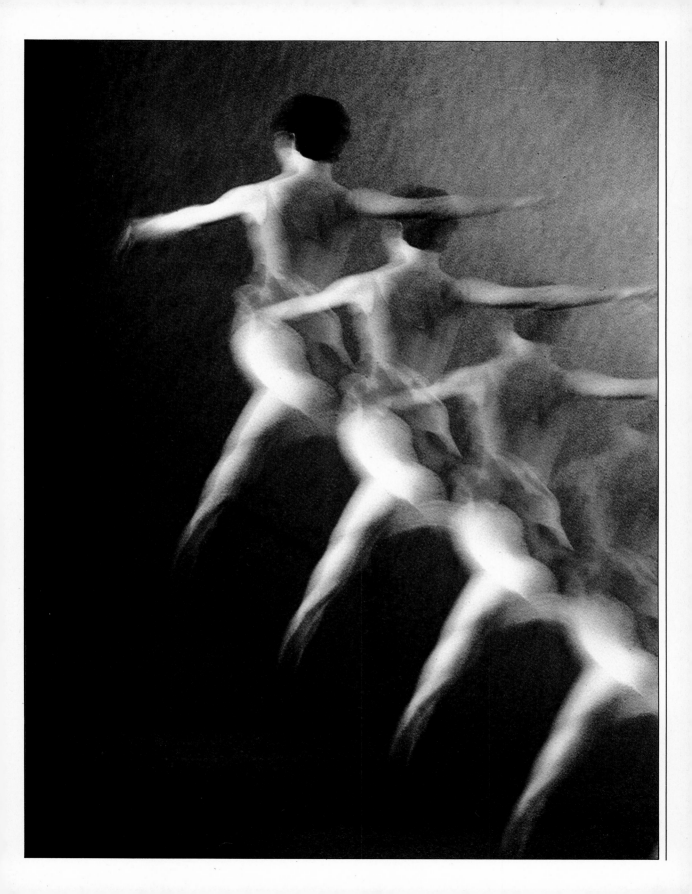

Reflections

Many photographers use reflective surfaces to combine unlikely subjects in one shot or to distort the natural shape of an image. Windows, polished paintwork, wet streets and smooth or rippled water are natural reflectors. And you can use reflective foil materials for indoor shots. For unusual juxtapositions, try including a reflector's surroundings; for semi-abstract results, crop in tightly. Store windows give a result similar to multiple exposure (p. 40), as they show the reflection superimposed on objects behind the glass. Stop well down and focus midway between the glass and the reflected subject so that both are sharp.

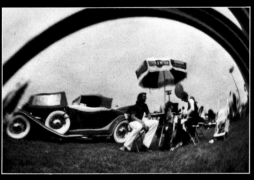

◁ **Found reflections**
Highly polished automobile bumpers and hub caps are a good source of distorted images. With a convex reflection like the scene on the left, you should use a telephoto lens to prevent your own reflection intruding on the image. Position yourself at an oblique angle in order to avoid flare spots.

Mirror-foil ▷
For this distorted portrait shot, the photographer placed his subject in front of a sheet of gold foil, and, positioning himself at an oblique angle to the foil, used a 135mm lens to record her reflection. When shooting in color, you can choose from a range of colored foils that will enhance the mood of your final image.

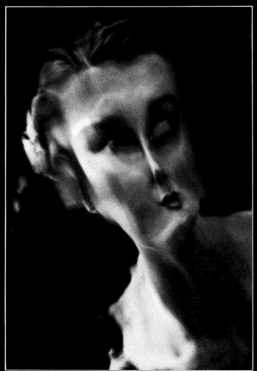

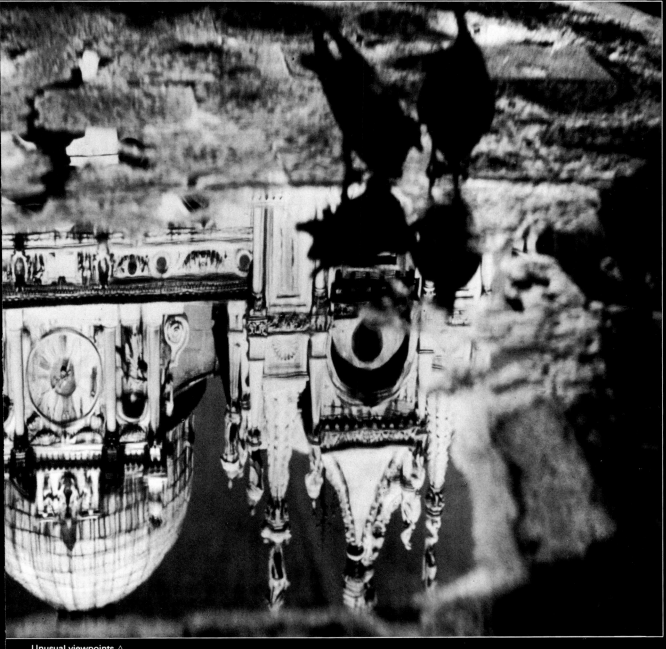

Unusual viewpoints △
A reflection will distort a
familiar image, giving a fresh
approach to an over-
photographed subject. To
capture a different view of
San Marco in Venice,
Francisco Hidalgo waited
for birds to settle on a
nearby puddle. The resulting
image, above, juxtaposes
unrelated elements in an
unusual manner. Scale, too,
is distorted by this effect —
note the size of the two
birds in relation to the size
of the church.

Kaleidoscope

A kaleidoscope is a very old optical toy for forming symmetrical patterns from bright-colored objects. It consists of a triangular-shaped tube of mirrors which you look down, while pointing it toward some simple, colorful scene. The first serious use of the kaleidoscope in photography was by Cubist-influenced Vorticist artists such as A. L. Coburn.

Kaleidoscopes are often overlooked as pattern-forming devices – they are similar to some prism devices, but offer much greater control and better image quality. For a clear image you must use front-silvered mirrors, or attach thick mirror-foil to an absolutely flat surface. (Normal glass-fronted mirrors produce double images.) Use two or three mirrors about 3–4 ins (7–10 cm) long in front of your lens.

You can also buy a special mirror hood that contains 10 or 12 reflective facets. Or wrap a circular tube of mirror-foil around the lens – this gives a normal central image encircled by whirling abstract shapes and colors. Alternatively, you can form symmetrical patterns from still-life subjects using a form of multiple exposure and a mechanical jig.

Symmetry and subject ▷
For this image Andrew de Lory used strong pattern and color to create a dramatic kaleidoscope image. The symmetry of the pattern suits the subject chosen (graphic equipment). The diagram below shows the arrangement of front-silvered mirrors used to produce this result. Two mirrors were taped together at 60° angles.

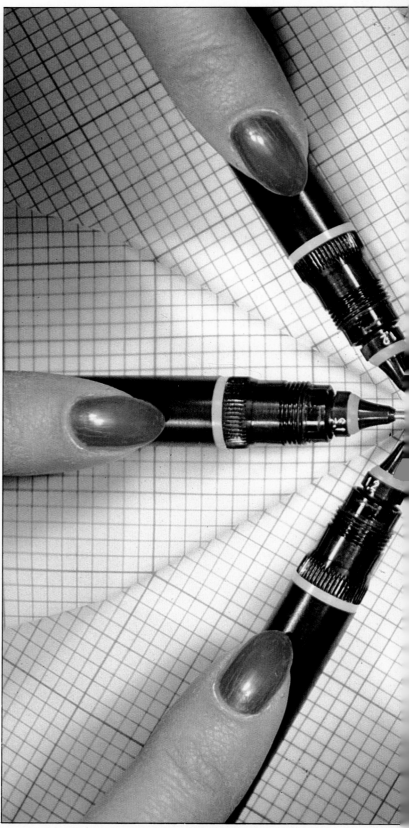

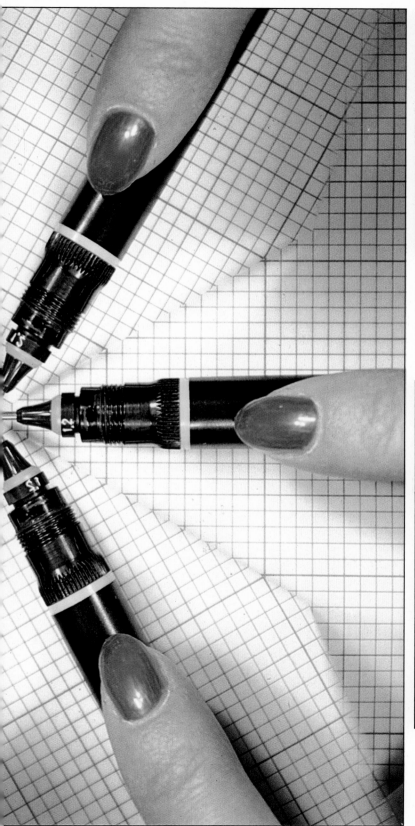

Simple pattern △
For this image the photographer used color and
shape to form a simple,
repeating pattern. Because
the camera was further
away from the subject than
it was for the photograph
left, the divisions between
sections are less sharp.

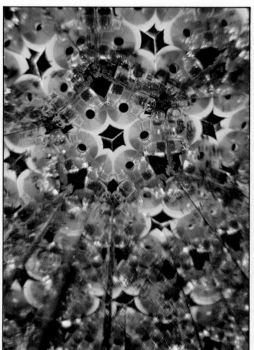

Indistinct images △
The photographer used
ordinary mirrors for this
pattern. As a result, the
repeating patterns have
blurred, ghost images. This
type of mirror is only
satisfactory if you intend to
produce such results.

Screens and masks

Use screens as pattern-making devices, either placing them right in front of the film, or, for a simpler effect, shooting through a screen-like mesh just in front of the subject. Screens change the image into a regular or irregular grid of lines or dots, destroying fine detail. Masks allow you to form unusual picture shapes, or to blend part of one scene with another by double exposure.

In general, you use masks on the camera, positioned a few inches ahead of the lens on the front of a slotted effects box that resembles a lens hood. Cut out masks from black cardboard, or purchase pre-cut shapes. You can make more elaborate masks (see p. 63) photographically on lith film. The smaller the lens aperture you use, the sharper your mask shape will be. A wide-angle lens makes the mask smaller in the frame, a telephoto makes it larger. Pairs of double masks – one shape is a "negative" of the other – allow you to take one image inside or alongside another for multi-image effects. You take the first scene through a mask with a clear shape and black surround. Then expose another scene on the same frame, through the second, negative version of the mask (see p. 63). You can also work with shaped masks in the darkroom to produce soft-edged white, black or colored vignettes on your prints.

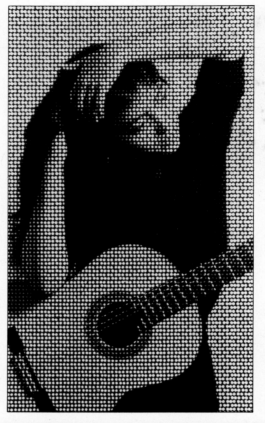

Making use of an existing screen ▷
For this portrait Alfred Gescheidt photographed his subject through a thin metal grid. Drops of rain highlight the pattern of the screen.

◁ **On-camera screen**
Here, the guitarist was photographed through scrim stretched over a wooden screen and placed between the camera and the subject. The graphic qualities of dot effect screens suit black and white film.

Mat box mask ▽
The photographer used a mask in the shape of a rear view mirror to create this simulation of a driver's view of night-time streets. He placed the mask in a mat box fitted to the front of his camera lens.

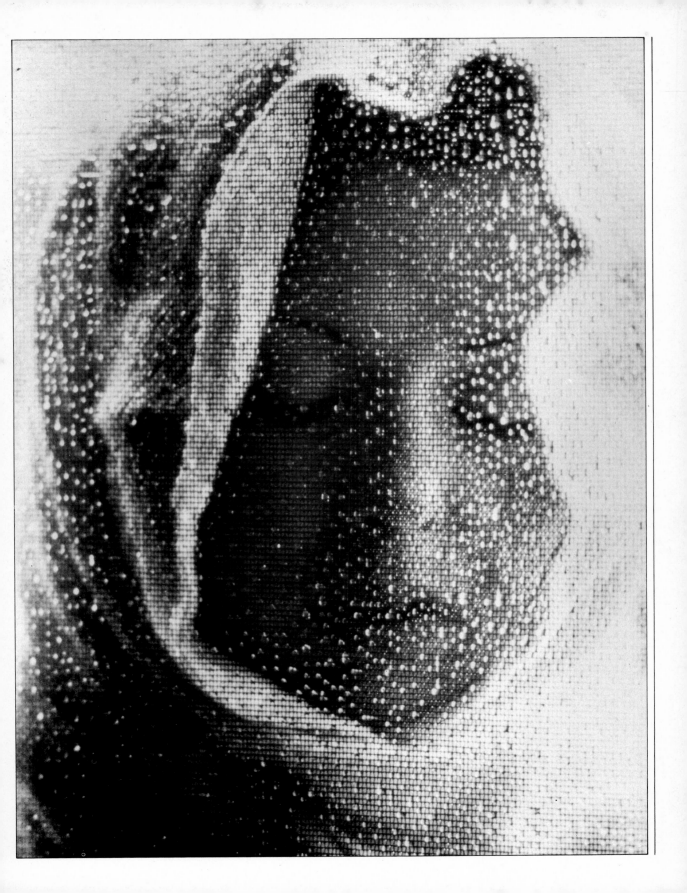

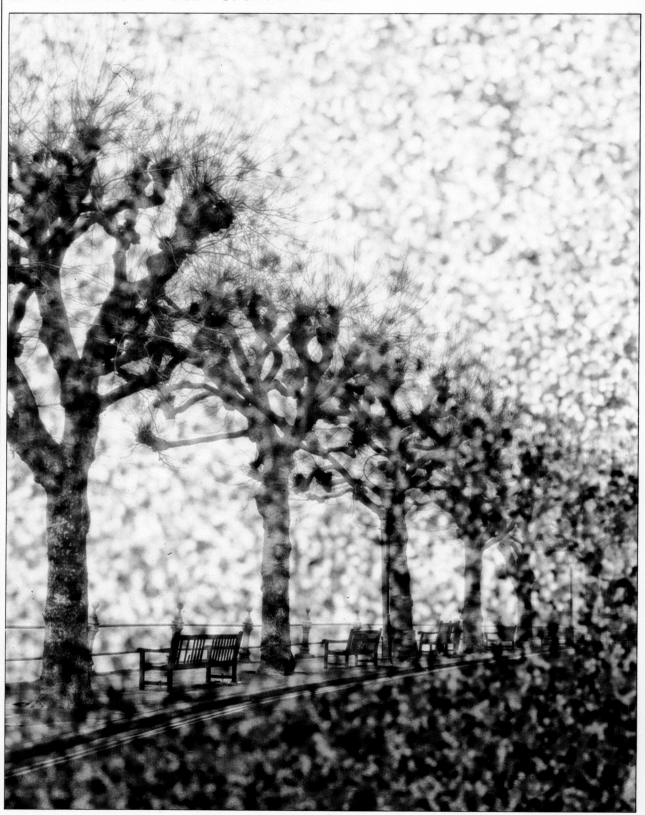

◁ Pointillist screen

David Carpenter achieved this subtle result by shooting his image through a photographic screen. To make the screen he photographed cake decorations on transparency film, see below. He used a medium format camera and inserted the screen just in front of the film surface before exposing the landscape.

Double mask ▷

For this picture Tim Simmons used a double mask attachment to combine two portraits of the same girl on one frame. With this type of mask you can divide the frame vertically or horizontally.

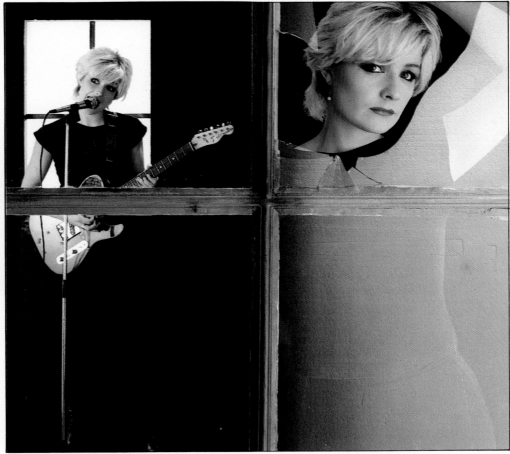

◁ Spot mask

The soft-edged attachment shown below allows you to juxtapose two separate images on one frame of film. Here, the photographer took a picture of an old plate camera through deep amber and diffuse filters, masking the center of the lens. Then he masked the area exposed to the plate camera and took a close-up of Nikon F3 circuitry, fitting it into the plate camera lens. For both shots he used a 55 mm macro lens, stopped down to f22, and tungsten type film and lighting.

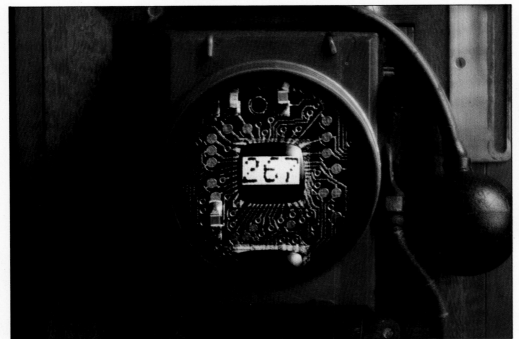

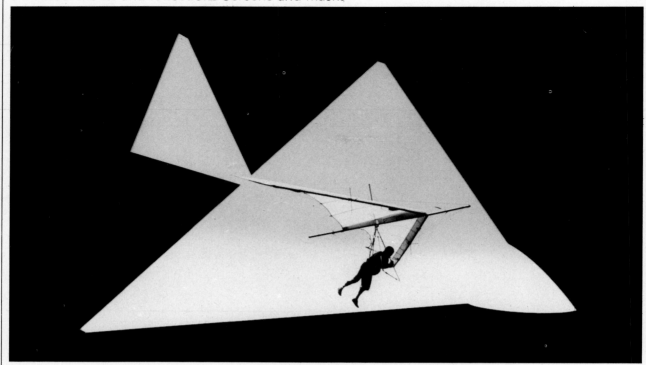

Pre-shaped printing mask △
For this image a cardboard
mask was used at the
printing stage. First, give
your negative a normal
exposure, then lay the pre-
cut opaque mask over the
paper, remove the negative
and give double the
exposure to turn the rest of
the print black.

◁ **Vignette**
To produce a graduated
white edge to a print you
will have to use a dodger
throughout the exposure.
This will allow you to hold
back the areas that you
want to stay white. Use
opaque cardboard with an
oval hole, and keep it
moving slightly.

LIGHTING AND STUDIO

This section deals mostly with special effects and illusions that you can create with light. Simple predominance of darkness, lightness, or strong color in a picture will have a powerful effect on mood and atmosphere. You can introduce a sense of mystery by lighting a dark subject dramatically from an unusual angle, or suggest a delicate mood by using pale subject tones and colors. And colored lamps or other unusual light sources, such as ultra-violet, will tint familiar objects in strange new shades.

Light itself can form the subject — if you move light sources in front of the camera you can draw patterns. High-speed flash gives an unnatural look to common but fast-moving objects, by freezing stages in an action that is too fleeting for the eye to see. To capture movement and flow, work with stroboscopic lamps, which chop up continuous action into patterns; or combine flash and time exposure in daylight for a combination of frozen detail and blur.

Light — in the form of projected images — provides endless pictorial possibilities in the studio. As well as providing abstract or fantasy settings for special effects purposes, front and back projection units give low-cost location realism for fashion and still-life shots. And you can use ordinary projectors to merge pictures for surreal results. Finally, this section covers studio sets which you build and light like stage scenery to create deceptive situations.

Low and high key

Although low and high key techniques are not strictly special effects, they manipulate mood and atmosphere and combine well with effects like flare (see p. 30), diffusion or long exposure (see p. 18). Low key pictures are predominantly heavy in tone, usually with rich shadows and dark colors. The effect is often somber and mysterious. Use a combination of a dark background, a mostly dark-toned subject, and rim-lighting (to produce highlights and pick out shape without illuminating large areas).

High key is predominantly light in tone and mood, and colors are pastel. The effect is delicate and romantic – its traditional use is in portraits of blonde women and children. Once again, your main controls are choice of subject, background and lighting. Try to keep heavy tones to a minimum, but include a few small dark-toned areas to avoid a flat look. In the studio, use large, closely-positioned, diffused light sources. Outdoors you can shoot into the light, and deliberately overexpose, see below.

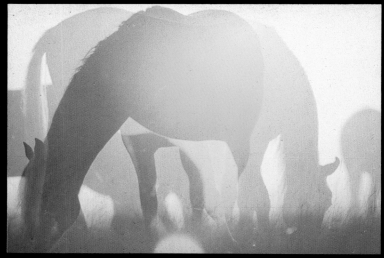

High key and overexposure △
To take this picture of horses, the photographer aimed into the light, overexposing the subject. Instead of a silhouetted result (normal exposure), the image appears as a simple, flat area of pale tone, with bleached colors. Bracket exposures for this technique, particularly when you are working with color slide film.

Low key silhouette ▷
A silhouette is often enhanced by a combination of a low key exposure and rim lighting, as in the picture on the right. Choose your angle carefully so that your subject is edged with light.

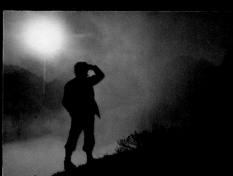

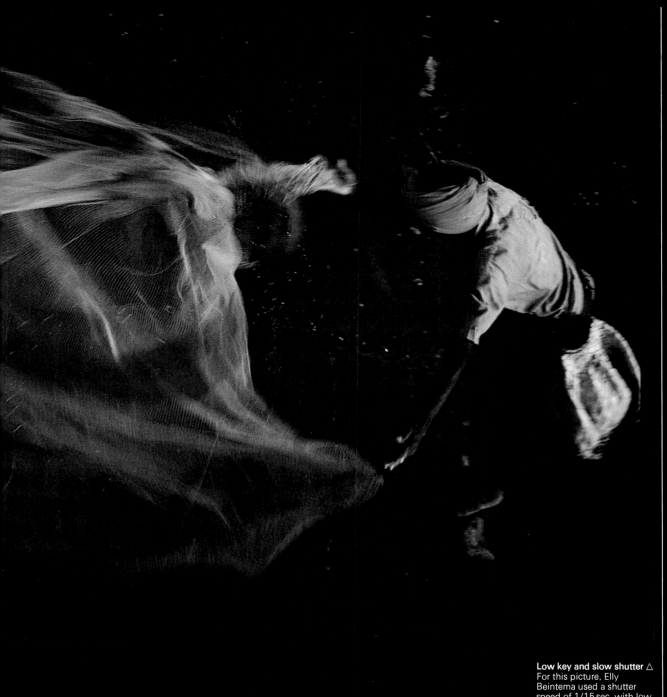

Low key and slow shutter △
For this picture, Elly
Beintema used a shutter
speed of 1/15 sec. with low
oblique lighting. Low key
given by the dark water suits
the rich, somber colors of
this Indian scene, while a
slow shutter captures the
flow of the fisherman's
movement as he shakes out
his net.

Shadow and contrast

A single artificial light source is an extremely flexible photographic tool. By controlling direction and quality you can create lighting effects that range from the naturalistic to the macabre. Sunlight illuminates scenes from above, so lighting from below gives objects an unnatural look. For the most macabre results, use a compact light source such as a small spotlight or flash because this gives hardest-edged shadows. When you use this source to light from below – with a face, for example – shadows will occur where you expect high-

lights, giving an almost negative image. If you direct the source from one side, or from the rear above, you can rim-light the shape of a subject set against a dark background without revealing detail.

Using the camera on a tripod in a darkened room widens the possibilities of a single light source. Move the lamp in an arc over a still life during a long exposure to paint it with light. Or use a flash or lamp to light the same subject in several different places, recording it on one frame of film.

Lighting from below ▷
For this horrific portrait, Andrew de Lory used a model painted with stage make-up. He placed a small spotlamp at floor level to light the whole face from below. Make sure that your subject's eyes are not lost in shadow. For this effect a lamp is better than flash because you can check the effect of the lighting on your subject.

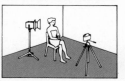 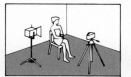 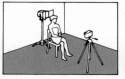

Multiple flash effect △
Use a single lamp for this form of multiple exposure. Place your subject in darkened surroundings, put the camera on a tripod and lock the shutter open. Fire flash, move subject in darkness, and fire again.

◁ **Lighting direction**
The direction of a single light on a subject will transform its final appearance. You can change the angle of a spotlight, as in this series of pictures, for a range of dramatic effects. Try combining these set-ups with effects such as a prism lens or color filters.

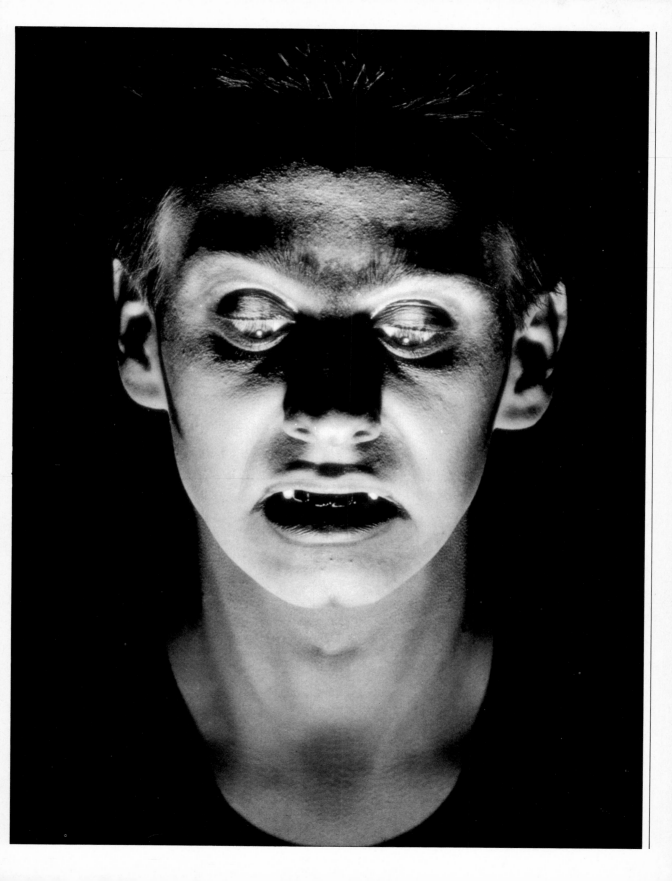

Mixed color temperatures

Several kinds of light source may illuminate a scene, each differing in its color content. For example, the setting sun may light most of a landscape at dusk, but light from the sky, domestic lights inside buildings, and street lamps also affect the scene. If you balance your color film to one of these sources, each of the others will record with a strong color cast, either in a warmer or colder direction. You can use this to draw attention to certain areas through local color accents, or to enhance mood, or give an unreal atmosphere.

Mixed lighting is common in indoor situations, when the room is illuminated by one type of source and the scene outside is lit by daylight. For example, if room lighting is fluorescent and you fit a 30M filter in order to record the interior correctly, the scene outside will have a strong magenta cast.

Color slide film is most responsive to mixed or wrong color temperature. Daylight-blanced film gives correct colors under noon sun, or with flash, or in moonlight. But in tungsten lighting this film gives a warm orange cast. Tungsten light film is balanced for studio lamps, and also produces acceptable results with higher-powered domestic lamps. In daylight its results are cold and blue, although at sunset the orange light may match tungsten light and record as white.

Urban sources ▷
For this photograph Ricardo Gomez-Perez used daylight film in the late afternoon. Three different color temperature sources are apparent; the warm orange tungsten light from the restaurant on the left, the green fluorescent light from the store next door, and the blue light on the automobile in the foreground — probably from a street lamp.

Landscape and color temperature ▽
In this picture, by Erik Steen, the main lighting is from the moon (daylight color equivalent). However, the foreground is lit by lamps in nearby bungalows, giving it a warm orange cast. Because the source of this light has been omitted from the scene the orange cast has an unreal quality.

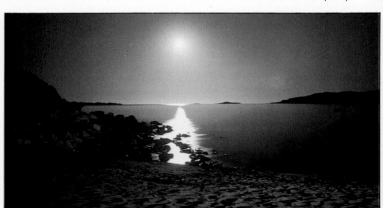

Color temperature scale (in Kelvins, p. 153)

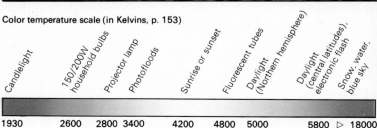

Candlelight	150/200W household bulbs	Projector lamp	Photofloods	Sunrise or sunset	Fluorescent tubes	Daylight (Northern hemisphere)	Daylight (central latitudes), electronic flash	Snow, water, blue sky
1930	2600	2800 3400		4200	4800	5000	5800 ▷	18000

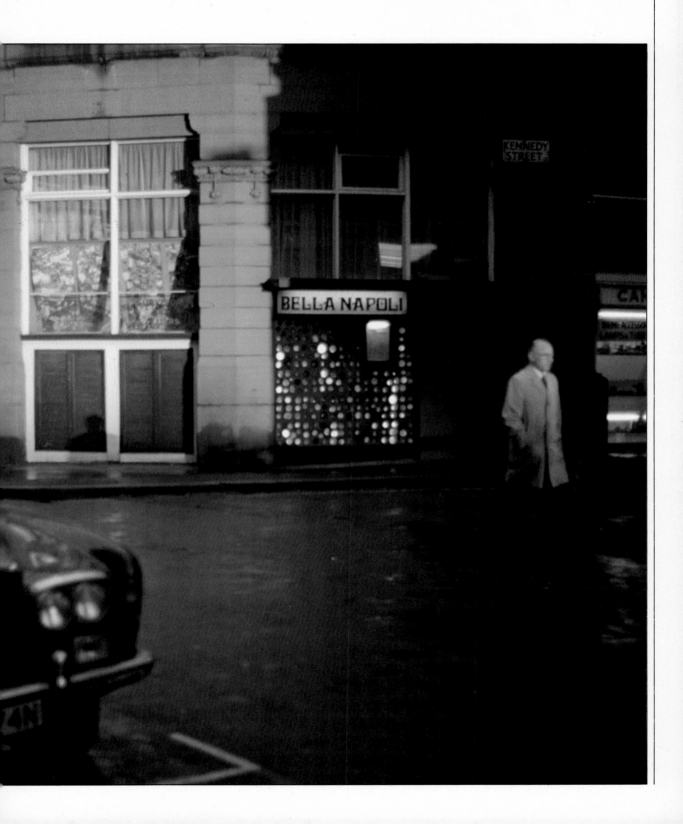

Physiograms

Moving a light source during a time exposure in a darkened room produces patterns known as physiograms. For formal, rhythmic designs, use a point source light suspended from the ceiling on a long string, and swing this like a pendulum in different directions to create patterns. Set up the camera on the floor looking upward, or stretch mirror-foil over the floor and photograph the light reflected in the foil. A steering string allows you to pull the lamp into different orbits during exposure, see below. Begin by focusing the camera on the static light source. Try using 125 ASA film – give an exposure of about 30 sec. and set aperture to f8.

You can draw irregular light trail patterns by hand in a darkened room. Set up your camera on a tripod facing a dark background, and hold a flashlight (hand torch) about 8 ft (2.5 m) away, facing the lens. You can write or draw in the air, or move the light around the outline of objects to trace their shapes. If you set up black masks or other obstructions in front of the camera, the scribbling light movements will fill in the remaining clear areas on the film. And you can tint light trails in any physiogram different colors if you use filters on either the camera or light source and change them during the exposure.

Masked physiogram ▷
For this dramatic result. Al Bridel used a lens hood mask of the outlines of two figures. He filled in clear areas with moving light trails, produced by hand in a darkened studio. He changed filters during the exposure to produce a range of colored lines.

Physiogram pattern ▷
To produce an abstract pattern, Etienne Weil set a long exposure on his camera and photographed a swinging light in a darkened room, see diagram below. The slower the light swings, the more exposure is given to the light trail, making a thicker line.

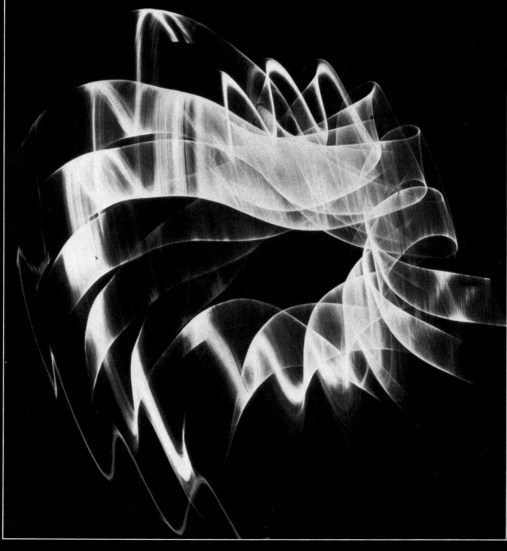

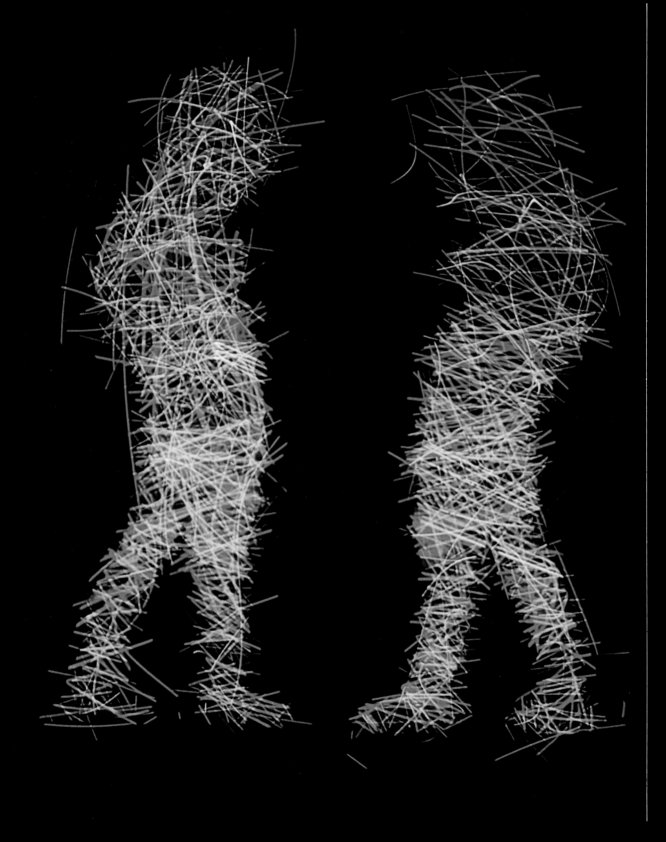

Colored light sources

The use of colored light sources to illuminate a subject – a technique familiar to theater, television and discos – is often under-rated as a way of creating photographic special effects. Colored lights can "re-tint" subjects, overwhelming their true colors, to suit a mood or theme. In addition, a colored source can separate a single element from another, or from the background, and harmonize objects of contrasting colors. Under colored lights, white parts of the subject and parts that match the lighting color become indistinguishable from one another. And complementary colors look almost black.

It is sometimes effective to keep at least one small part of the picture lit with white light, as a foil to the other rich colors. Another promising method is to filter two lamps in complementary colors – strong green and magenta for example; wherever they illuminate the same part of the subject in equal amounts, they form white light and so reveal the true colors of your chosen subject.

A blacked-out studio is the best place to experiment with colored lighting. Use spotlights or strobes with theatrical acetate filters, and fit barn doors or snoots to direct the light. Or you can light small objects with filtered slide projectors or fiber-optic scientific lamps – these provide colored light without heat. For another source of diffused colored light try bouncing a floodlight or spot off colored paper.

◁ **Lighting to heighten color**
To create this colorful picture, the photographer set up some deep-red flowers in a vase and lit them with tungsten floodlights – one filtered deep blue and placed on the left of the subject, the other filtered deep green and placed on the right. He positioned a third orange-filtered lamp well behind the subject to illuminate the orange background paper. To shoot this picture he used tungsten-light color slide film.

Lighting for mood ▷
For this moody portrait, Andrew de Lory put a deep mauve gel over his main tungsten lamp and positioned it to illuminate the subject's face, as in the diagram below. Then he lit the green background paper with a green-filtered floodlight. To take this photograph he used tungsten-light slide film, and a standard lens on a medium format camera.

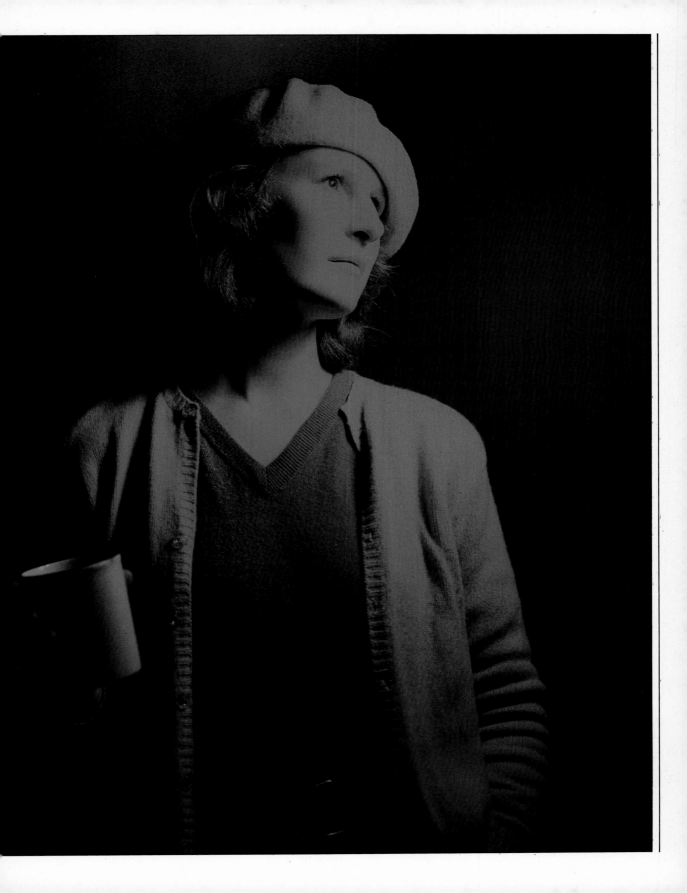

Many objects record in odd, unearthly colors if photographed under a light source that lacks the full range of wavelengths found in normal white light. Photographers use this type of lighting to produce science-fiction effects, see facing page. Daylight and tungsten-type slide films will react strangely to ultra-violet lamps, fluorescent tubes, and sodium (orange) or mercury (blue) street lamps.

Ultra-violet or black light lamps give out mostly UV wavelengths which the human eye cannot see, but which cause certain materials to fluoresce (glow brilliantly in white or a particular color). UV lamps or tubes are sold as health lamps and for horticultural, theatrical or disco purposes. All these units give either black or deep purple light. To take UV photographs, set up your lamp in a darkened room on subjects such as white or fluorescent-colored papers, plastics or synthetic fabrics. Most liquid detergents, unrefined oil, toothpaste, and powdered chalk added to water also glow well. Although you will only see the glowing objects, the film responds to the UV light too, recording it as bluish-white light. If you want to reproduce only what you see, use a UV filter on your lens.

Filtering UV light ∨
Plastic objects like the flowers below glow brilliantly in UV light. Here, the light was filtered so that the roses recorded on the film exactly as they appeared to the photographer.

Science fiction images ▷
To create this image Robert Hallmann placed two toy robots against background paper under a UV lamp. For added atmosphere, he worked with tungsten film, and he did not use a filter so that the strange-colored UV light would also be recorded. The multiple outlines were achieved by shooting several exposures on the same frame using different focal lengths on a zoom lens (see p. 26).

Lighting for mood
For the images above and left the photographer used different film with the same fluorescent tube to color the mood of the subject. Blue light gives a cold, remote feeling to the shot of the sleeper, above, taken on tungsten film. And a green cast heightens the tense, neurotic atmosphere of the portrait, far left, on daylight film. When taking fluorescent tube photographs you should make test shots to find the color bias of your tube beforehand.

Flash and long exposure

The combination of a slow shutter speed with flash results in images which have peculiar qualities of lighting and movement. Photographers use this technique to create highly impressionistic results or to give a ghostlike sense of action. The effect is due to the trigger mechanism arrangements for electronic flash. A focal plane shutter synchronizes with flash at 1/60 sec. or 1/125 sec., but at any slower speed the flash fires (taking about 1/1000th of a sec.), and then the shutter remains open, allowing the normal lighting of the scene to record.

The most unusual outdoor flash and slow shutter images have totally blurred background detail and a subject that is a mixture of sharp and blurred detail, with highlights eating into it. For this result set a speed of around 1/8 sec and pan or shake the camera during exposure. If you want a sharp background, lock your camera on a tripod so that only main subject movement occurs during the exposure that follows the flash. In the studio you can set up spotlights and on-camera flash to record a sharp figure followed by blur trails. Another method is to disconnect your flash from the camera and fire it manually just before the end of a time exposure, see below.

Avoid bright ambient light – early dusk gives best results. Use slow film so that when you set lens aperture to suit flash and subject distance a slow shutter speed is necessary. And if your flash is a dedicated type, set it to "manual".

Subjects for long exposure and flash ▷
For an effective result your main subject should be darker than the background, and be the object closest to you, like the chicken in this picture. Here, Andy Earl has used on-camera flash to add to the impression of movement — look closely at the chicken's tail feathers and you will see ghostly shadows cast by the flash, giving the impression of imminent movement.

Flash effects outdoors ▽
For the partly blurred movement in this shot, the model jumped in front of the camera during a 1/2 sec. time exposure. The flash was fired by hand at the end of the exposure in order to freeze the figure as the shutter closed. The picture has a sunlit look, although it was taken on a dull day, because the photographer used a powerful flash held well up and off camera, brightening colors.

Filtered flash

Color-filtered flashguns offer the visual potential of colored lamps (see p. 74), with the advantage of mobility and the chance to freeze action. They are easy to carry with you to any location, and this enables you to use them in conjunction with scenes lit by daylight or other light sources. Most advanced flash kits include strongly-colored plastic filters that clip over the gun. These filters also carry information on the number of stops you need to increase exposure, because strongly-colored light affects meter cells of auto-exposure circuits.

To make full use of colored flash have at least two flashguns. You can filter and direct one gun, on-camera or to one side, and use the other without a filter to light the main subject.

Or filter both heads, using contrasting colors (have the heads either side of the lens, placing one well off-camera). Outdoors, allow daylight to illuminate most of the scene normally, but use an off-camera flash to sidelight a dark foreground object in an unusual hue. Try using tungsten-light color slide film in daylight with an 85B filtered flash on the camera — foreground objects will appear in the correct color, against a blue-tinted landscape. Extend this principle with the "colorback" technique — use one filter on the flash and a complementary-colored filter covering the camera lens. For example, an orange filter on camera corrects a blue-colored flash (although reducing it in power) but tints daylight parts of the scene orange.

Color back ▷
For this shot Andrew de Lory used tungsten-light slide film. He filtered the flashgun in deep amber. This has produced a normal color foreground and turned the background blue.

Multi-color flash △
The photographer used two flash lamps, one each side of the subject, see diagram right. One head was filtered in blue, the other in orange. He taped one cup to the edge of the boot, and his assistant threw the rest.

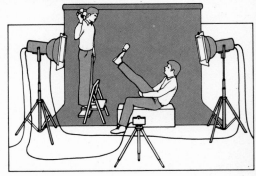

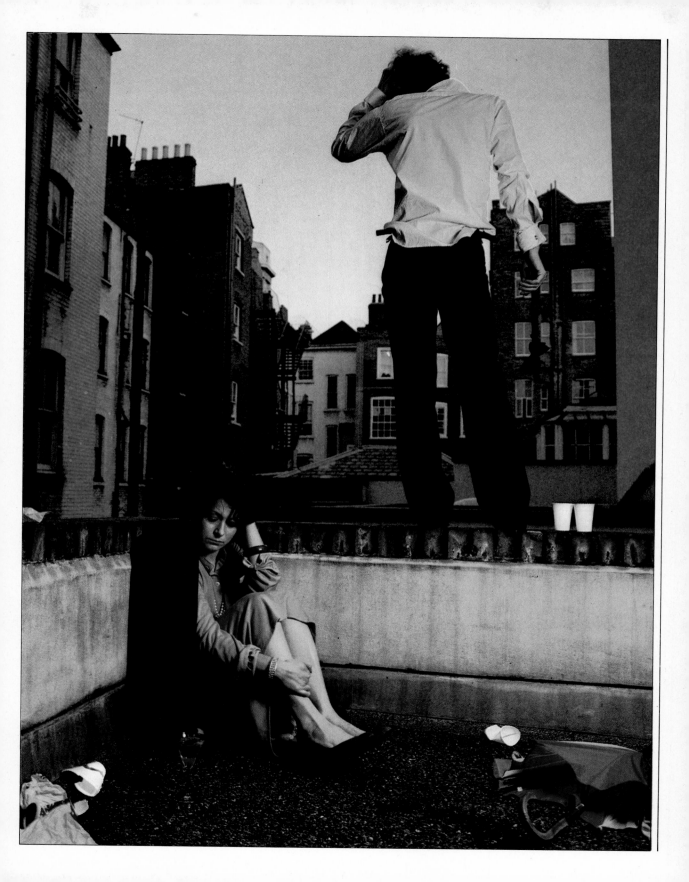

High-speed flash

A flash of a very short duration (1/10,000 sec. to about a millionth of a sec.) will record events far too brief for the eye to see, and change the visual appearance of familiar fast-moving actions. For example, a short flash will make running tap water look like a frozen pillar of ice, or petrify pieces of breaking glass in space, showing each sliver pin-sharp. High-speed flash is commonly used for scientific purposes such as the visual analysis of explosive chemical changes. And in the natural sciences it is a key tool for the study of insect and bird movement. For special effects, use it to record events that look highly unreal when frozen on film – for example, the contents of a tray suspended in space at the moment the tray is removed.

Most modern self-regulating flashguns shorten flash duration with reduced subject distance. With a close-up subject this reduces flash speed to about 1/30,000 sec. To halt faster movement you will have to rent special scientific microflash units. It is difficult to avoid underexposure with this equipment – you should either enclose the set with reflective surfaces or use banks of microflashes.

Unless the action you plan to photograph is continuous (like a running tap), you must decide how to cue your flash to the event. In general, the best trigger is a circuit with an infra-red light beam which the subject breaks. You must open the camera shutter in the darkened studio just before the action occurs. If necessary, you can incorporate minute delays in the trigger circuit so that the subject continues in its path for a set time before the flash fires.

Studio surrealism ▷
John Cooke staged this scene in the studio (see p. 92). The tap was replumbed to hide the pipes, and the orange was secured from behind to hold it in the air. He used high-speed flash to freeze the running water, and filtered the flash heads to color the translucent screen in the background.

Creating new shapes ▽
This splash, formed when a small sphere was dropped into green liquid, was frozen by a flash of 1/25,000 sec. The flash has recorded detail too fast-moving for the eyes in the picture to see. To take this type of shot you will need to work close-up.

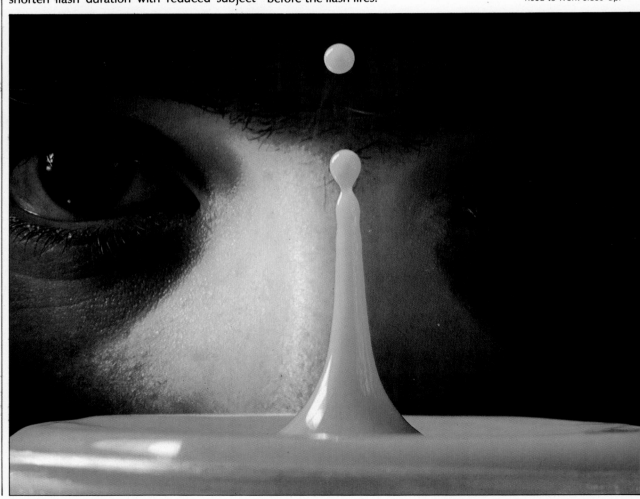

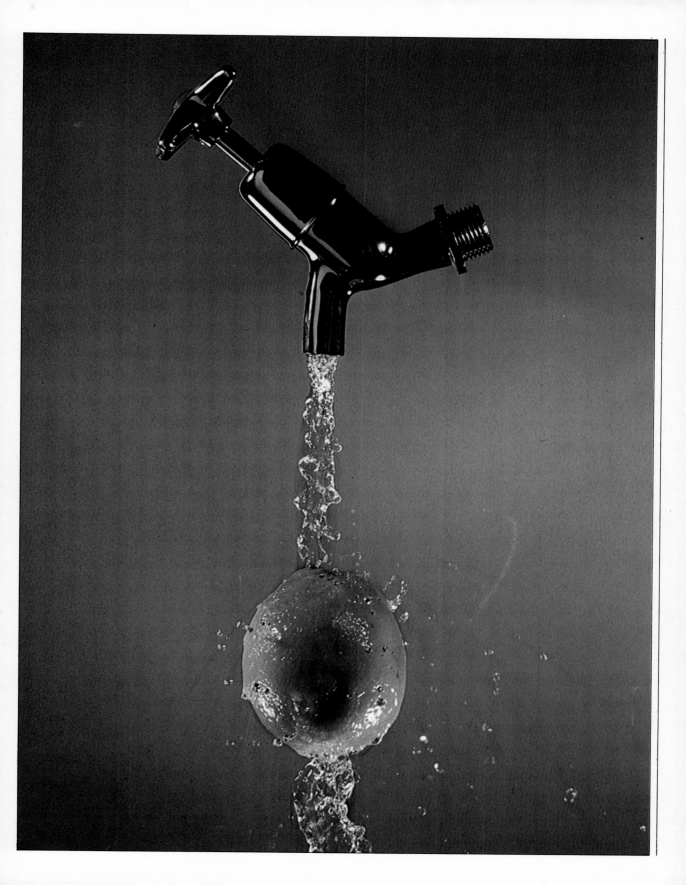

Stroboscopic effects

Stroboscopic lighting units, like disco lamps, flash regularly at pre-set intervals. You can use them in the studio to turn a continuously moving subject into an overlapping sequence of frozen images. Strobe photography can produce an intriguing pattern of shapes, or a scientific analysis of movement against time.

Stroboscopic units give a flash of about 1/10,000 of a sec., and they can be set to fire at frequencies from 20 flashes a sec. to 2 flashes a min. Lamps operate separately, or synchronize in pairs or banks. Use a control unit linked to the shutter to start and stop flashes. When you set up the lights, make sure that they light the subject only – the background must remain dark and in shade. Arrange the lamps to give double rim-lighting, picking out the whole body outline from the background. You can filter each lamp for a more colorful effect. Support your camera firmly and exclude all other light sources.

The number and frequency of flashes you will need depend on the subject, the speed of the action, and the degree of clarity you require. A slow ballet movement may look best with eight flashes over 10 sec., but a faster tennis stroke may need 20 flashes in 1.5 sec. Base your exposure reading on one flash, and assume that your subject will have changed position by the time the next flash fires.

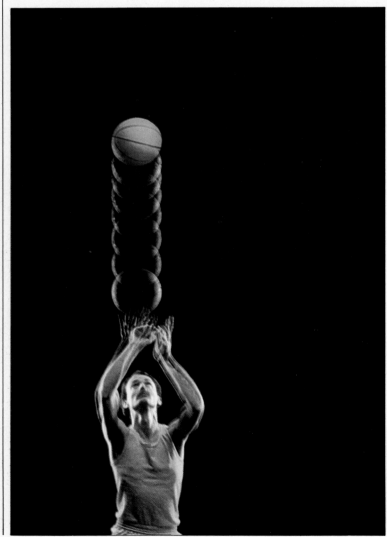

◁ **Capturing action**
For this picture, Ben Rose used a pair of stroboscopic lamps each side of the subject, giving seven flashes to capture the movement of the ball. Then he gave another two flashes from these lamps, plus a single flash from a third strobe positioned above and in front of the subject to give one detailed image of the player and ball.

Filtered stroboscopic lamps ▷
This shot, by Horvas, was lit by two pairs of stroboscopic lamps, filtered in red, green, yellow, and blue, see diagram below. Each pair of lamps was fired alternately. The result turns the dancer's movement into a multiple pattern of color.

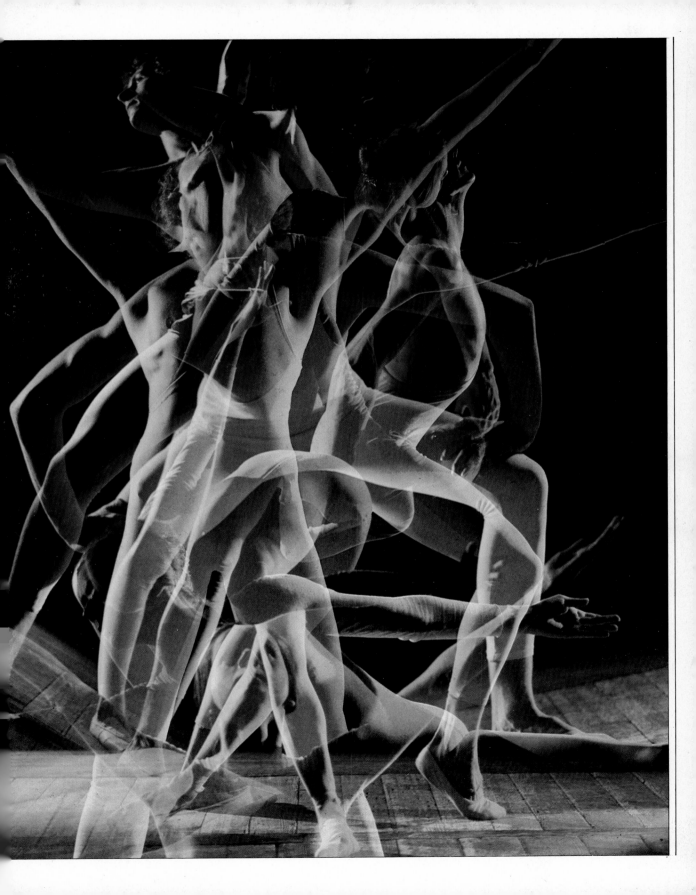

Back projection

Projected backgrounds allow the creation of virtually any setting in the studio, at a relatively low cost. The simplest system is to project a slide on the back of a translucent screen, then set up your studio props in front of this. (The same system is used in cinema and theater.) The screen material should be texture free, thick enough to prevent a central glare spot from the projector placed square-on behind it, yet capable of showing a sharp, clear image from the other side. Special plastics are made for this purpose. However, if you do not want to use a purchased screen a large sheet of thick tracing paper stretched over a wooden frame will also work well.

Use a slide projector with a long focus lens, and place it well behind the screen to minimize uneven illumination. Make sure that no light other than projection light reaches the back of the screen. Choose fairly contrasty background slides – the screen material tends to give slight diffusion. Make sure that your studio lights match the direction and quality of lighting in the background image, and have the same color temperature as the projector. You must shade the lamps from the screen, otherwise dark parts of the background will appear gray and flat. Build your set some distance in front of the screen. Back projection requires more space than front projection.

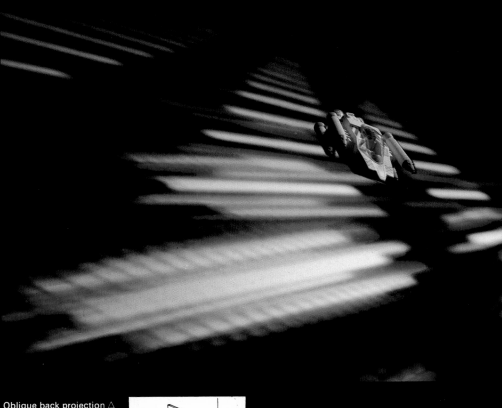

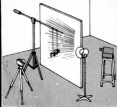

Oblique back projection △
To create an oblique view of the background image, position the camera square-on to the screen, but place your projector at an oblique angle to it, see diagram right. Here, this technique gives the constructed scene a sense of depth, making it appear realistic.

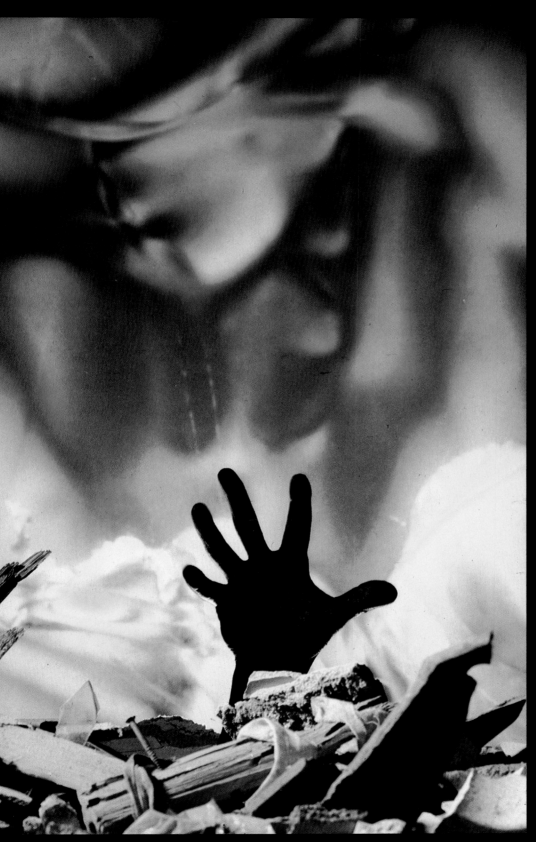

◁ **Using back projection**
You can use back
projection to make
believable pictures of
impossible situations. To
create this scene of
devastation, Andrew de
Lory projected a slide of
polarized plastic (see p.117)
on a tracing paper screen,
and placed rubble in front
of it. Then he positioned his
model's hand in the rubble,
see diagram below, and
photographed the result
using a telephoto lens.

Front projection

Front projection of backgrounds offers all the advantages of back projection (see pp. 86–7), but the equipment takes up far less space and is easy to use with studio flash for action pictures. Front projection is used extensively for advertising work and portraiture.

The special projection equipment sits under or to one side of the camera, and makes it very easy to change, shift or focus the background slides. The heart of this system is a large screen covered with tiny, highly reflective glass beads. You project a slide through a semi-reflective mirror toward the screen along exactly the same axis as the camera lens, see

diagram. The projector dimly lights the set, models, and props set up in front of the screen.

Provided that you match and align your camera and projector lenses, shadows of items in front of the screen are all cast exactly behind the objects. And you can use studio lighting from any direction to illuminate figures and props, because the screen reflects each light back to its source – the lamp itself. You can project slides, negatives, or hand-made transparencies (see p. 130). Most front projectors have a modeling light for lining up, and contain a flash which fires in unison with studio units, synchronized to the camera shutter.

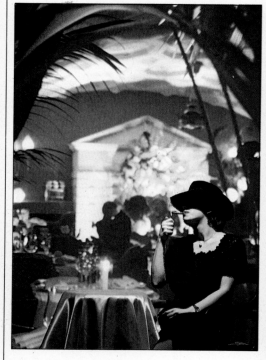

Studio realism △
To take this picture the photographer used a slide of a café scene in a front projector unit. He set up a table, studio lights, and the model in front of the special screen.

Out-of-scale images ▷
You can create strange settings simply with front projection units. For this picture the photographer projected a slide of a flash close-up by Stephen Dalton on the screen behind the model, slightly softening projector focus to increase the sense of depth.

Front projection and lighting

To create the picture above Andrew de Lory used a front projector unit alone, see diagram right, to display the desert background and silhouette the girl. For the smaller version shown on the left, he added studio lamps to light the girl. The evenly-lit foreground subject does not affect the brilliance of the background. Because camera and projector lenses were not aligned, a shadow line shows along the model's back.

Effects with projectors

A flexible and convenient way of mixing images for surreal effects is to use one or more slide projectors to project slides on a flat or three-dimensional surface in a darkened room. With your camera on a tripod, copy the image on color negative or slide tungsten-light film.

For an unusual image distortion, project a slide on an undulating plain surface such as white curtains or crumpled paper. Set up your camera and telephoto lens alongside or behind your projector, lining up the two lenses closely if you want to eliminate shadows from folds. If you intend to project on three-dimensional objects — for example eggs or mat white painted objects or parts of the human figure — position them against a black ground.

To create a superimposition effect, project both images on a flat white screen, then shade out unwanted parts of each image using black cardboard held a few inches in front of each projector lens. Where images overlap, each will appear in the light areas of the other. When copying the result, measure exposure from the projected image as if it were a normal scene. You should support your projectors firmly so that the images are vibration-free.

◁ **Superimposed transparencies**
Here, a color slide of a snowy, winter landscape with a starburst sun was mixed with a slide of an eye close-up. Use two projectors and a flat screen for this technique, see diagram. Shade unwanted parts of the second slide with black cardboard. Photograph the image on the screen for a final result.

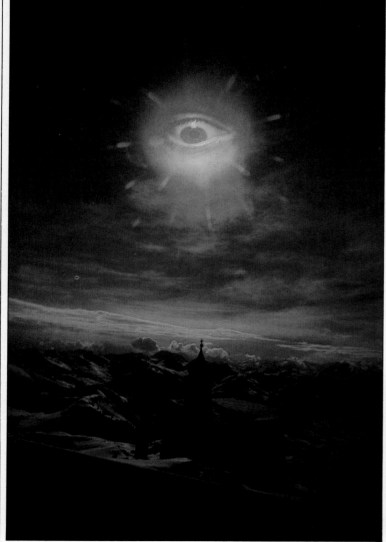

◁ Projecting on a three-dimensional object
To produce this unusual image, a slide of cracked, dry earth was projected on a white boot placed against a dark background. Use simple, strong shapes for this special effect.

Distorting shapes ▷
If you project a slide of a familiar object on crumpled paper, then re-photograph it, the resulting image will have a distorted, collapsed appearance, as in this shot.

Projecting on draped material △
You can use the curves of draped material to alter the shape and texture of an image projected on it. For this picture, a slide of Manhattan was projected on silver material to create the impression of a penthouse view through translucent curtains. Set up your camera and projector side-by-side, see diagram right, aligning the lenses closely in order to avoid excessive shadows.

Staged images

Fake backgrounds and settings are possible without front- or back-projection facilities. Constructed studio sets, like film sets, often deceive the eye. For realistic photographs of extraordinary situations you can build a horizontal-looking scene as a vertical set, or shoot scaled-down models and specially-made props, or transform everyday materials with imaginative lighting and arrangements.

A simple way of working is to use table-top scenes with model automobiles, houses, and figures, plus natural materials such as small plants, stones and sand (in scale to the models). And you can cut out photographs and set them in among actual objects (color the print edges to match the background for a more rounded appearance). With small models, take care that shallow depth of field (because you are working close) and unconvincing detail do not reveal the true nature of your subjects. Calculate a viewpoint – distance and height above the ground – that matches model scale.

With studio sets you can create a white, cloud-like ground mist with a piece of dry ice in a bucket of water. A cobweb machine will festoon the setting with realistic strands of rubber solution. You can make sets that defy gravity – for example, if you clamp a large wall panel containing a door frame horizontally just above the surface of a swimming pool, and photograph from above your result will show an open door into a room filled with water.

Setting up an impossible situation ▷
For this picture Red Saunders worked with Steve Burton and Liam Neary, who created all the misshapen tools. The modelmakers fixed the glasses, soldering iron and other tools to a neck clamp and rod behind the model. A sheet of plexiglass in front of the model held other "suspended" items. Wind machines blew the model's hair on end. To light the scene the photographer used a series of studio lights around the subject. Finally, he took a separate shot of the fuses, and sandwiched this with the main image.

Using lighting ▷
To create this image, Ricardo Gomez-Perez placed his model in front of a crumpled gold foil background. He lit the scene with tungsten light and flash. Then he took a 1/15 sec. exposure on daylight film, moving his camera slightly to blur the highlights on the foil.

Creating an abstract ▷
To make this abstract image
Andrew de Lory backlit a
fishtank with diffused flash
light. Using a series of
eyedroppers, see diagram
below, and a hypodermic
syringe, he dropped
different colored inks into
the water. He set up his
camera and normal lens on a
tripod, and used a long
cable release.

EFFECTS
WITH FILM

The special effects in this section are produced by your choice of film and the way you process it. You cannot preview the strange colors or tones of results on the camera focusing screen, so expect to make test exposures first. Color infra-red sensitive film will translate a landscape into fairytale colors, whereas black and white infra-red film gives a snow-covered appearance to all vegetation in mid-summer. And if you give color slide film color negative processing you will get reversal of tones as well as startingly incorrect colors. Flowers, street scenes and portraits all turn into a mixture of familiar shapes with bizarre coloring. It is usually best to choose relatively straightforward camera images and avoid adding optical effects on top of film effects.

Films that give grainy images, or convert images into stark black and white lines, move results away from photographic realism toward graphic design. Grain destroys detail, whereas line film destroys most gradation of tone, so both films work best on subjects that have strong interesting shapes and patterns. Instant picture films have their own special effects features. When prints emerge from the camera you can manipulate them by hand to distort the image, changing its photographic look to an impressionistic, painted effect.

Infra-red

Infra-red radiation is present in sunlight and in most artificial lighting, although it cannot be seen by the human eye. Special IR films record color or tone strangely because subjects that appear similar to the eye reflect infra-red in very different amounts. Ektachrome infra-red film (color slide) can transform ordinary-colored scenes into dream-like mixtures of false and accurate colors. And black and white infra-red negative film (see pp. 98–9) will distort the tones of certain subjects.

Infra-red color slide film has three emulsion layers; it is sensitive to green and red light as well as to infra-red. When you expose it through a deep yellow filter, healthy green foliage records magenta and most red plants or fabrics appear yellow, yet skies record a rich but relatively normal blue. If you expose without any filter, results will show a strong overall blue cast. An orange or red filter gives an increasingly yellow cast to the highlights. Try a deep green filter for purple foliage. For best landscape results shoot in direct sunlight in early spring. (New leaf growth reflects infra-red strongly.) As the film is contrasty, you should keep the sun behind you and make several bracketed exposures of each image.

You must expose black and white infra-red film through an extremely deep red or IR-transmitting (black) filter. With an SLR camera, compose your image first, then cover the lens with the filter immediately before you shoot. Adjust focus to the IR mark, and measure the exposure with a separate hand meter. Negatives are grainy despite the slowness of the film. Prints show blue skies as black and living vegetation as white, so that landscapes appear snow-laden.

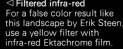

◁ **Filtered infra-red**
For a false color result like this landscape by Erik Steen, use a yellow filter with infra-red Ektachrome film.

Still life ▽
Infra-red film will subtly alter the colors of subjects like fruit or vegetables. Compare its effects with the harder false color that mismatched processing produces (see p. 100).

Infra-red and human subjects ▷
In an infra-red photograph, like this picture, human skin has an unnatural, waxy surface appearance. And its color is often distorted — here it has a magenta tinge.

Infra-red landscape △
Erik Steen took this view of a lake on infra-red Ektachrome film, using an orange filter on his 20 mm lens. Distant haze has little effect on infra-red film, so landscapes are very clear. This unnatural clarity, combined with the strange colors, and also the extensive depth of field of the wide-angle lens used, has given the picture an unearthly, painted look.

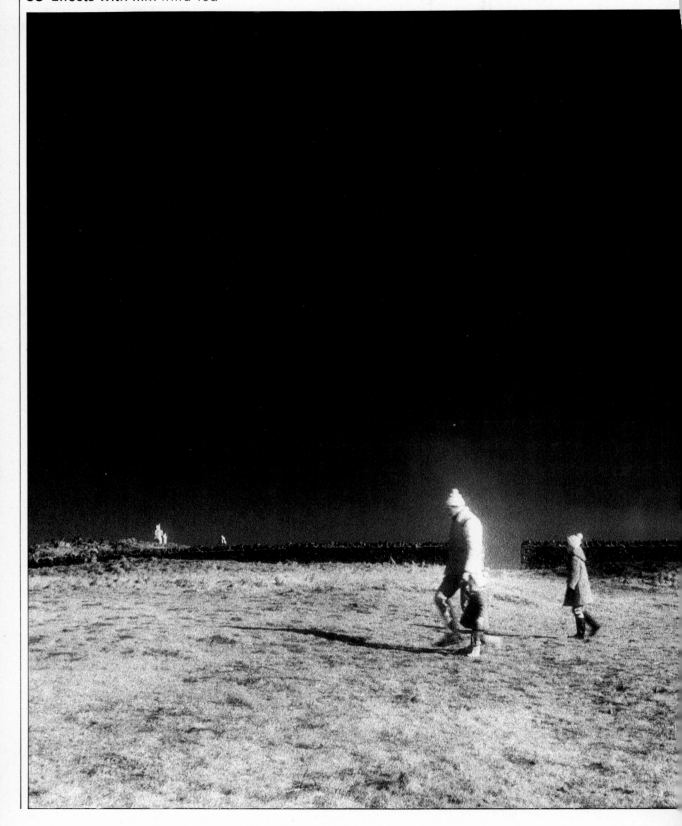

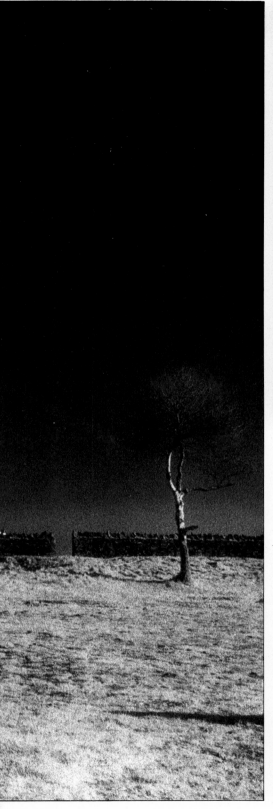

◁ Infra-red portrait
Infra-red film — black and white or color — gives human skin an unreal appearance and darkens eyes considerably. This effect is especially disturbing in black and white, where there is no obvious false color. With black and white infra-red film, focus on your subject carefully, then adjust focus to the IR indicator on the lens, below.

◁ Flare and infra-red film
The halo around the largest figure in this picture is produced by flare. An intensely IR-reflective surface (such as the coat in this photograph) will create flare at the correct exposure for the rest of the image.

Black and white infra-red landscape ▽
Correctly-filtered black and white infra-red film records living vegetation as white, giving landscapes a snowy, wintry look.

Mis-matched film and process

Most color slide films are designed to produce objective reproduction of color, given the recommended form of subject lighting and correct processing. But rules are made to be broken – mis-matching either of these factors creates false colors which may portray the mood of a subject more successfully than the "correct" result. The simplest way to shift colors toward the yellow/red end of the spectrum is to use daylight-balanced slide film in tungsten lighting. Results have a warm cast that resembles candlelight. Or, for a cold, bluish cast, expose tungsten film in daylight.

Negative colors present familiar objects in a startling way – photographers such as Erik Steen use them to great effect (see p. 6). The best way to produce negative colors with neutral blacks and whites is to process color slide film in the chemicals used for color negative stock. Because such slides will be contrasty, you should use soft, frontal lighting. For a different effect, expose tungsten film in daylight, then give it negative processing and it will show a yellow cast. For still more surreal results process infra-red color slide film in color negative chemicals, see facing page. You should bracket exposures whenever you take a photograph with mis-matched processing in mind, because this often alters the effective film speed. Another method is to shoot and process slides normally, then make copies and mis-process these.

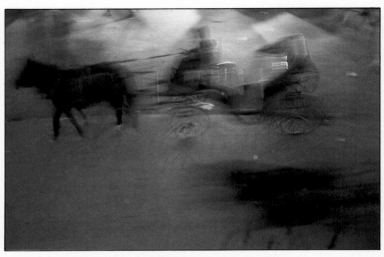

Daylight film in tungsten lighting ▷
For this night-time self-portrait, the photographer loaded his camera with daylight fim and placed it on the hood of his automobile. Then he switched the headlamps on, set the self-timer, and took up his position in the beams of light. The orange cast this mis-match produces has a warm, intimate feeling.

Tungsten film in daylight △
For this shot the photographer used tungsten-balanced film at dusk. A shutter speed of a 1/4 sec. allowed the moving cart to blur. The blue cast heightens the unreal atmosphere of this photograph.

◁ **Processing for false color**
For a result like these tulips, shoot on Ektachrome slide film, then process it in C41 color negative chemicals.

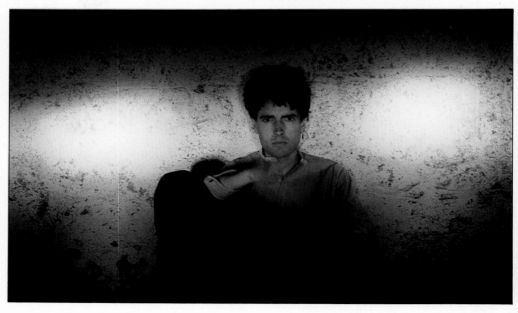

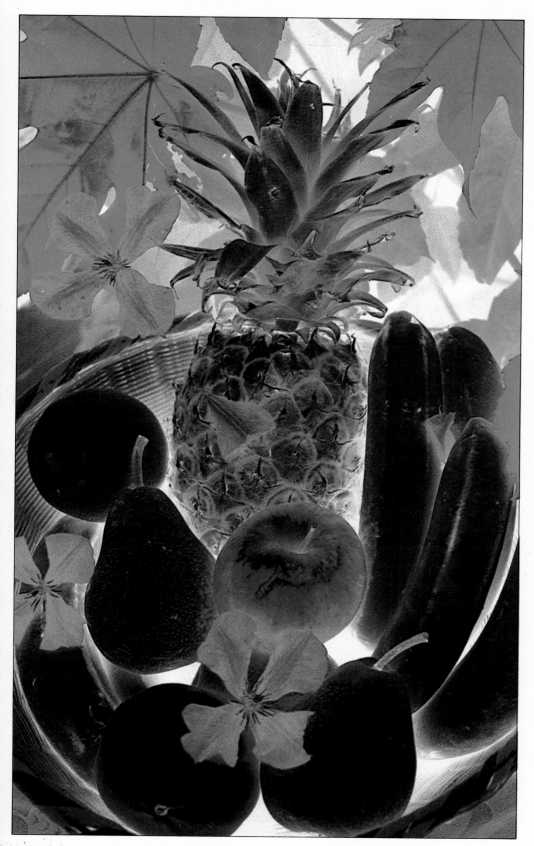

Grain

A grainy, mealy structure destroys fine detail in an image; pictures have an impressionistic, non-photographic quality. Grain suits both the mood and the atmosphere of some photo-journalism and advertising photography, as well as nudes, landscapes, and portraits.

You can produce grainy results in several different ways. One method is to shoot on very fast coarse-grain film, then enlarge a small part of the image. Or take a normal image and copy it on coarse-grain film, or sandwich it with a grain-pattern screen before enlarging. You can buy screens, or make your own by photographing a sheet of even, dark gray cardboard on coarse-grain film. In general, screen results are not so interesting as genuine image grain, because the pattern is too even. With both methods, grain shows up most strongly in mid-tone parts of the picture, so try to choose low-contrast, softly-lit subjects. (This type of subject also allows you to overdevelop and print on hard-grade paper, to exaggerate the image grain.)

Another way of producing grain is to enlarge a small section of a slide or negative using a microscope. You must start with a small, pin-sharp image. Copy it through the microscope on slow, fine-grain slide or negative film so that the recorded grain is purely from the original. When making prints, try to use a condenser enlarger – preferably a point-source light type – in order to maximize grain contrast.

Grain screen △
For a result like this image, sandwich your negative and grain screen, right, between glass, and print on hard-grade paper.

Coarse-grain film image ▷
To produce this photograph, Andrew de Lory copied a black and white print on ? coarse-grain film (Kodak Recording film 2475). He uprated the film to 6000 ASA and push-processed it. He then enlarged the image × 10, using a condenser enlarger. For this detail he enlarged the original print × 17.

Grain via the microscope ▷
This picture is a microscopic enlargement of a tiny part of the color slide shown left. When you look for suitable subjects for this technique scan slides with a magnifying glass and try to pick out strong, simple shapes.

Grain for effect ▽
Like the picture above, this image was isolated from a color slide, left, using a microscope. The image was copied on slow film — the grain visible in the result is the true grain of the original magnified many times.

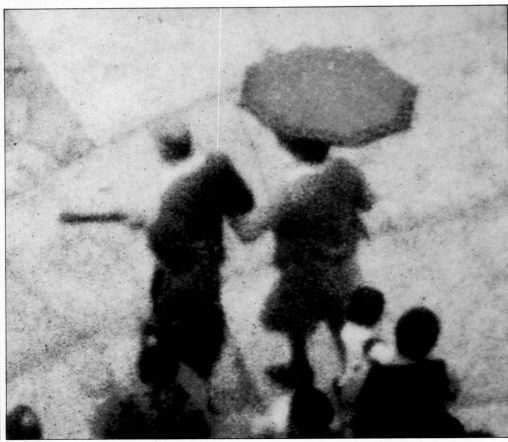

Processing to emphasize grain ▷
To create this colorful, textured image, David Fairman enlarged a very small section of a color slide on film. Then he push-processed the film to exaggerate the contrast of the grain pattern.

Line images

A line image is a photograph simplified to only black or white, giving it stark, graphic qualities. This high contrast exaggerates shape, pattern, texture and image grain. And you may lose detail, because the midtones merge into solid areas of either black or white, depending on the exposure given. Subjects for line treatment should have interesting outlines and be sharp throughout. You do not necessarily have to use harsh subject lighting.

High-contrast materials are very slow and have little exposure latitude, so it is generally best to shoot the original scene on normal film. You can either make a regular bromide print from this original and then copy it using line film, or contact print your original negative on line film. In the latter case, you get a positive, which you then contact print to create a line negative. You can convert a color slide original directly into a high-contrast negative by contact printing it on pan lith film. Finally, enlarge the resulting line negatives on bromide paper or lith paper.

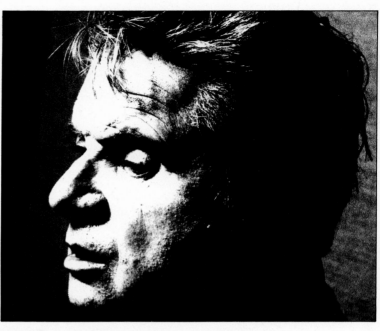

Line film
If you print a normal negative on high contrast paper, like the print by Dave Strickland above, you will get a contrasty result, but with some surviving tone values. For a more extreme result with dense black and clear whites, see right, copy your print on line film.

Emphasizing shape △
A strong, simple shape, like this spider's web, converts to line very well. The stark white lines of the web, beaded with rain, stand out from the background. If you do not have a darkroom, send your image to a processor for conversion.

Lith paper print ▷
This image was enlarged from a normal contrast negative and printed on lith paper. If you overexpose and then process this paper in diluted developer you will get a brown mid-tone with a stark black line image.

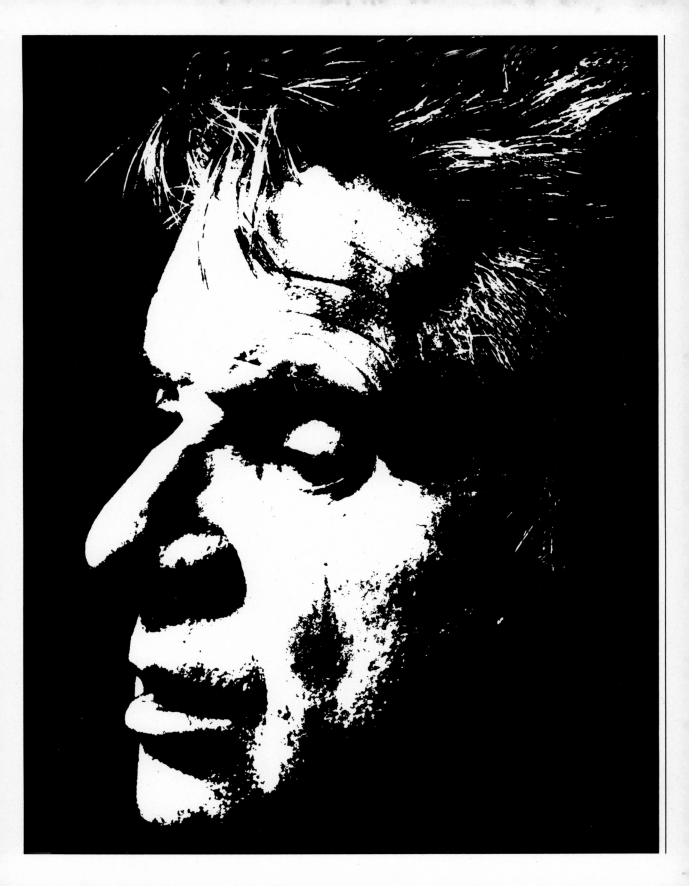

Manipulated instant material

Instant pictures have a special structure which artists such as Mari Mahr exploit to create unusual, semi-abstract results. SX 70 color prints consist of complex image layers and jellied processing chemicals sealed between plastic. These layers respond to manipulation.

During the first seconds after an SX70 print leaves the camera its emulsion layers are soft and pliable, and you can manipulate it by pressing the surface with a blunt tool. This will distort the lines and colors of the image. Or you can burn or crease the print for effect, or cut open the back and scratch or paint over selected areas or add parts of other prints. With peel-apart color prints, try soaking the print in hot water, then creasing or pulling it when you transfer the emulsion to a new surface. You can use the negative portion to make a second color print on writing paper. Squeegee the negative face down on the paper. Once paper and negative have dried, peel them apart. To manipulate peel-apart black and white materials, score the film packet while it is processing. This creates patterns on the print.

Soaking instant prints ▽
To create a result like this picture by Rosamund Purcell, soak an instant peel-apart print in hot water, then transfer the emulsion to an acetate support, as shown in the diagram below. When you begin to experiment with instant manipulations, start by using unwanted prints.

Manipulating SX 70 prints ▽
For this image Mari Mahr taped a rose to white tiles. Then she pressed the resulting print with a blunt tool to distort the lines of the tiles and soften their stark appearance.

Burning images △
To create this cracked image the photographer shot an SX 70 picture of a jointed wooden doll against an orange background. Next, she held a lighter about 4 ins (10 cm) away from the print. (Any source of heat will have the same effect.) Try using this technique before applying color to the back of a print.

Coloring an instant picture ▷
To achieve this effect, M̶ Mahr cut open an SX 7C print and removed most ̶ the rear layers, leaving o̶ part of the clockwork to̶ a photographic image. T̶ she colored the back wit̶ gouache, converting it i̶ flat color. For a different̶, delicate result, leave the emulsion intact and pain̶ over it with water color c̶ dye — this produces a tin̶ photographic image.

Black and white manipulation ▷
Lawrence Lawry worked in the darkroom to create this image. He projected a color slide on black and white positive/negative peel-apart instant film, then pulled the film through pressure rollers to release the processing chemicals. During the timed processing period he hit the back of the packet repeatedly with a blunt tool to produce spots. He used a tracing from the slide as a guide to placing the spots, see below.

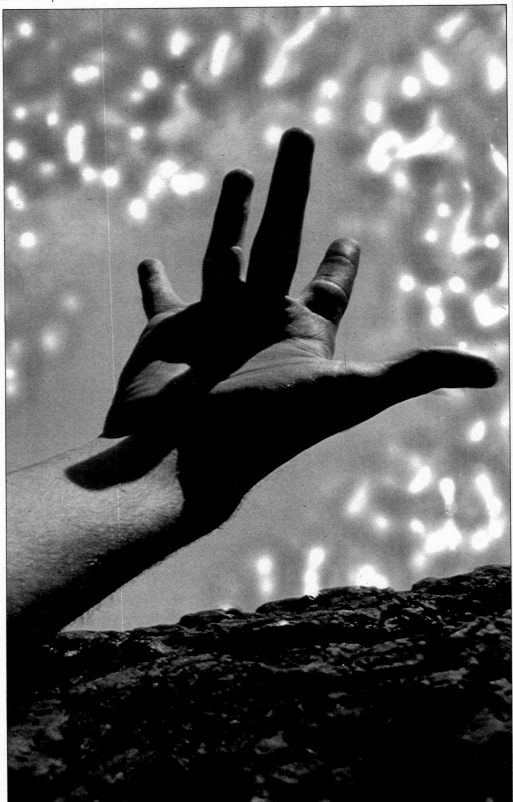

POST-CAMERA EFFECTS

This final creative section deals with ways of manipulating and combining the image that you have already taken and processed, making use of existing negatives and slides to produce special effects. There are several advantages to working at the post-camera stage — whether in the darkroom or the workroom. You will have more time, greater control over the image, and the opportunity to change course without the need to reorganize subject matter. On the other hand, you should avoid the temptation to manipulate for its own sake. Devise a theme and plan your approach carefully. You will find that the simplest route often produces the best image. Sometimes you will need to take extra pictures to fit in with existing images — make sure you match lighting, contrast and perspective meticulously.

The first techniques in this section — sandwiching, copying, montaging and composite printing — deal with the mixing of scenes and situations. Coloring and toning give you total control over the color scheme of a picture. And solarization produces a special mixture of negative and positive. Finally, this section covers several unusual ways of making images. Photograms substitute shape for surface detail. Diazo, video and photocopy derivations produce bright, crude colors. And liquid emulsion allows you to make photographic prints on any receptive surface. You can combine many of these techniques successfully. For example you can hand color photograms or make montages from photocopies.

Sandwiched images

Sandwiching is a simple but effective way to combine images. It consists of placing two images in the same slide mount or negative carrier, and then projecting, copying or printing them. By careful selection of images it is possible to construct surreal, fantasy situations. You can mix different scale items or images shot at totally different times together – to place a person in an impossible environment, for example. Use sandwiching to illustrate a symbolic relationship between items or to combine busy pictures, producing a scrambled image that suggests confusion.

Sandwiched images must fit together successfully – often you will have only one suitable image, and then you must shoot another to sandwich with it. Use a camera that allows you direct access to the top of the focusing screen, and sketch your first image on it with a grease pencil. When sandwiching two color slides, you must use weaker than normal images – at least one stop overexposed – or your combination will be much too dense. Unless you are aiming for confusion, sandwich simple shapes and textures, and choose subjects that have plenty of light areas (one sandwiched image will show through the highlight areas of the other).

Try a positive/negative sandwich of the same image – make a black and white negative copy of a color slide and recombine it with the slide for a result with black or gray highlights. If you place the two elements out of register you will get an offset effect. Or process color slide film as color negative, then combine this with a black and white positive. Sandwiched images do not have to be all camera-based. You can combine a normal slide or negative with many of the materials used for hand-made negatives (see p. 130) or with a patterned screen or a mask (see p. 60–3).

Printed sandwich ▽
To create this picture Erik Steen combined a weak slide of a tree with a color slide of a girl's face. Then he placed this sandwich in his negative carrier and printed the image on color paper. Finally, he hand-tinted the eyes red.

◁ **Sill life**
This still life picture is a positive/negative sandwich of the same image. To make a negative of an existing image, contact print your color positive on black and white negative film. For the final result on the left the combination was enlarged on positive/positive color printing paper.

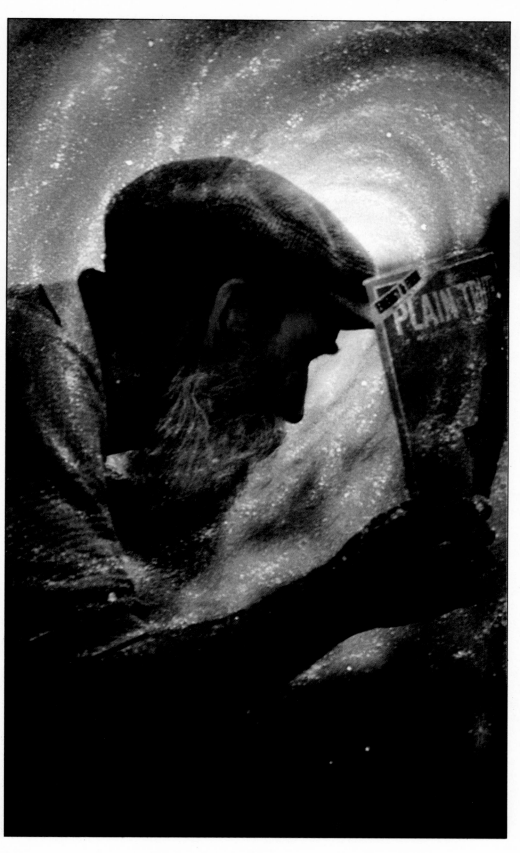

◁ **Choosing subjects for sandwiching**
For this image Erik Steen combined a NASA slide of a nebula with his own slide of a preacher. The subject of this sandwich is simple and direct, and as a result the picture has great visual impact. To sandwich two images, tape them together along one edge, see diagram below, and then mount and project the result.

Copy manipulations

Copying – the direct re-photographing of a print or slide – is not just a mechanical process for making an additional record. It is also a creative tool for the manipulation of existing images. You can place patterned glass in contact with a bromide print and copy through this for a distorted result. Or you can multiple expose (see p. 40) slides – superimpose two images, or give one image a sideways shift, or "flop" it left to right between part exposures, or, with color film, change filters.

In order to add pattern to your picture, cut down autoscreen or line sheet film to fit the back of your camera, and copy prints or slides on this. Enlargements will be made up from half-tone dots. To produce spectacular colored patterns use a light box and clear plastic sandwiched between two polarizing filters. Copying is also a flexible way of producing posterization effects. Working in the darkroom, enlarge a color slide to produce a series of 4 × 5 ins (10 × 12.5 cm) line film images at different exposures. Using a light box, copy the line images in register on one frame of color film. Have a series of deep filters to fit over the lens and change them for each exposure.

◁ **Flopped image**
Here, the original picture of a vintage automobile was turned halfway through the exposure to produce a symmetrical pattern showing two right sides.

Copying through molded glass ▷
Here, Andrew de Lory placed a regular black and white print of a woodcutter under a sheet of patterned glass. He set up his camera on a copying stand and photographed the image using soft, even lighting.

Photographing through oiled glass △
This patterned picture was made from a regular black and white print of birds. The photographer copied it through a sheet of plain glass covered with patches of cooking oil.

Autoscreen film ▷
This enlargement from an autoscreen negative shows how the image is made up from a series of dots. Enlarge your negative to coarsen the pattern. Use this type of film to give your image a newsprint quality.

Polarizer patterns ▷
Place plastic objects between two polarizers, see below, to produce this type of rainbow-like pattern. Andrew de Lory used plastic polarizing sheet material on a light box with a plastic bag and disk placed on top, and fitted a polarizing filter over his 55 mm macro camera lens.

◁ Creating a mock solarized effect
You should start with an infra-red slide (this original had a predominant magenta cast). Copy original on daylight Ektachrome film and process in C-41 developer. Sandwich the copy with the original and copy on regular slide film for the final result.

Adding color △
You can make colorful posterized pictures like this from black and white negatives, using copying and black and white darkroom equipment. First, make two enlarged 4 × 5 ins (10 × 12.5 cm) lith positives – a short exposure for a shadow positive and a long

exposure for a highlight positive. Contact print these on lith film to form two high-contrast negatives. Place a sheet of glass over your light box. Fasten the lith images to the glass, in register or offset, with tape hinges. Then make three exposures on one frame of color film. First expose the

shadow negative through a chosen camera filter (deep blue for this picture), then combine the shadow positive and highlight negative and change the filter (deep green here) for the second exposure. Finally, expose the highlight positive with a third filter (deep orange here).

Montage

Surreal, satiric or humorous pictures used for posters, record covers or magazine illustration are often created by montage. This technique involves constructing pictures from portions of various prints, arranging them so they join or overlap. Usually the work is carried out at a large size – this enables you to retouch, then copy the original to make smaller prints in which imperfections and joins are less apparent. Building pictures in this way gives great freedom over choice of elements, their scale and juxtaposition, perspective and color.

Make rough prints from existing negatives and arrange them so that they overlap. Then draw a master sketch of the total image. You will often find that you have to photograph some elements specially. When shooting, take care over the direction and quality of light – there should be no conflict between different parts of the picture and the background.

Make a large print of the background and matched-density prints of each component, sized to conform to the master. Mount the background print, then carefully cut out the desired elements from the other prints, and reduce their edge thickness by sandpapering prints on the back. Glue elements in place with spray adhesive. You may want to hand color your montage, or add shadows and other simple shapes with an airbrush (see p. 124).

Creating an impossible scene ▷
For this montage, Bob Carlos Clarke combined the jumping girl, butterfly wings, and seascape background. This carefully constructed montage resembles a multiple print (see p. 122). For a less photographic result, rough cut elements to emphasize their cut-and-stick nature.

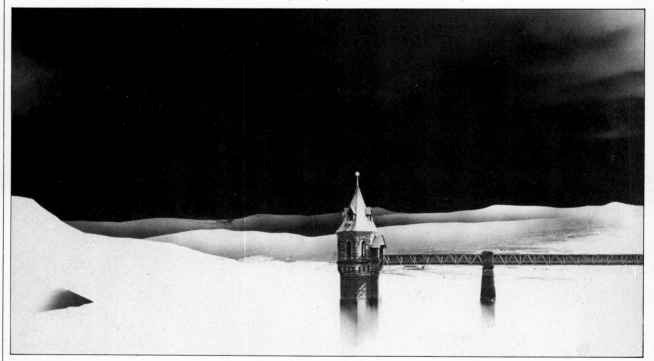

Simple montage △
Enlarge the background image and trace its outline on paper. Use this tracing as a master sketch to ascertain the degree of enlargement you need for the second image. Make density-balanced prints of the elements and mount the background on thick cardboard. Cut out the second element and sandpaper it on the back to feather the edges, then attach in place with spray adhesive.

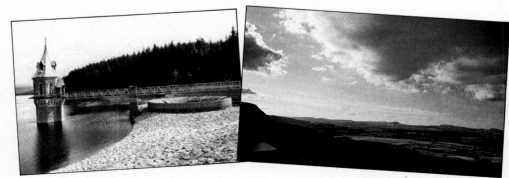

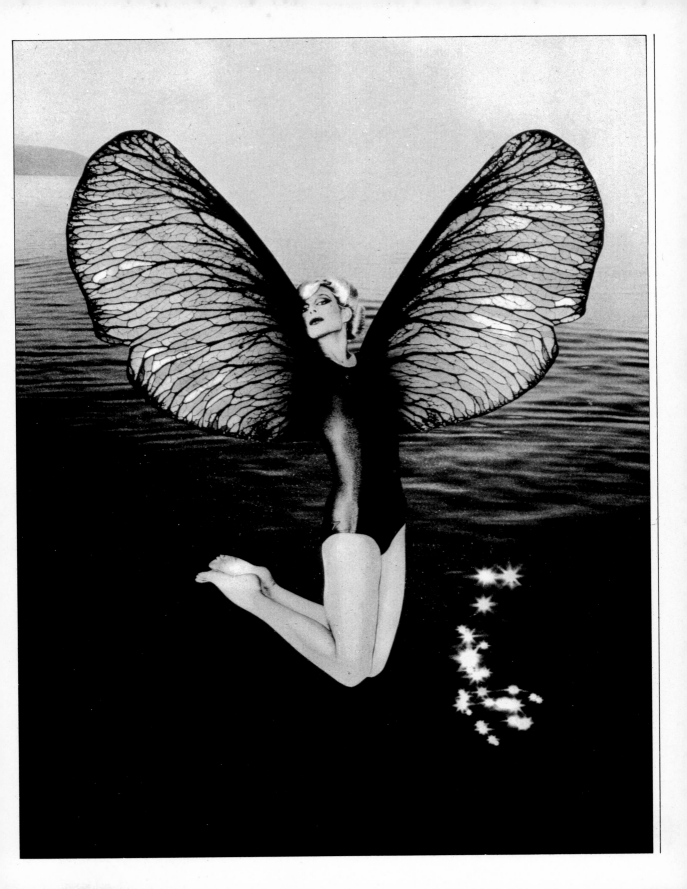

◁ **Manipulating scale**
For this picture, Bob Carlos Clarke used eight separate elements to create his final result, combining out-of-scale images for a dramatic effect. Then he hand colored the black and white montage, giving it a natural overall colored finish.

Selectively-colored montage ▷
Bob Carlos Clarke used seven different elements to achieve this dream-like image. After mounting the background, he thinned the edges of the elements, see diagram below, then stuck them in place. Next, he hand colored and retouched selected parts of the final result to add to the eerie quality, turning the truncated elements (taken from a photograph of two girls) into broken statues. The eagle is deliberately emphasized with bright colors so that it dominates the scene.

Multiple prints

The technique of printing from several negatives on one sheet of paper builds up scenes that seem very convincing, even though the situation shown is clearly impossible. Surrealist photographers such as Jerry Uelsmann, Sam Haskins and Hag find this an ideal way of composing pictures. Multiple printing offers great freedom in choice of scale, and the juxtapositioning and overlap of elements. Originals can be black and white or color, positive or negative.

If possible, have at least two enlargers available, so that you can set up negatives in advance and simply move the masking frame from one enlarger to the next for each exposure. All negatives, or parts of negatives, should match each other in contrast and subject lighting. You will find that you have to take photographs specially, but it is helpful to have a range of stock images – such as clouds, trees, and foliage.

Plan every composition by making a master sketch – trace outlines of the elements from each negative in their final position. Then use the sketch as a hinged opaque cover over the printing paper, so that you can position each negative correctly as you make the component exposures. While you are exposing one part of the paper, you must shade all the other areas – use your hands, or lay carefully-prepared cardboard or high contrast film masks in contact with the paper. In addition, you may have to use dodgers to prevent hard edges between elements.

If you are making a color print, further permutations are possible by changing filter settings – you can match or vary color in different parts of the image. It is often helpful to make your final print larger than necessary, so that you can retouch small errors of shading. Then copy and reduce the master print.

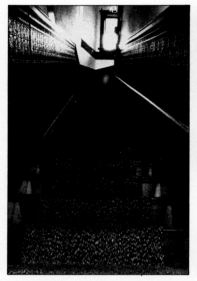

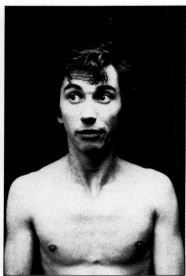

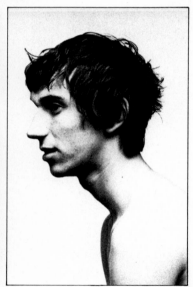

Using a master sketch
To make the multiple print shown on the right, Hag drew a master sketch, left, of the positioning for the different elements, taken from the prints above. First he printed the stairs, then he made a mask to cover the spaces for the man holding the bottle and the profile. Next, he printed in the face, then the figure, dodging the edges to avoid a solid black outline. Finally, he printed in the profile, dodging once again to give a soft edge.

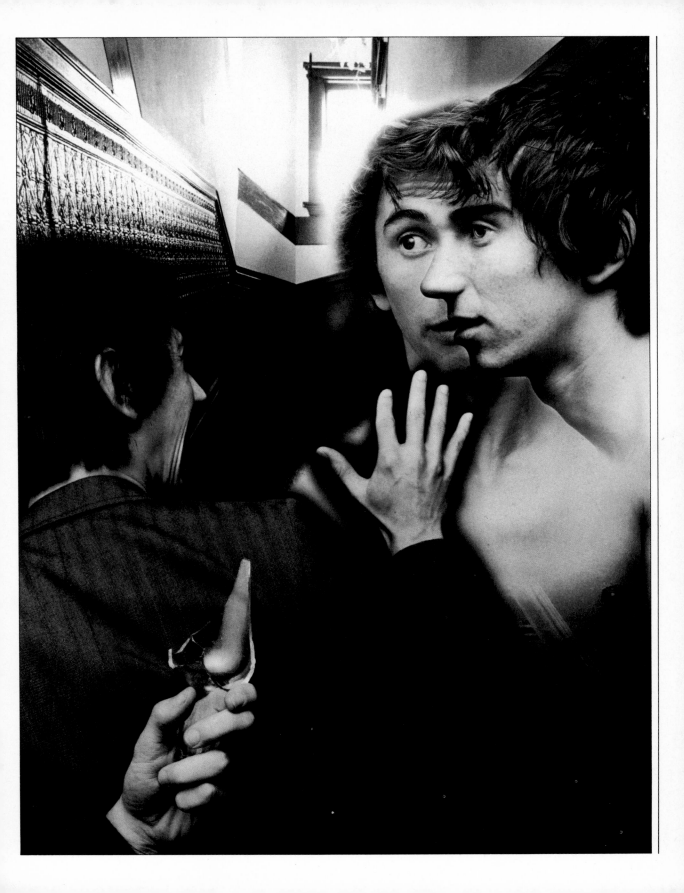

Applied color

The application of color to a black and white print allows total control over each individual hue. You can emphasize selected areas with a touch of color, or give a full-color realism, or produce bizarre false-color effects. This type of work is also used for record covers, book or magazine illustration, or advertisements.

Start with a mat-surfaced black and white print that is light, but full of detail. It is best to sepia-tone the image first, especially if you plan to use water-based paints, because black will mute colors. Apply color with brushes, swabs, or an airbrush. You can use oil, spirit- or water-based pigments or dyes. If you are using water-color, wet the print first, then blot it off. Treat broad areas with a large brush or swab, building up color gradually in layers. Finally, color smaller areas with a fine brush. With oil paints, work on a dry print. Begin with large areas, but allow these to dry for 24 hours before you add details. The special feature of an airbrush — a miniature spray gun for spirit or water-colors — is that it allows you to form graduated tones and convincing false highlights and shadows.

Airbrush result ▷
To create the image on the facing page from the original print, right, Tim Stephens used an airbrush to turn excess detail into areas of flat color. He covered the whole print with an adhesive film mask. Scoring the film with a scalpel, he peeled off one area at a time and airbrushed in the desired color. If you use water-based color in your airbrush, as here,

you can obliterate any unwanted areas, then rebuild them. And you can wash off water-color and start again if you make a mistake. Always start with a clean, dry print.

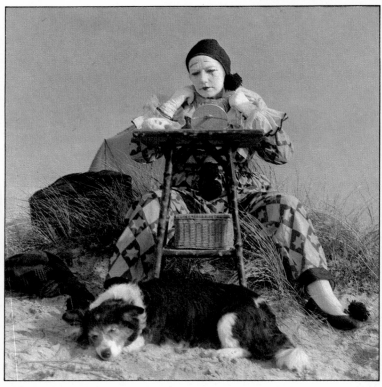

Oil-colored print △
To produce the picture above, Amanda Currey started with a dry, sepia-toned print. Using fine brushes moistened in turpentine, she colored large areas first. After 24 hours, once the paint had dried, she filled in details. If you want to change any area of oil color, use a cotton bud dipped in turpentine. Choose your medium to suit your subject — here the rich colors of oil paint suit the exotic dancers.

Water-colored print ▷
The black and white print, right, was sepia-toned, far right, damped, then painted with water-color to produce the picture above right. With water-based paint, build up depth of color over large areas gradually. Take a full brush and, using broad strokes, apply several washes of weak color to the sepia-toned print, shown far right. Once you have tinted large areas, work over smaller details, building up color in the same way.

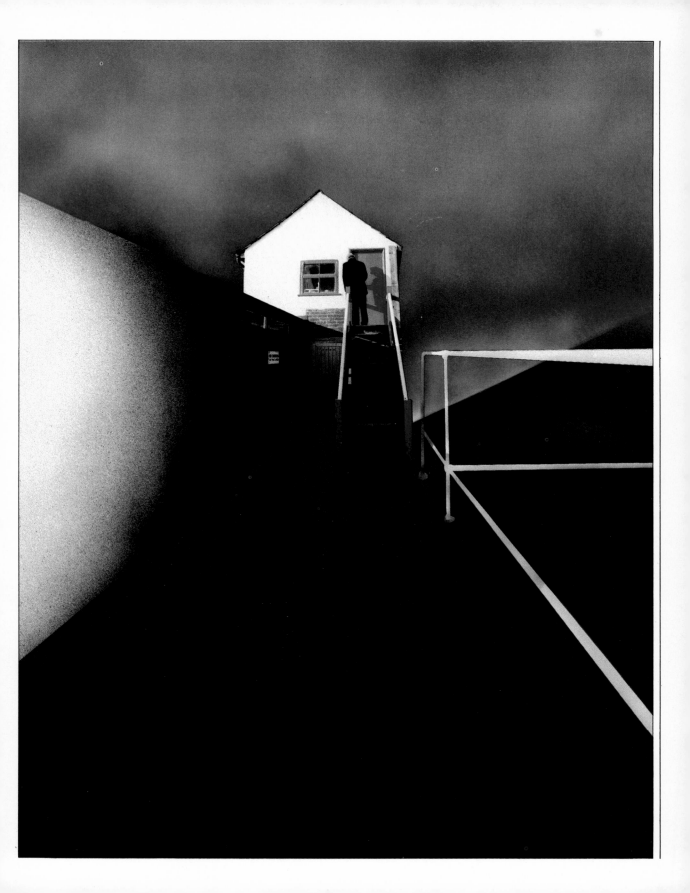

Toning

Toning is the conversion of a silver black and white image into a colored chemical result that retains the same tonal values as the original. Toners are available in sepia, blue, red, and many other colors. Choose a color to match the mood of your image – blue gives a cold, snowy look that suits landscapes, whereas sepia gives a warm, antique effect. You can tone selectively to emphasize a single object, or to convert different areas into bizarre colors.

Start with a fully processed black and white print, and work in normal room lighting. With most toners you bleach the black and white print in one solution, then redarken it in a toner to form the chosen color. If you cover parts of the print in a mask (such as rubber solution) before you bleach the image, the unprotected areas will remain black and white. You can subsequently peel off the mask and tone these areas in another color. Partial bleaching in a diluted solution retains the darkest shadows as black – only light and mid-tones change color.

Toners only convert the silver image, leaving the paper base white. However, if you soak the paper in dye, this will stain the gelatin so that highlights turn the color of the dye. You can tone a silver-image black and white negative or positive to make color slides or negatives.

Toning for a bizarre effect ▷
Lawrence Lawry used a blue color to tone this print, giving the jelly-smeared subject an ink-spattered look. This type of image would also be suitable for toning in a bizarre color such as pink, purple or green.

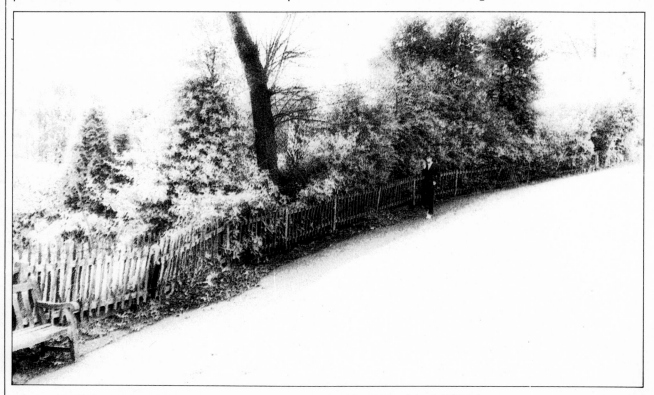

Toned landscapes △
This print is a toned version of the black and white print shown on the far right. To eliminate the foreground detail on the right-hand side of the picture, the area was shaded when the initial print was made. This empty space has accentuated the isolation of the figure, giving a lonely mood to the scene. The first print was bleached, see right, then toned blue. The blue toner gives a cold, snowy impression and shifts the season to winter.

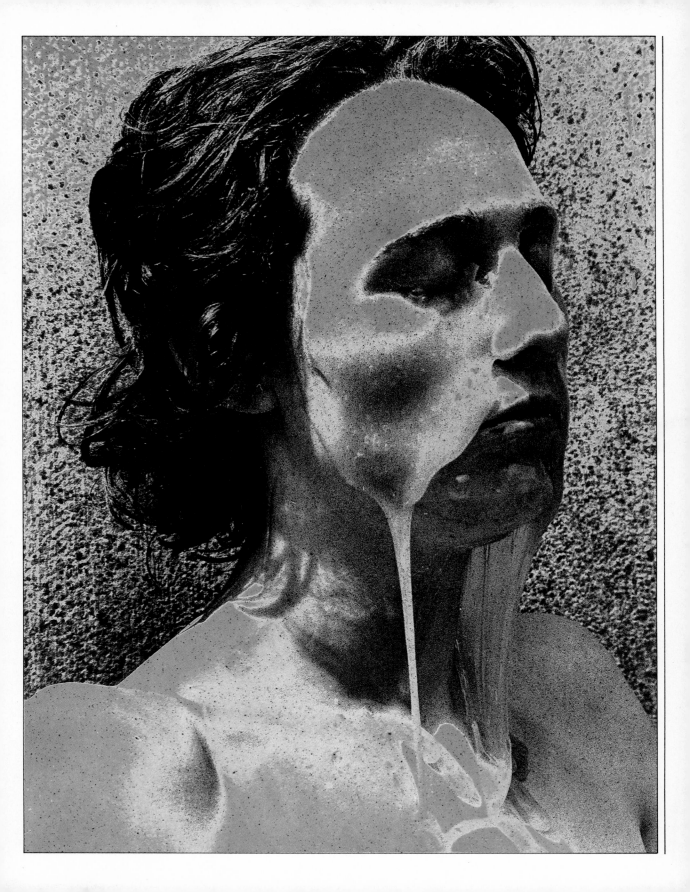

Solarization

Solarization (or the "Sabattier effect") is a dark-room manipulation that involves fogging an image by exposing to light part way through development. Results contain positive and negative elements, often with a white or black edge-line along the borders of previously black and white tones. Choose subjects with strong shape and uncomplicated backgrounds.

For maximum control over results, photograph and process the original image normally. Then contact print it on contrasty black and white sheet film in the darkroom, processing like paper with one exception: you expose it briefly to light halfway through development. You print and enlarge the resulting dense, partly reversed image on black and white paper.

To make solarized color prints you can use a black and white solarized film image plus its color original. First enlarge the solarized film on color paper, then enlarge and expose the original on the paper in exact register. You can change filtration and exposure time to vary image colors. Try using positive/negative and positive/positive papers for complementary results. Or print the solarized black and white image on film, then print this contact, the solarized image, and the color original together.

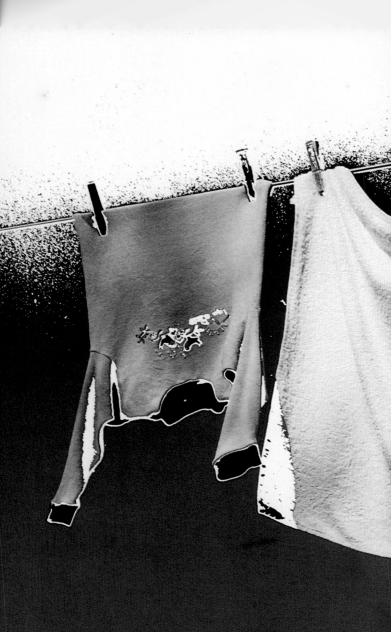

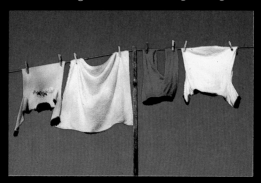

Making the lith solarization △
For the solarized pictures on these pages, Tim Stephens contact printed the color transparency, above, on ortho lith film. First he gave a 3 sec. exposure, followed by 1 min. development with vigorous agitation. Next, he placed the sheet film (in the tray) under the enlarger and gave a 3 sec. fogging exposure with the carrier removed. Finally, he gave another 1½ min development, agitating the film for the first minute.

Solarized prints
For the pictures above right and right, Tim Stephens printed the solarized lith film and original transparency in register on positive/positive color paper. For the large picture above right, he gave the solarized film an exposure of 40 sec. at f22, with filtration of 0Y 10M 20C, and the original slide 20 sec. at f16 with filtration of 10Y 0M 15C.

For the picture near right, the solarized film was exposed for 40 sec. at f22 with a filtration of 0Y 10M

20C. Then a green-filtered lith image, sandwiched with a pan lith contact from the original, was exposed for 8 sec. at f11, filtered 60Y 60M 0C.

For the third print, center right, Tim Stephens exposed the lith film for 10 sec. at f22, filtered 10Y 0M 25C, and gave the original transparency a 5 sec. exposure at f16, with a filtration of 0Y 8M 2C.

Photograms

Photograms are shadow pictures of objects laid on light-sensitive paper or film, formed when the material is exposed to light. This type of imagery pre-dates photography – Fox Talbot made photograms long before he produced his first successful camera pictures. Since the 1920's, beginning with the work of Dadaists like Man Ray, photograms have been widely used by artists as a direct source of abstract images.

You can use any convenient lamp to make a photogram, but to produce a controlled result it is best to use your enlarger as a light source. Position the head at the top of the column, and stop the lens well down so that shadows are sharp. Use opaque objects – cogs, dry pasta or cut paper – or translucent materials – glass or crumpled tracing paper. With the red filter over the lens, lay out your subject on paper to assess the position of the shadows. Make exposure tests for a full-bodied black in uncovered areas. To form intermediate tones remove or shift objects part-way through exposure.

To create other sorts of cameraless pictures use a photogram as a negative or make negatives by hand on glass. There are several ways of doing this – dribbling on pigment, running water over soot or dye, or sandwiching colored gelatins or detergent between glass.

Soot patterns ▷
For this cameraless image, Bob Dainton took a glass plate and spread soot on it, then added a small amount of denatured alcohol to create the pattern. (Try swirling the spirit around the plate or pour it on from a height.) Then he placed the plate in the negative carrier and enlarged on normal grade paper. Use a plate that is the same size as the largest negative your carrier takes.

Applying localized light △
To make photograms of small objects, it is a good idea to use a more flexible and precise light source. Tape a black paper cowl over a flashlight, below, and give a 1 sec. burst of light over each object.

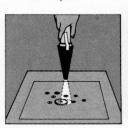

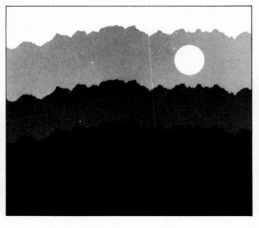

◁ Multiplying shapes
For a graduated image cut a "skyline" shape from black cardboard. Cover all but a strip at the bottom of the paper, below. Start with half the exposure for rich black, then switch off and move the cardboard up. Give half the previous exposure, then move the cardboard and repeat this procedure.

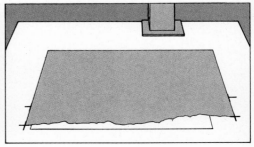

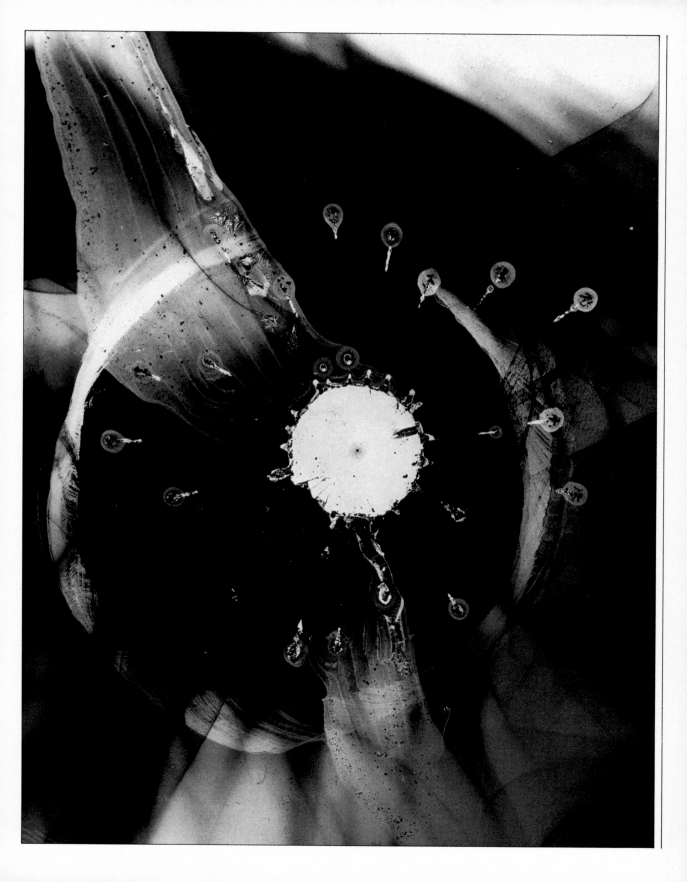

Diazo

Materials containing diazonium compounds are designed for proofing in the printing industry. Special effects photographers use them to produce brilliantly colored results with simplified tones. Diazo materials look like sheets of dyed film. But unlike film, they only respond to ultra-violet and blue-rich light, and are therefore safe to use in normal room lighting. Diazo is too slow to enlarge on directly – make contact prints instead, from camera-size negatives or line film enlargements, using sunlight or a UV lamp as a source.

There are several types of diazo material. The Color Key negative type you have first to expose, then wipe over with a single solution to remove color from unexposed areas. No other processing is necessary; just sandwich it with the original. With Agfa Gevaproof, you transfer the colored diazo coating to a paper base, expose it in contact with a negative image on line film, then treat it in "sensitizing" chemical, finally washing off color in unexposed areas. You can transfer a different-colored sheet of diazo on top and repeat the process to expose a second color. The best way to build up multi-colored images is to turn an original color slide into a set of enlarged tone or color separation line negatives. Contact print each negative on a different diazo color, and stack in different ways for a range of results.

Diazo images

When you select an original for diazo manipulation, choose a bold, simple subject. For multi-colored results make color separations first, see right. Enlarge your original on high-contrast lith film through the set of color separation filters (RGB). Then contact print separations on different colored diazos. You can expose diazo to any combination of the negatives and positives. For the print on the facing page, Tim Stephens exposed a cyan negative on magenta diazo, a cyan positive on yellow diazo, and a magenta negative on cyan diazo. For the picture, top right, he used a magenta positive on magenta diazo, cyan positive on yellow, and cyan again on cyan. The image, bottom right, was made from a yellow negative on magenta, a yellow positive on yellow, and a cyan negative on cyan.

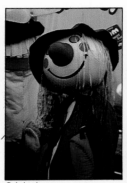
Original transparency

Y separation from blue filter

M separation from green filter

C separation from red filter

Emulsion manipulations

Manipulation of emulsion causes an image to lose its conventional photographic appearance, and allows the use of different base materials that suit the subject or approach. There are two main techniques. The first involves scraping parts of the emulsion from existing prints; the other coating emulsion on a suitable surface and using this for printing.

If you scratch the damp surface of a print carefully, using a needle or scalpel blade, you can remove emulsion down to the white resin-coated base. You can treat negatives in the same way – etched lines will print black. Scraping color prints cuts away each dye layer in turn – dark areas generally turn red, then they turn yellow, and finally white.

Another approach is to buy black and white print emulsion as a liquid and coat this on paper or materials such as glass, ceramics or stone. Working in the darkroom, apply warmed emulsion using a soft brush, or pour it over your material to form an even coat. Work with a rough sponge roller, or a dribble-on technique if you want brushmarks or irregular patches. You must precoat non-porous materials with a priming layer. When emulsion has set dry, expose it to the image under the enlarger, then process it normally.

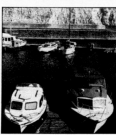

Uneven images ▷
The abstract photograph on the right was made from the same negative as the print above. If you lay down an uneven coat of liquid emulsion on paper, then expose and develop normally, results are patchy. Or, for similar results apply developer unevenly to an exposed print.

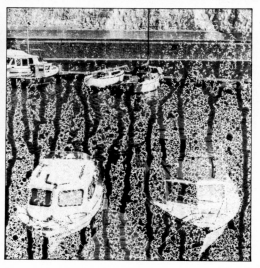

Scraping the emulsion △
To create this picture, Mari Maar took a print of a curtained window, and scratched in the figure with a scalpel blade. You can use scraping techniques to add new images to a print or to emphasize existing elements. And you can fill in scratch marks by hand with colored paint or wax crayon.

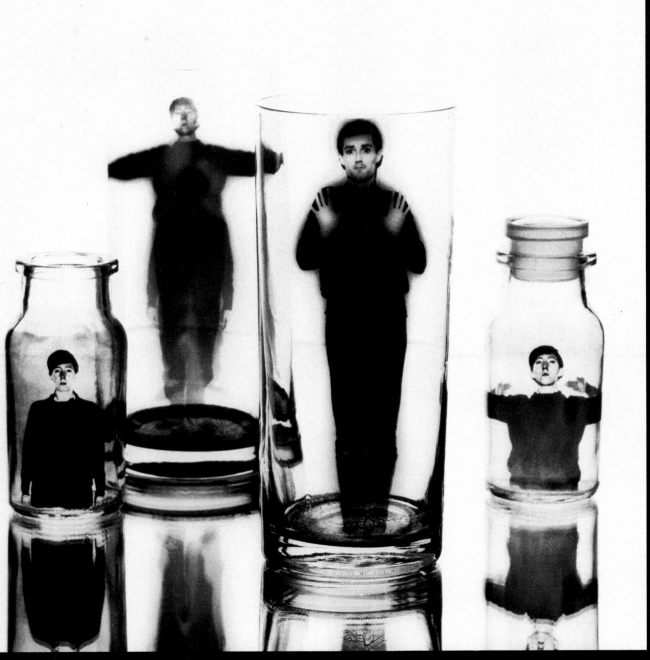

Painting emulsion on three-dimensional surfaces △
You can coat surfaces such as eggs, plates, or bottles with emulsion. If necessary, apply a primer layer. Then coat object with emulsion, expose under the enlarger, and process and develop with care. If you wish, you can hand color results before varnishing them. Pete Truckel exposed these emulsion-coated bottles in contact with a lith positive, moving the glass to give an even exposure, see the diagram right.

Video

Video equipment offers a simple, convenient way of changing the color and general appearance of images. Work with a videotape recorder (VTR) and domestic color TV set (preferably trinitron tube type). Take images from broadcasts (subject to copyright), or copy your prints, negatives or transparencies on videotape. Then play the image back through your own television, and photograph the displayed image on color film using a camera set up in front of the screen.

You can tune the color controls to form garish, distorted colors, part-cover the screen with masks, or expose a sequence of images on top of each other for blur or superimposition effects. All results carry a fine grid of color dots formed by the tube itself. Each TV picture takes 1/30 sec. to form fully (1/25 sec. in Europe), so you must use a slower shutter speed than this for an even result. Place your camera on a tripod in a darkened room. If you require color slide results, use daylight type film.

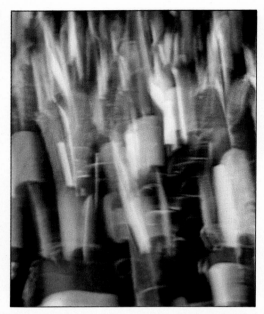

Using masks ▷
For this sequence, Chris Andrews used a portable video camera to create an image of a face on a screen. Then he photographed the screen several times, covering it with a series of black paper masks, revealing more of the image with each shot. For this type of sequence, position your camera on a tripod so that distance and angle remain the same.

◁ **Creating blur**
This image was created by photographing a video movie from the screen. The photographer set a shutter speed of 1/15 sec., and pressed the release just as the picture changed, so that an abstract blur of color recorded on the film. Results are unpredictable — you may have to take several shots to get the result you want.

Distorting color ▷
To create this image, the photographer copied his slide with a video camera and relayed it through a domestic TV set, altering the color controls. Then he copied the screen using a 35 mm camera and daylight film. For the picture above he used his self-timer so that he could include himself in the shot.

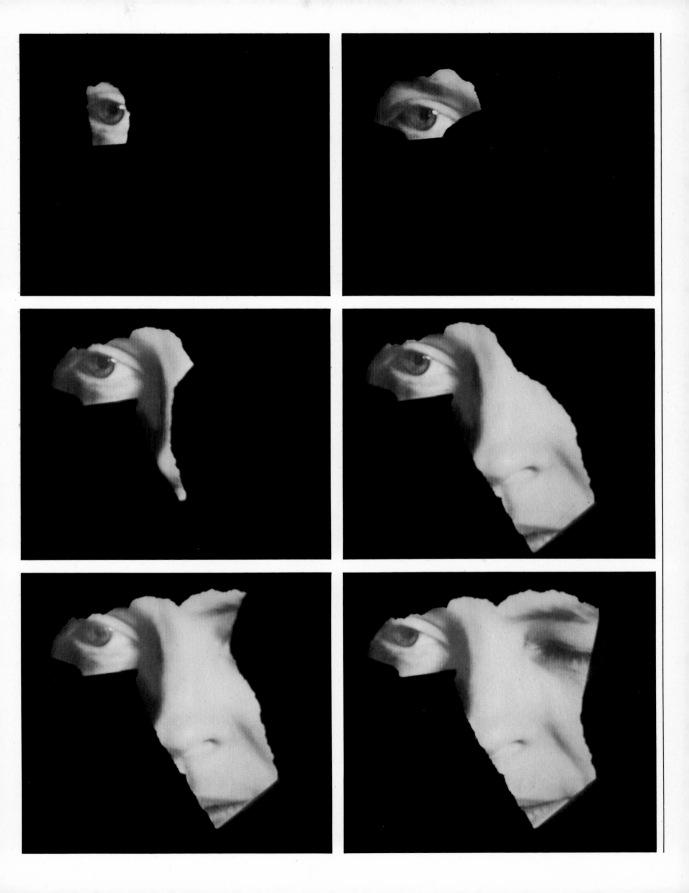

Photocopy derivations

Interference with the controls or operation of a photocopy machine produces distortions of image shape, tone, and color. A Xerox photocopy machine operates by scanning a document placed face down on its glass surface – a light bar passes under the glass, forming an image on a specially-treated metal drum. This rotates, picking up toner powder which sticks to unexposed areas. Then the drum transfers and fuses the powder to ordinary paper. Color machines make three separations in succession through blue, green, and red filters, superimposing yellow, magenta, and cyan images on one sheet of paper or acetate.

You can shift or rotate photographic prints during scanning to distort their shape. And try breaking up tone and detail by reproducing images over and over again, or by projecting a color slide into the machine through a screen. If you work fast, you can change an original between scans in color copying and use black and white separation prints to alter color.

Photocopy portrait ▷
To make this photocopied profile, Neil Menneer positioned his subject's head on the glass surface of the machine. Depth of field is shallow on copies of three-dimensional objects, and you may have to cover the subject's head with dark cloth to get the best exposure.

Breaking up detail △
To degrade detail in a mechanically-printed image, this picture was copied twelve times. The first copy was used to produce a second, the second to produce a third, and this process continued until the dots that make up a mechanical print turned into lines.

Distorting an image ▷
If you shift a flat copy original during exposure, its shape will be distorted when printed. Here, the original photograph was rapidly pushed, then pulled in the opposite direction from the scan, and finally twisted to and fro.

Photocopied collage △
This picture started with an original collage made from dot-screened adhesive film, photographs and drawings. The dots form a moiré pattern at crossover points. This result is a third generation copy.

Introducing grain ▷
To produce this image,
Andrew de Lory copied a
small section of a slide,
below, overprocessed it,
then projected it into a color
photocopy machine through
a grain screen (see p. 102).

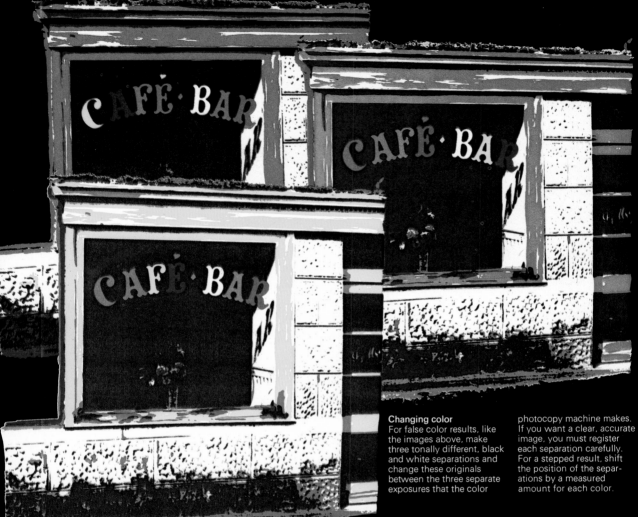

Changing color

For false color results, like the images above, make three tonally different, black and white separations and change these originals between the three separate exposures that the color photocopy machine makes. If you want a clear, accurate image, you must register each separation carefully. For a stepped result, shift the position of the separations by a measured amount for each color.

Photocopying small objects ▷

You can place any small object on the glass surface of a color photocopy machine and produce a remarkably realistic picture of it. With this technique, you can create still life of found or household objects, exploiting texture and color. As well as printing on paper, color machines print on acetate or heat transfer film. You can iron this type of result on most fabrics.

Mixed media

The fact that you are a photographer should not prevent you from mixing drawings, three-dimensional objects, video pictures, photocopies, or any other images with photographic prints. Painters no longer limit themselves to paint, and attach all kinds of material to canvas to give a particular quality or effect.

You can combine photographs and drawings, apply ink or white paint over parts of a print, or even print on a photolinen base and embroider the result. Try photographing three-dimensional artifacts placed on the surface of a print, matching lighting to the direction and quality of light in the main print image. To create strange mixtures of scale, cut holes in prints and place them over patterned or textured materials. Another interesting technique involves silkscreen-printing on part of the surface of a photograph, mixing flat, two-dimensional design with photographic realism. For all these special effects, combinations of black and white and colored objects work particularly well.

Mixing photographs and drawings ▷
To construct this picture Mari Mahr combined a photograph of a clown with an artwork of a domestic interior. She cut out one wall of the room for the photograph to show through. When you mix photographs with drawings, use differing scales or unexpected combinations for a striking effect.

Isolating photographic areas △
White paint covers some of this picture, leaving only the glass and ornament photographic. These realistic elements stand out dramatically against the hand-made background. Applications of both pencil and blue ink on top of the white paint create hand-drawn areas of shadow and tone.

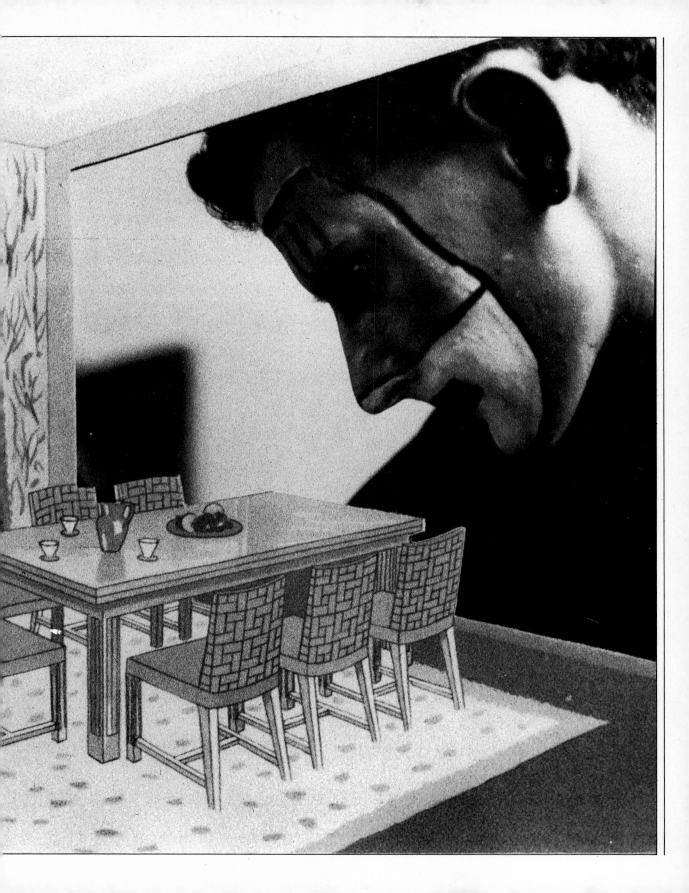

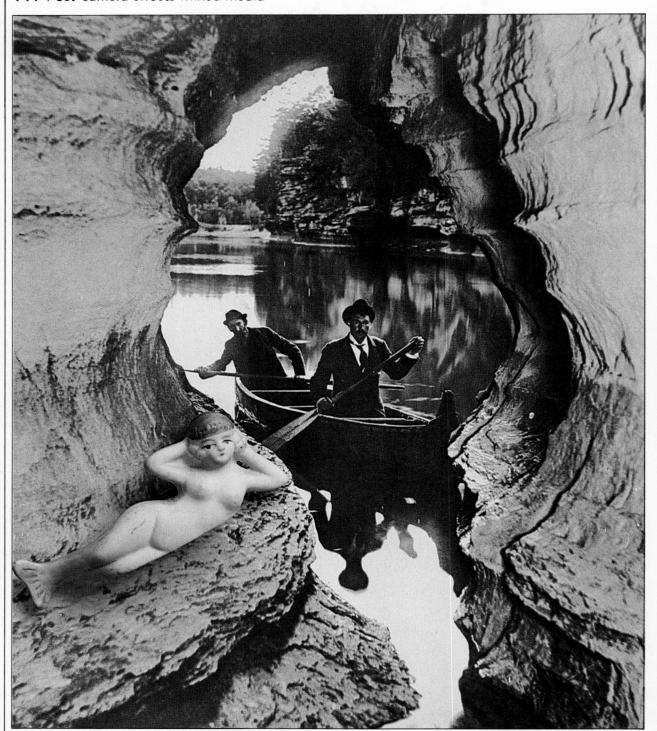

Using three-dimensional objects △
For this humorous picture Mari Mahr placed a small painted china figure on a black and white print and photographed the combi- nation on color slide film. For this type of result, size your print to suit the three- dimensional object, and then arrange and light the print and object carefully before shooting.

APPENDIX

In this appendix you will find additional technical information, data, step-by-step techniques, and charts. *Cameras and exposure* (pp. 146–7) includes stereo photography, pinholes, double and multiple exposure, shutter speeds, neutral density filters, and reciprocity failure. *Tripods* (p. 148) covers types available and the pan and tilt and panoramic heads. *Lenses* (pp. 148–9) gives details of types, projected zoom, angle of view and depth of field. *Filters and attachments* (pp. 150–2) contains information on types, exposure, holders, lens hoods, polarization, and darkroom filters.

Unusual film types and processing methods are detailed in the *Films* section (pp. 153–4). *Flash* (p. 155) covers types, exposure, speed, strobe, and synchronization. *Studio work* (pp. 156–7) provides information on equipment and layout, lighting types, projectors, back projection, and drawing with light. *Workroom techniques* (pp. 158–60) range from copying and diazo to dry mounting, hand coloring, airbrushing, montage, scratching or toning prints.

Darkroom data (pp. 161–2) includes registration, making separations, posterization, shading and vignetting, using liquid emulsion and special paper and chemical types. *New media* (pp. 163–4) gives a brief view of exciting changes in the world of image-making. Finally, *Working as a professional* (p. 164) gives practical advice on making use of your skills.

Cameras and exposure

An SLR camera that gives you full control over shutter and aperture is the most versatile camera for special effects purposes. Through-the-lens viewing allows precise framing, depth of field preview gives control over sharp and unsharp elements, and the interchangeable lens system provides scope for unusual optics. For sandwiching and most multiple exposure techniques you will need an SLR with a removable head to allow direct access to the focusing screen, or a medium format camera, so that you can draw the first image on the screen, to make sure that you position the second accurately. The 35 mm format is the most accessible, and is perfectly adequate for effects in this book. However, larger format cameras are easier to use for some lighting and studio techniques. Their interchangeable backs allow you to make instant test shots. Sheet film cameras allow individual processing and assessment of each exposure.

Direct viewfinder cameras have a limited use. However, camera movement, flare, reflections, mis-matched film, mixed color temperatures, and low and high key are all possible. If you have control over shutter speed you can try slow shutter. Other useful cameras are panoramic (see p. 36), instant (see p. 108) and stereo.

Stereo photography
When we look at objects existing on more than one plane they stand out in three dimensions because of the difference in viewpoint of our two eyes. To create this effect photographically, take two pictures of the same subject with camera viewpoints about $2\frac{1}{2}$ ins (6 cm) apart.

Stereo equipment
You can use a stereo adaptor on your SLR camera and lens, see below, to form a pair of upright images side-by-side on the normal 35 mm frame.

For full frame stereo images, tape two SLRs baseplate to baseplate, see below, spacing lenses about $2\frac{1}{2}$ ins (6 cm) apart. You must press both shutter releases at the same moment.

Making a pinhole camera
You can make a simple pinhole camera from any discarded container such as a cardboard box or tin can.

Make a 1 cm diameter hole at one end, and cover this with aluminum foil. Pierce foil with a needle. Make a black paper shutter to cover the pinhole. You must place your film or reversal color paper in position in the darkroom. The optimum hole-to-film plane distance is the diagonal of the film.

For a telephoto image insert a cardboard tube opposite the film. Cover the far end of the tube in foil and pierce a hole in this.

Or you can pierce a hole in the top of an 8 x 10 ins (20 x 25 cm) photographic paper box and place the film at the bottom of the box for a wide-angle result.

Pinhole exposure
For best results on a 35 mm camera, make your pinhole size between 1/50 and 1/100 in (0.05–0.1 cm). To calculate the f number of your pinhole (in order to measure exposure), you must measure the size of the pinhole and divide this into the distance from film to pinhole. This gives an effective f number. With bright scenes, your TTL meter will still give a reading. Or read with a lens or hand meter, set at f8. Multiply this exposure time by 200 for a 1/50 in (0.05 cm) pinhole, or by 50 for a 1/100 in (0.1 cm) hole. You may have to increase this to compensate for reciprocity failure if exposure time exceeds 1 sec.

Double and multiple exposure
There are several ways to record more than one image on a frame of film. If your camera has a multiple exposure button or lever, simply turn it on. Many cameras allow you to override the automatic lock (designed to prevent accidental double exposure) using the rewind system. Look in your camera leaflet for details. If you cannot do this there are three other methods you can try. You can use a simple double mask (p. 63) to divide the frame horizontally or vertically, combining unlikely elements in each half. Or run a film through your camera once, taking the first set of images, then run it through again, superimposing further images. You must mark the film leader and camera so that you register the images exactly, see the diagram on the facing page. The other method involves controlling the exposure by improvising an external "shutter". Lock the camera shutter open (B setting) and hold black cardboard over the lens between the separate parts of the exposure.

At the end of a multiple exposure your camera may not advance the next frame completely. To avoid any errors, press the shutter and wind on the next frame with the lens cap on. To make sure that a camera's registration — alignment of the frame — is accurate, put it on a tripod and shoot a fixed subject such as a printed page several times on one frame of film.

To determine exposure time for each element of a multiple exposure, you must consider the degree of overlap. If your

subjects do not overlap, give the full exposure time for each part exposure. With overlapping subjects give each individual exposure the appropriate fraction of its normal exposure — for example, in a triple exposure give each shot one-third the normal exposure.

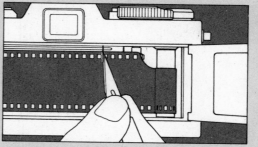

◁ **Registration for double exposure**
If you intend to run the same film through your camera more than once you should make alignment marks inside your camera and on the film leader, using a scalpel blade or sharp knife. When you reload the film, match up marks carefully for accurate results.

Rental services

Equipment rental is the ideal way to obtain the expensive item, such as a fisheye lens, you need for a single shot. When you are deciding whether to rent or buy, take into account how often you will use the item. A third alternative you should consider is secondhand purchase. As well as all types of camera and lighting equipment, you should be able to find a studio for rent in most large cities. Most of these provide studio flash, tungsten lights, camera stands and background papers. And some have front- or back-projection facilities. In addition, there are agencies that specialize in costume and prop rental. With all these firms you will have to pay a refundable deposit, as a cover against any type of damage or loss.

Model release form

Whenever you use a model in any of your special effects photographs you should ask him or her to sign a release form. This is an agreement which gives you permission to publish his or her photograph.

Neutral density filters

ND filters reduce the amount of light entering the camera without affecting the colors or tonal range of the final image. ND filters allow you to give a shallow depth of field, or to set a long exposure in bright light. ND filters are especially useful to increase exposure for special effects such as slow shutter, flash and long exposure, circles of confusion, or defocus. When you fit an ND filter, you can either increase aperture or exposure time, see right.

Filter designation	Multiply exposure time by (Filter factor)	Increase aperture (f stops) by
ND 0.1	1.25	$\frac{1}{3}$
ND 0.2	1.5	$\frac{2}{3}$
ND 0.3	2	1
ND 0.4	2.5	$1\frac{1}{3}$
ND 0.5	3	$1\frac{2}{3}$
ND 0.6	4	2
ND 0.7	5	$2\frac{1}{3}$
ND 0.8	6	$2\frac{2}{3}$
ND 0.9	8	3
ND 1	10	$3\frac{1}{3}$
ND 2	100	$6\frac{2}{3}$

Shutter speed

This chart gives approximate speed to freeze action at various camera distances, with typical subjects and a normal lens. A telephoto lens enlarges the moving image, giving more blur for the same speed and distance of subject. And a wide-angle lens decreases blur. For a blurred special effect you must always set a slower speed.

	Under 5 mph		
	(5 m)	(10 m)	(20 m)
Movement toward the camera	1/60	1/30	1/15
Movement at 45°	1/125	1/60	1/30
Movement across the camera	1/250	1/125	1/60

	Over 5 mph		
	(10 m)	(20 m)	(30 m)
Movement toward the camera	1/250	1/125	1/60
Movement at 45°	1/500	1/250	1/125
Movement across the camera	1/1000	1/500	1/250

Reciprocity failure

If you give extremely brief or long exposures most films behave as if they have a slower speed rating and give slightly altered contrast. Color films may show an imbalance of color between highlights and shadows. You must give extra exposure when working at speeds faster than 1/1,000 sec. or longer than $\frac{1}{2}$ sec. Do this by opening the aperture (setting a longer exposure simply increases the reciprocity failure). This table shows aperture increases, development changes or filters you need for popular films.

	Black and white film		Color slide film Ektachrome 64		Ektachrome 200		Ektachrome 400		Kodacolor II		Kodacolor 400	
Sec	Aperture increase	Reduction in development	Aperture increase	Filter	Aperture increase	Filter	Aperture increase	Filter	Aperture increase	Filter	Aperture increase	Filter
1	1	10%	1	CC15B	$\frac{1}{2}$	CC10R	$\frac{1}{2}$	—	$\frac{1}{2}$	CC15C	$\frac{1}{2}$	—
10	2	20%	$1\frac{1}{2}$	CC20B	Not recommended		$1\frac{1}{2}$	CC10C	$1\frac{1}{2}$	CC30C	$1\frac{1}{2}$	CC10M
100	3	30%	Not recommended		Not recommended		$2\frac{1}{2}$	CC10C	$2\frac{1}{2}$	CC30C	2	CC10M

Tripods

For shots on a standard lens at shutter speeds below 1/60 sec. you must use a tripod to avoid camera shake. With a heavy telephoto lens you will need a tripod at most speeds. And a tripod is necessary for close-up pictures or unusual viewpoints — for adequate depth of field you must set a small aperture and long exposure. Use a cable release to enable you to control the camera, lens and lighting accurately. A model with a geared-crank adjustable center column allows you to set various levels, and raise or lower the camera during exposure for vertical blur effects.

Reversible columns help you to photograph from a low viewpoint. A pan and tilt head allows you to pan or tilt the camera smoothly. It will revolve through 360°, tilt 90° downward and 45° upward. A panoramic head allows you to make an accurate panoramic view. With a rotating camera bracket you can make kaleidoscope-type images. The bracket has two circular rails, one inside the other. You fix the outer rail to the tripod, holding it stationary. The inner rail attaches to the camera, revolving it on the lens axis. All tripods and heads must have lockable controls.

Tripod types
Tripods for special effects should be adjustable for photographing from unusual viewpoints, and take interchangeable heads for techniques such as panning and tilting.

Panoramic head ▽
This head is fitted with click-stops to move your camera through 360° to produce a complete panorama image.

Pan and tilt heads ▽
These heads allow you to move the camera sideways or up or down smoothly for action shots.

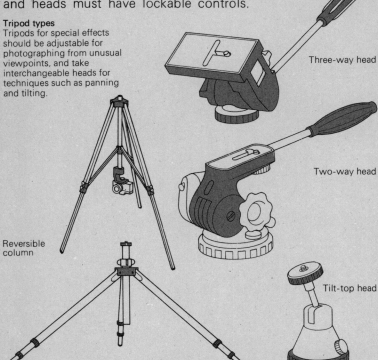

Reversible column

Extendable legs

Three-way head

Two-way head

Tilt-top head

Lenses

Very wide or long lenses, fisheye lenses, anamorphic and zoom lenses are all useful for special effects purposes. Very short focal length lenses give an increased angle of view, see right, which results in image distortion — straight lines appear curved and curved lines straight. Wide-angle lenses are built to correct this distortion, but they elongate shapes at picture edges. Fisheye lenses differ from wide-angle lenses in that they do not attempt linear correction of the image. With fisheye lenses angles of view of 220° are possible, giving circular images within the film frame. A less extreme 180° fisheye fills the whole 24 × 36 mm frame. All these short focal length lenses enable you to include large areas of a scene from a close viewpoint. This gives strong perspective and scale change, exaggerating depth.

As focal length increases you will need to increase your distance from the subject. As a result scale changes and perspective diminish, reducing depth and distance in the picture. Long focus lenses enlarge distant objects which would normally appear small. The image magnification is proportional to focal length. For example, if you change from a 100 mm lens to a 500 mm lens you enlarge the image five times. Telephoto lens construction enables the lens barrel to be shorter and more compact than its true focal length. Extremely long lenses — from 250 mm and upward — are often of the mirror type. A mirror lens uses internal mirrors to reflect the light twice, making possible a much shorter and lighter (although broader) lens barrel. Like all long focus lenses, it gives very shallow depth of field. A mirror lens has a fixed aperture, and turns out-of-focus highlights into rings of light (circles of confusion, see p. 25 and 34). Telephoto lenses are very heavy — you will need a tripod to support them.

A zoom lens has an extra control which allows you to vary its focal length. This requires very complex optics within the lens so that focus and aperture remain constant. Zoom controls are either one-touch (focus and zoom combined) or two-touch (separate focus and zoom controls). Zoom effects are easier with a one-touch slide control lens.

Angle of view ▽
The angle of view is the amount of the subject that is included within the picture at any camera position. Changing lenses has a dramatic effect on the amount of the subject you can include in the picture, below. With a 50 mm lens the angle of view is about the same as normal human vision. With a short focal length lens more of the scene is included, but everything is reduced in size. A long focal length lens magnifies the main subject, filling your picture frame with a smaller area of the subject.

5°	500 mm
12.5°	200 mm
18°	135 mm
29°	85 mm
46°	50 mm
74°	28mm
83°	24 mm
107°	16 mm
180°	7.5 mm

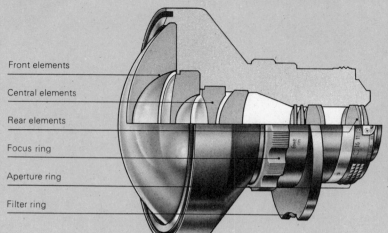

Front elements
Central elements
Rear elements
Focus ring
Aperture ring
Filter ring

Soft focus lens ▷
This type of special soft focus lens is available in 200 mm, 250 mm and 300 mm focal lengths. You control image sharpness with interchangeable perforated disks. Stopping down lessens the effect, so always focus the lens at your working aperture. Optical quality is superior to that of diffusion attachments; therefore the lens is ideal for portraiture.

◁ Fisheye lens
This diagram shows the complex arrangement of lenses inside an 8 mm fisheye lens. Two large diverging collector elements at the front of the lens give it an 180° angle of view. Fisheyes need many more elements than standard or long focus lenses. Good fisheyes are expensive. You can achieve the same image distortions with a cheaper fisheye converter. This deeply curved lens attaches over your standard lens. For best results use a small aperture.

Projected zoom △
You can project a transparency using a zoom lens, then copy a series of images on the screen with your camera and standard lens. Use a pencil to pre-mark the screen with planned steps, see diagram. Then adjust the zoom until the picture fits the first pre-marked shape. Give three superimposed exposures at different zoom settings for an effect similar to stepped zoom (see p. 26).

Depth of field chart (Lens focused at 10 ft/3.1 m)

Lens	Aperture settings		
	f2.8	f3.5	f5.6
28 mm	7¼ ft (2.3 m) – 14 ft (4.3 m)	7 ft (2.2 m) – 15¾ ft (4.8 m)	6 ft (1.8 m) – 25 ft (7.5 m)
50 mm	8 ft (2.5 m) – 12 ft (3.6 m)	8 ft (2.5 m) – 12½ ft (3.8 m)	7¼ ft (2.3 m) – 15 ft (4.5 m)
85 mm	8¾ ft (2.7 m) – 11 ft (3.3 m)	8½ ft (2.6 m) – 11¼ ft (3.4 m)	8 ft (2.5 m) – 12¼ ft (3.7 m)
135 mm	9 ft (2.8 m) – 10½ ft (3.2 m)	8¾ ft (2.7 m) – 10½ ft (3.2 m)	8½ ft (2.6 m) – 11¼ ft (3.4 m)
200 mm	9 ft (2.8 m) – 10 ft (3.1 m)	9 ft (2.8 m) – 10 ft (3.1 m)	8¾ ft (2.7 m) – 10½ ft (3.2 m)
300 mm	9¼ ft (2.9 m) – 9¾ ft (3 m)	9¼ ft (2.9 m) – 10 ft (3.1 m)	9 ft (2.8 m) – 10 ft (3.1 m)
400 mm	9¼ ft (2.9 m) – 9¾ ft (3 m)	9¼ ft (2.9 m) – 9¾ ft (3 m)	9 ft (2.8 m) – 10 ft (3.1 m)

Lens	Aperture settings		
	f8	f11	f22
28 mm	5 ft (1.6 m) – 69 ft (21 m)	4½ ft (1.4 m) – ∞	2¾ ft (.8 m) – ∞
50 mm	6½ ft (2 m) – 17¾ ft (5.6 m)	6 ft (1.8 m) – 29 ft (8.8 m)	4 ft (1.3 m) – ∞
85 mm	7¼ ft (2.3 m) – 13¾ ft (4.2 m)	7¼ ft (2.3 m) – 16 ft (4.9 m)	5¼ ft (1.7 m) – 44 ft (13.4 m)
135 mm	8 ft (2.5 m) – 12 ft (3.6 m)	7¾ ft (2.4 m) – 12¾ ft (3.9 m)	6½ ft (2 m) – 19 ft (5.8 m)
200 mm	8½ ft (2.6 m) – 11¼ ft (3.4 m)	8 ft (2.5 m) – 11½ ft (3.5 m)	7¼ ft (2.3 m) – 14½ ft (4.4 m)
300 mm	8¾ ft (2.7 m) – 10½ ft (3.2 m)	8¾ ft (2.7 m) – 11 ft (3.3 m)	7¾ ft (2.4 m) – 12½ ft (3.8 m)
400 mm	9 ft (2.8 m) – 10 ft (3.1 m)	8¾ ft (2.7 m) – 10½ ft (3.2 m)	8 ft (2.5 m) – 12 ft (3.6 m)

Filters and attachments

A filter alters the color, nature, or brightness of light reaching the film. With some types the light is partially absorbed, with others (strictly attachments, but often called filters) it is selectively dispersed, diffracted, or refracted. Filters exist for each of these effects, and often you can use two or more together to extend their versatility.

Filters serve two functions: either they correct and strengthen the image, bringing it closer to reality, or they alter it for a special effect. With black and white film they control tone or contrast. With color film they correct light balance, and alter color subtly or boldly. Filters are either glass, gelatin, or high quality plastic, in disks or squares. The round types usually have a metal or plastic frame, and, like square types, you can use them unmounted. Or you can make inexpensive filters from sheet gelatin. You can use most filters with any camera, but only through-the-lens viewing models allow you to preview the effect. Through-the-lens viewing is essential with polarizing filters and devices such as split filters and double masks.

Exposure

All filters reduce incoming light to some degree. If you use TTL metering, you will find the effect of most strong filters on exposure readings unpredictable. The filter factor method of calculating exposure is far more accurate. To compensate for the loss of light you need to increase either your exposure time or the lens aperture. To calculate the increase necessary you must multiply the exposure by the filter factor. Thus, if a filter has a factor of two you must either double the exposure time or open up the aperture one full stop. Published filter factors are worked out for average conditions and you may need to modify them by trial and error. If you are relying on the metering system inside your camera you should check in your camera leaflet for information on the use of filters with regard to the color sensitivity of your particular meter cell.

Lens hoods

A lens hood protects your lens from extraneous light when shooting toward the light source. Often this light reduces

Sheet filters △
Gelatin or plastic filters are available in small square sheets. Tape them over the lens, or hold them in front of it. Oversize square types allow you to use split filters in a variety of positions.

Filter holders ▷
This filter system is based on a filter holder which you can use with various size lenses. Different-sized adaptor rings attach the holder to the lens. All filters in the range fit this holder, and you can use more than one filter at a time. Also you can turn the filters in the frame (important for polarizing filters, for example).

Filter care
Always handle filters by their edges, and clean them with a fluid recommended by the manufacturer.

Ring filters △
Simple ring filters are threaded directly on the lens. They are easy to use, but each filter is restricted to one lens thread size.

◁ **Filter systems**
Some filters are sandwiched between two adaptor rings. You screw this assembly on the lens. Various size rings are available — these enable you to use the filters with different-sized lenses.

Lens hood types ▽
Hoods are made of metal, plastic or rubber. They either thread on or slip over the lens.

contrast generally, or records on the film as flare spots or chains. Hoods are designed to suit particular lenses. A hood for a normal lens will protrude into the field of view of a wide-angle lens, slightly darkening all four corners of the image. Similarly, it will not shade a telephoto lens adequately. Consequently, you should always use each lens with its own specific hood. Remove your lens hood if you want deliberate flare (see p. 30).

Types and uses

Filter	Cokin	Hoya	Filter Factor	Examples	Effect
Strong color filters	●	●	Yes	pp. 44–5	Available in primary and related colors. Produce striking color changes with color film, and can heighten contrast in black and white.
Pastel color filters	●		Yes	—	Available in a range of colors – from sepia to pink. Remove color casts, enhance original colors. Combine well with soft focus filters.
Dual color filters		●	Yes	p. 47	Produce images with strong two-color effects. Enrich colors. Use to strengthen subject or create contrast. Designed to have equal density across the picture.
Graduated filters	●	●	Yes	p. 46	Available in many colors. Density changes across filter surface. Useful for toning down bright skies or water, or tinting dull skies.
Center spot filters	●	●	No	—	Available in most colors. Use with a long lens to frame subject with a soft vignette of color. With a wide-angle lens the division is sharp.
Fog filters	●	●	No	p. 49	Available in several densities. Reduce contrast and give a misty effect. Combine well with color filters.
Diffraction filters	●	●	No	pp. 50–1	A grating of minute lines covers these filters. Their diffractive effect on light produces bands, streaks and flares of color, or rainbow arcs.
Starburst filters	●	●	No	p. 50	Also known as cross-screen. Form star-like radiations from a light source. Available in different sizes (4, 6 or 8 points).
Multi-image filters	●	●	No	pp. 54–5	Prismatic facets in surface separate incoming light to form several identical images. Circular and linear types available.
Multi-image colored filter		●	Yes	p. 54	Tinted prismatic facets in surface separates incoming light into several identical, but differently colored images. Circular type only.
Double mask	●		No	p. 62	Consists of two filters – one with opaque half (or center) and clear half (or surround), the other with the opposite. Allows you to mix two subjects on one frame. Use with lens at wide aperture to give soft edges.
Pre-shaped masks	●		No	p. 60	Available in a variety of shapes (hearts, keyholes, etc.). Black out part of a scene.
Speed filters	●		No	—	Give impression of speed to part of picture area. Blur effect is similar to panning, but fully controllable.
Infra-red filter		●	Yes	pp. 96–9	Very deep red. Use with black and white infra-red film to limit response to long wavelengths.
Ultra-violet filter	●	●	No	p. 76	Also known as skylight filter. Pale pink or colorless. Corrects blue cast on distant views, or in overcast conditions. Use for UV shots to absorb direct reflection of UV light.
Polarizing filter	●	●	No	pp. 116–7	Reduces or removes reflections from non-metallic surfaces. Improves contrast, brightens colors, darkens blue skies. Rotate to alter effect.
Split-field filter		●	No	p. 53	Half close-up lens, half clear filter. Allows near and distant points in a scene to appear in focus at the same time.

Home-made filters and attachments

Use transparent colored material such as colored gelatin squares to make strong or pastel color filters. Cut the material to fit a gelatin holder or adaptor ring. Try colored cellophane, flat or crumpled, for a combination of filter and diffuser. And nylon panty-hose stretched over the lens has a diffusing effect. Try patterned types (spots or diamonds) for further distortion. You can make a diffuser by smearing petroleum jelly on the outside of a clear UV glass filter. Selectively diffuse any area by covering only part of the filter, and vary the degree of diffusion by adding a thin or thick layer. Clean the filter after use to prevent an accumulation of dust.

You can use virtually any small opaque object for a mask — from your own fingers to the eye of a large needle. The only limit is the extent of your ingenuity. And you can employ a range of "found" materials as screens. Try hat veiling, netting, or wire mesh, positioned between the lens and the subject. To make your own special effects screen, photograph a fine colored texture or pattern, enlarge this on continuous-tone sheet film and use the result as a screen. Or draw dots by hand on clear film. Contact print this on a sheet of line film to turn dots white, then color them in with inks. Finally, copy the result on color film. You can use screens and masks at the printing stage, too. Sandwich them in contact with the film in the negative carrier, or place them in contact with the paper.

Half-tone screens

To build an image from lines or dots use a half-tone contact screen, placing it over line or lith film on the enlarger baseboard. Then enlarge your image on this sandwich. Process film for an image that consists of dots in various sizes. Or use Autoscreen film (p. 115), enlarging or photographing on it directly.

Color conversion filters

These filters are made to compensate for color casts caused by light sources outside the scope of tungsten (3200K) or daylight (5500K) film. Always use conversion filters with color slide film. You can correct color negatives at the printing stage.

Darkroom filter kit ▽
You can introduce some filter effects at the printing stage if you use this kit for color enlargers. The kit has colored, prism, diffusion,

center spot, graduated, flare (contrast-reducing), and diffraction filters. You slide the filters into one of the compatible enlarger lenses

(50 mm or 75 mm) across the image path. The color analyzer fits over the lens and you read off the color balance on an LED display.

Printing filters

Color analyzer

Lens with filter

Polarization ▽
Light travels in vibrating waves in all directions at right angles to its direction of travel, but when light is reflected at certain angles from non-metallic surfaces it polarizes — vibrates in one plane only. A polarizing

filter will also reduce vibrations to a single plane. Rotate the filter to its most effective angle to suppress polarized light by crossing subject and filter planes at right angles. Reflections disappear, and light from a blue northern sky darkens.

Two crossed polarizing filters prevent any light reaching the film. However, certain bi-refringent plastics have the ability to twist the plane of polarization. When placed between polarizers these plastics appear colored and illuminated.

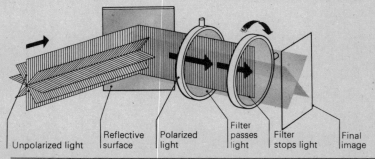

Unpolarized light | Reflective surface | Polarized light | Filter passes light | Filter stops light | Final image

Kodak filters

Filter	Type
CC range	Color compensating
80A–D, 85, 85B–C, 85N3, 85N6, 85N9, 85BN3, 85BN6	Conversion
81 range (& 89b), 82 range, 87 range	Light-balancing
21, 22, 23A, 24–6, 29, 70, 72B	Orange and red
30, 31, 33–6, 34A	Magenta and violet
52–61, 57A, 59A, 64–6, 65A, 74, 75, 99	Green
3, 3N5, 4, 6, 8, 8N5, 9, 11, 12, 13, 15, 16, 73	Yellow and yellow–green
38, 38A, 40, 44–8, 44A, 47A, 47B, 48A, 49B, 50, 98	Blue and blue–green

Films

Several special effects films are available in 35 mm format. Some techniques require the use of sheet format film, either in the darkroom, or in a large format camera, or cut down to fit a medium format or 35 mm camera. You will need to use films of all ASA speeds (sensitivity to light) — from 1000 ASA (ultra-sensitive or fast) for grainy results, down to 25 ASA (less sensitive or slow) for copying. You can override or "push" the recommended speed of a film for a contrasty, grainy effect, below right. And you can process films in the wrong chemicals to alter colors. The two main types of color film — tungsten type B and daylight — are designed to match these sources (see Color temperature, below).

There are two main types of instant film. Integral print film forms an image just after leaving the camera, whereas peel-apart consists of a sandwich of negative and receiving paper, which you must pull apart after a timed processing period. You can manipulate the emulsion of both film types while it is processing, just after it emerges from the camera rollers. The rollers release the processing chemicals that are sealed inside the film packet.

You can make use of several films designed for scientific or graphic purposes for special effects. Infra-red films distort colors or tone, see right. And line or lith film, below right, turns images into stark black and white. Autoscreen film gives a direct half-tone dot image. Diazo films produce single-colored line images.

Color temperature

"White light" is a mixture of wavelengths containing all the colors of the spectrum. The type of light source affects the way this mixture is made up. For example, candlelight contains more red than blue wavelengths, giving it a slightly warm color, whereas in shadow areas on a clear day, when the only light is scattered from a blue sky, the light is bluish. These differences in the components of white light can be expressed in temperatures on a scale measured in Kelvins (K), see p. 70. The temperature of each color corresponds to the temperature of a hypothetical black body that has been heated to emit that color light. As the body grows hotter, it glows red, then orange and yellow, and finally blue. As a result, because it is cooler in temperature, reddish candlelight is lower on the scale than bluish midday light. If you want to correct these effects, use the appropriate light-balancing color correction filter.

Mis-matched processing

Film	Correct process	Suitable mis-match	Effect	Exposure increase
Kodak Ektachrome Infra-red	E-4/E-6	C-22/C-41	False color negative	+1 stop
Kodak Ektachrome	E-6	C-41	Contrasty color negative	+½ stop
Kodacolor	C-41	E-6	Degraded color slide	+½ stop
Kodak Photomicrography	E-6	C-41	High-contrast color negative	+½ stop
Ektachrome slide duplicating	E-6	C-41	Low-contrast color negative	+½ stop

Pushing film

Push-processing — uprating your ASA setting at the exposure stage, and increasing or "pushing" the developing time — gives you a contrasty, grainy result. The amount by which you alter your development time depends on the type of film and developer you are using, see below. These examples of development adjustments are for Kodak Tri-X black and white negative film (400 ASA). Fast film is the best type to use for pushed results.

Camera exposure	Developer	Development time adjustment
−1 stop	D-76	Increase by 30%
−2 stops	D-76	Increase by 75%
−3 stops	Microphen	Increase by 160%

Line and lith films

These slow, fine-grain, high contrast copying materials are designed for photographing documents and drawings. Most are orthochromatic (non-red-sensitive), but a few panchromatic types (sensitive to all colors of the spectrum) are available. Lith film is of an extremely high contrast. You must use a special highly alkaline lith developer, and take care to remove spots and dust from the original. Line film has a marginally lower contrast, however it shows marks less, and you can process in any concentrated film or paper developer.

Infra-red films

There are two infra-red films currently available: Kodak Ektachrome Infra-Red color slide film and Kodak High-Speed Infra-Red black and white negative film. If you are using 87 or 88A filters with the black and white film, rate it at 25 ASA in daylight. Adjust focus to your IR indicator (see p. 99). With color slide film and 12 or 89B filters, set your ASA rating to 50 or 100 in daylight. Bracket exposure two stops either side of your TTL meter reading. You must handle and process these films in complete darkness. Color slide film requires a color reversal process (see pack). For black and white film use normal fine-grain developer, or D-19 developer for maximum contrast.

Subject	Color
Green foliage	Magenta
Red rose	Yellow
Brown hair	Red/brown
Buff seashell	Orange
Blue sky	Sky blue
Green paint	Magenta
Yellow flower	Off-white
Human skin	Pale yellow

Special film types

Film	Sensitivity	Process	ASA speed	Sizes	Comments
Color					
Kodak Ektachrome Infra-Red	IR	E-4	100 (with yellow filter)	35 mm (20)	False color
Kodak Photomicrography 2483	Color	E-4	16	35 mm (36)	Heightens color and contrast
Kodak Ektachrome Slide Duplicating 5071	Color	E-6	—	35 mm (36)	Makes slides direct from slides
Kodak Vericolor Slide 5072	Color	C-41	—	35 mm × 100 ft	Makes slides direct from color negatives
Polacolor 2 Type 58/668/88	Color	None	75	4 × 5 ins (10 × 12.5 cm) $3\frac{1}{4} \times 4\frac{1}{4}$ ins (8 × 11 cm) $3\frac{1}{4} \times 3\frac{3}{8}$ ins (8 × 8.5cm)	Peel-apart instant
SX 70 Time–Zero	Color	None	N/A	$3\frac{1}{2} \times 4\frac{1}{4}$ ins (8.2 × 11 cm)	Integral instant
Polaroid Type 46L	Color	None	800	$3\frac{1}{4} \times 4$ ins (8 × 10 cm)	Instant transparency
Polaroid Type 146L	Color	None	100/200	$3\frac{1}{4} \times 4$ ins (8 × 10 cm)	Instant transparency
Black and white	Sensitivity	Developer	ASA speed	Sizes	Comments
Kodak High-Speed Infra-Red 2481	IR	D–76	50 (with filter)	35 mm (20)	Unusual image tones
Kodak Recording 2475	Pan	Speed-enhancing	up to 4000	35 mm (36)	Grainy
Kodak Royal-X Pan	Pan	Speed-enhancing	up to 4000	120 rolls	Grainy
Kodalith Autoscreen Ortho 2563	Ortho	Lith	—	Sheet	Gives direct half-tone dot images
Kodalith Type 3 2556	Ortho	Lith	10	Sheet	High-contrast
Kodalith Type 3 6556	Ortho	Lith	12	35 mm × 100 ft	High-contrast
Kodalith Pan 2568	Pan	Lith	40	Sheet	High-contrast
Kodak Technical Pan 2415	Pan	D–76	25	35 mm (36)	Variable-contrast
Kodak Professional Copy 4125	Ortho	D–76	25	Sheet	Increased highlight contrast
Agfacontour	Ortho	Agfacontour	—	Sheet	Equidensity image (not camera material)
Polaroid Types 57/107C/87/47	Pan	None	3000	Sheet	High-speed instant
Polaroid Type 55	Pan	None	50	4 × 5 ins (10 × 12.5 cm)	Pos/Neg instant
Polaroid Type 665	Pan	None	75	$3\frac{1}{4} \times 4\frac{1}{4}$ ins (8 × 11 cm)	Pos/Neg instant
Polaroid Type 51 High-contrast	Pan	None	125/320	4 × 5 ins (10 × 12.5 cm)	High-contrast instant
Polaroid Type 410	Pan	None	up to 10000	$3\frac{1}{4} \times 4\frac{1}{4}$ ins (8 × 11 cm)	High-speed instant

Flash

Flash is a brilliant, cool light source, but it lights the subject for such a short time that both exposure and lighting quality are difficult to judge. You can use special studio flash systems, but advanced portable flash systems are cheap and effective. For special effect purposes, choose a flashgun with an adjustable head and a range of accessories. It should have the option of battery, power pack or main supply power source. A fast recycling unit will allow sequences of flashes in quick succession. Most systems offer filters that clip over the gun. Soft light diffusers and reflectors allow you to vary the flash effect, and help you to control bounced flash. Tilt heads are adjustable — vertically or horizontally — for bounced flash or directional lighting. Most guns have a manual adaptor that overrides the thyristor circuitry to give you more control over lighting. And a quick-release grip enables you to use the gun off-camera. Finally, slave units let you use more than one flash head. They trigger other heads instantly, in synchronization with the camera flash.

Flash synchronization

At the moment that your flashgun gives out most light, your camera shutter must be fully open. Electronic flash uses the X socket to synchronize the light output to the shutter. With focal plane shutters you must set shutter speed to 1/60 sec. or slower, but the effective speed will be the duration of the flash.

Stroboscopic lights

Strobe units, right, give between 1 and 40 flashes per sec. Use the lower frequencies to synchronize the unit with a motor drive. The faster frequencies create action sequences (see p. 84–5). In general, you will need to use several units in conjunction with a separate synchronizing box. Some strobes offer "open flash". The unit does not have to be synchronized with the camera, and this enables you to leave the shutter open for a long exposure.

Movable head

Calculator disk

Batteries

Remote sensor

Hot-shoe connection

◁ **Flash speed**
"Computer" flashguns — with sensors — regulate the light they produce by altering the duration of the flash. When flash-to-subject distance is small, the duration may be very short. This type of gun is suitable for some high-speed flash pictures (see p. 82–3).

Flash exposure ▽
Unless you have a flash meter, you must follow the settings recommended on your flashgun's calculator disk. Set the ASA rating for your film, find the flash-to-subject distance, and read off the required aperture.

Reflector holder

Sensor extension cord

Synch lead

Manual adaptor

Strobe units

Cable release

Filter adaptor

Flash accessories
Advanced flashguns often have a range of accessories that allow you to bounce or direct the light, or to diffuse or color it for effect (see pp. 80–1).

Studio work

A studio gives you complete control over lighting, background, composition and viewpoint. For front projection you will need to rent a specially-equipped professional studio, but for most other special effects an improvised studio — with tungsten lights, background papers and stands — will suffice. You can purchase rolls of colored background papers in 9 ft (2.8 m) and 12 ft (3.6 m) sizes. You will need a frame table or paper holder to keep the roll firm and taut. More complex background effects are possible with back projection or a front projector unit, see facing page. To soften lighting make a portable diffusion screen — stretch tracing paper across a frame. White painted walls allow you to bounce lighting. You can rent special effects machines — wind machines, cobweb fans and fog generators.

Special effects studio ▽
Set aside the largest space you can. You will also need room to store your equipment. If possible, choose an area where you can leave larger items out between sessions. In order to use lights from high positions or take pictures from a low angle you must have a room with a high ceiling. To avoid unwanted color casts, paint walls white or black.

1 Fiber-optic light source
2 Screens, masks, dodgers
3 Microscope
4 Table spotlight
5 Carousel projector
6 Back projection screen
7 Mirrors, reflectors, foil
8 Patterned glass
9 Barn doors
10 Snoots
11 Acetate gel
12 Strobe unit
13 Flash unit
14 Tripod
15 Background paper

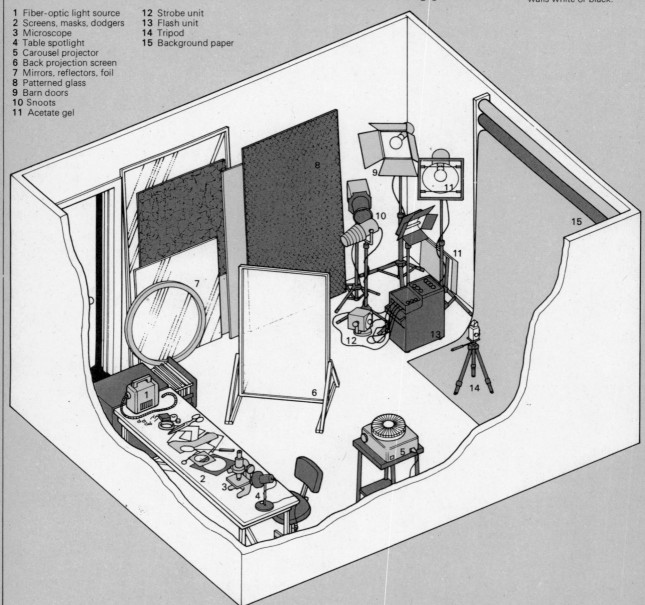

Artificial lighting

There are three main types of tungsten artificial light sources: spotlights, flood-lights, or quartz-halogen adjustable focus lamps. Tungsten lights are easy to control, but because they become very hot, they do not suit some subjects. Spotlights give you a concentrated beam of hard light. You can soften the light by diffuse reflection from a mat white surface such as a white-painted wall or board. You can also pass it through a diffuser made of gauze or tracing paper. Barn doors and snoots attach to spotlights to restrict the beam width. A floodlight has a diffused lamp and large mat reflector, and gives softer, even lighting. The larger and closer the floodlight, the softer the quality of illumination will be. You will need to use tungsten-light slide film with tungsten lamps for correct color balance, or fit them with blue acetate filters to match daylight.

Projectors

Image brightness depends on the light output of the projector lamp, the aperture of its lens, the type of screen you use, and its distance from the projector. Do not try to project an excessively large picture — your result will not be bright enough to show the true image quality. Choose a projector with a good lens, and avoid models with fans which cause excessive vibration, or with push-pull focusing. A model with adjustable aperture allows you to stop down the lens to improve definition and dim the light. However, small apertures may give uneven lighting. All projectors heat up color slides to a greater or lesser extent. A film in a cardboard mount will bow slightly, so that the center or edges appear out of focus. To avoid this problem use glass-faced plastic mounts. When you project slides, black out the room properly — even a small amount of light will dilute image blacks to gray, degrade contrast and desaturate color.

Back projection

Your slide projector must have a color temperature of 3200K to match studio lighting and to suit tungsten-light film. If you cannot match the color quality of your subject and background, use a multiple exposure technique to balance them. Turn off subject lights, turn on the projector and make the first exposure for the screen. Switch off the projector, and cover the screen with black paper or velvet. Then turn on the subject lights and make the second exposure. Make one of the exposures through a correcting filter to balance lighting color. Always position your projector square-on, well behind the screen, and set up your tripod and camera square-on in front of it.

Lighting accessories ▽
Square and umbrella-shaped diffusers soften light and reduce shadows. Scrims control the amount of light. Each one you fit to your lamp reduces illumination by one stop. Half scrims allow you to vary the strength of light on different parts of a subject. Snoots lessen the size of the light circle, forming a directional beam. And with barn doors you can restrict the area of light from a broad spread to a narrow slit. Barn doors will also prevent light aimed at the subject from flaring into the camera lens. Use fiber-optic light sources for lighting small areas of a figure in different colors, or for still life subjects that need to be kept cool. Illumination is ducted along glass fiber tubes from a box containing a bright lamp.

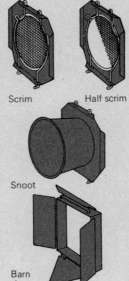
Scrim　　Half scrim
Snoot
Barn door

Drawing with light ▽
You can draw light patterns freehand using a row of flashlights (hand torches) taped together and filtered with different-colored acetates. Place your main subject in a darkened room against a dark background, and set a time exposure. You will need an assistant to walk around the subject, holding the flashlights pointed at the lens at right angles to the direction of movement.

Projection size

This table gives the length on the screen of the longest side of a projected 35 mm slide.

Projector to screen	150 mm lens	75 mm lens	50 mm lens
30 ft (9 m)	7 ft (2.2 m)	14 ft (4.3 m)	21 ft (6.4 m)
25 ft (7.5 m)	6 ft (1.8 m)	12 ft (3.6 m)	18 ft (5.4 m)
20 ft (6 m)	5 ft (1.6 m)	10 ft (3.1 m)	15 ft (4.5 m)
15 ft (4.5 m)	4 ft (1.3 m)	8 ft (2.5 m)	12 ft (3.6 m)
10 ft (3.1 m)	2½ ft (0·7 m)	5 ft (1,6 m)	7½ ft (2.3 m)

▽ **Front projection units**
Simple units consist of a small projector and semi-reflective mirror. You mount the camera on top of the unit, with the mirror at a 45° angle in front of the lens. Advanced units contain both camera and projector, see right, on an integral stand. With this type, camera and axis is already aligned.

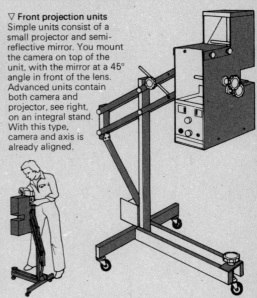

Workroom techniques

Copying

Copying is a very versatile technique — use it to record hand-colored or montaged pictures, or to change color to black and white and vice versa, or to turn an ordinary original into a special effect through multiple exposure, filtering or zoom. Color slide originals should be sharp, and either correctly exposed or slightly underexposed. Use lighting that is even and shadowless, and without any color casts. If you want to add a color cast to a slide, use the appropriate filter. Always match your film to your light source (see p. 153). There are several types of slide copying equipment on the market. You can fit an extension tube or bellows to your camera and lens. Or buy a copying stand, or replace your enlarger head with a reflex camera and use your enlarger and baseboard for copying. You will need two lamps, angled at 45 degrees to avoid flare, to illuminate it evenly. Slide copiers have a translucent diffusing screen that covers a built-in flash unit. A lamp helps you to focus your lens. The slide sits on the diffuser, and a clamp holds the camera above it. Some bench-top copiers have dial-in filtration and contrast control.

Exposure for copy manipulations

Copying boosts contrast with regular film, so for single copy shots use a special low-contrast duplicating film (see p. 154). For a multiple exposure copying effect use slow or medium speed regular film (such as Ektachrome 64) rather than duplicating film. To find the correct exposure for a double exposure copy, double film speed and use the TTL meter.

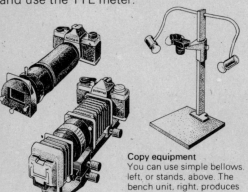

Copy equipment
You can use simple bellows, left, or stands, above. The bench unit, right, produces high-quality copies.

Toning and coloring

1. Apply bleach to damp print using a clean, un-contaminated brush. Follow image outlines carefully. Sponge larger areas.

2. Rinse bleached print, and insert it in sepia toner. Remove the print after 1–2 min and wash it thoroughly. Blot off excess water.

3. Using water colors, build up the correct depth of color gradually to avoid ridges. Sponge off excess color at each stage. Next, use a fine brush to add small areas of color.

Dry mounting

To dry mount a print you will require a dry mounting press, heat-sensitive tissue, an electric tacking iron (to fix tissue to print), print trimmer, ruler and cardboard. Tack tissue to the back of the print and trim print edges to size. Then tack the tissue to the mounting board in the correct position. Cover the print with silicon release paper and place it in the press for 30 sec. You can use a texturing kit with a dry mounting press — the surface finishes suit certain special effects results.

Hand coloring

You can hand color black and white prints or large-format negatives. Work with transparent dyes on a negative, or water-based colors on a damp print, or oil colors, felt pens or colored pencils on a dry print. With a negative, colors will print in reverse on negative/positive paper. (You can also work on film positives and print directly on SDB paper.) Hand color on a well-illuminated light box, and use a magnifier to follow the outlines.

For a print, start with a mat or semi-mat type 8 × 10 ins (20 × 25 cm) or less in size. If you intend to color with oils, you should avoid resin-coated paper. Sepia-tone (see p. 160) a black and white print before you start. You can also use a selective bleaching and toning technique for partially-colored results, see left.

To hand color images you will require a small sable brush, some artist's sponges, a photographic tray, and a non-absorbent work surface. As well as your colors, you will need size 0, 1, 4 and 6 brushes, containers for diluting water colors, and plenty of blotting paper.

Hand coloring integral instant prints

You will need a sharp knife, cotton balls, colored gouache, inks, and small and medium sized brushes. To color prints you must first open them up, see right, using a sharp knife. The image is attached to the transparent plastic front, backed by an opaque, plastic layer. You must wipe off this layer if you intend to tint the picture, or scrape it off along with the image if you want to form "windows" for flat color or montage.

Coloring instant prints

1. Cut open three sides of the black backing on an SX 70 print. Use a damp cotton ball to wipe away the white opaque layer.

2. Paint over the back of the image layer to tint selected parts of a picture. Add montage elements or paint in clear areas.

Etching bromide print surfaces

Use pen nibs, knives or scalpel blades, and coarse and medium-sized darning needles for scratching print surfaces. Push needles into corks for easier handling. Take a resin-coated print and soak it in water for 5–10 min to soften up the emulsion. Blot away any surface liquid, then clip the print to a flat surface. Scratch the image with a brushing action, using a needle or blade. If you wish to color the etched result, add liquid color to the damp print with cotton balls or a brush, or use pencils on a dry image.

Airbrushing

An airbrush uses compressed air to project a fine spray of spirit-based or water-based dye or pigment. It has a hollow, pointed nozzle filled by a tapering needle, and a reservoir on top which holds about 1 fluid ounce (28 ml) of color. A long hose connects the brush to a supply of compressed air. The button control allows the air to flow if you press it down — push it back to make the color flow, and control its rate. Use either canned compressed air, or a special pump and a compressor unit. You will also need water colors and gouache (or oil colors and turpentine), inks, paint pallets, masking tape, scalpels and blades, cotton balls, pencils, brushes, and a magnifying glass to see fine detail. Have a large sable brush to fill the airbrush with color, and self-adhesive masking film to shade different areas of the print.

Airbrushing is a skilled job that requires a great deal of practice. You can use it to remove a background from a print, see right, or take out unwanted shadows and

Removing a background

1. Dry mount print. Cover surface with self-adhesive mask film. Using a scalpel, cut round subject. Give enough pressure to cut film without marking print.

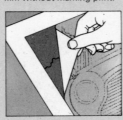

2. Peel off masking film from the background, leaving the main subject protected. Dilute process white to a thin, creamy consistency.

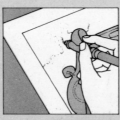

3. Fill the airbrush and hold it at a 45° angle about 5 ins (12.5 cm) from the surface. Use a broad spray setting.

reflections. First identify the main lighting direction, then airbrush highlights and shadows so that they appear realistic. Mask over the background, and protect all other parts of the subject except for those areas that require most tone. Spray the whole print lightly with pigment. Cut away the mask from the areas that need slightly less pigment, and spray again.

Montage

You will need a mounting board that is larger than your planned print, a dry mounting press, tacking iron and tissue. You should use sharp scissors to cut out montage elements. But a scalpel knife with a new blade is best for cutting intricate shapes. To disguise joins, use felt-tipped pens, pencil, spotting brushes and water-color or dye. Construct the montage at about twice the size of your final print, then copy and reduce it. Plan and make component prints so that each element has a similar balance of contrast, density, and color. Next, dry mount the background print. Then rough-cut components to within about ½ in (1.2 cm) of their final shape. Compare the density, color, and contrast with the background. If you want a torn or cut-out look, simply reduce prints to final size and attach to the background with double-sided tape. To make image joins invisible, reduce edge thickness by thinning the paper. Cut your print to shape, then carefully sandpaper the back. With resin-coated paper, score the emulsion around the image outline, then peel the paper base from under the emulsion before you sandpaper. Use a spray adhesive to attach components.

Constructing a montage

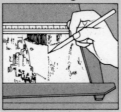

1. Enlarge background image and trace it on paper. Plan the relative sizes of the other elements.

2. Cut around image outlines of component prints using scissors or a knife. Sandpaper edges if you want invisible joins.

3. Coat the back of each component with adhesive. Position elements carefully, applying pressure from the center. Wipe away seepage.

Toning

There are four main toning techniques: single-solution toning, which gradually replaces the silver; two-bath toning, where you bleach the silver, then re-darken it in toner; three-bath toning, where you bleach, color develop, then remove the silver; and multi-stage patented toning kits, such as the "Colorvir" kit. Work in normal room lighting. Soak dry prints in water for at least five minutes before toning in order to remove surface grease. Take special care when you mix acid, and always wear gloves.

Purchased kits

If you want a range of different colored toners you should buy a kit of color couplers. This kit contains a bleach, color developer, liquid couplers, a stop bath, a silver bleach solution, and print stabilizer. You add the color toning kit couplers to the developer in the ratio 1 part coupler to 10 parts developer. Couplers are made in basic tints only, but you can mix them.

A "Colorvir" toning kit contains dyes, toner and pseudo-solarization chemicals. You can use it on film negatives and positives, as well as on resin-coated paper. Single or multi-colored toned results vary according to the density of grays in your original image, and the sequence and duration of the different dye baths. Dyeing mostly affects the lightest areas of your prints. You must always precede dyeing by toning — this "mordants" the image (chemically prepares it to accept dye).

Diazo systems

There are two types of diazo-coated materials: negative-working and positive-working. They both produce high-contrast images in one of a range of strong colors. Neither give mid-tones — they are designed for contact printing from line or half-tone images. Work in normal artificial light. With negative-working diazo, first rinse the plastic base in 100 per cent denatured alcohol. Then apply the first color to the base using a squeegee. Dry the film and place the first separation in contact with the base (emulsion to emulsion). Expose it to a mercury vapor lamp for $1\frac{1}{2}$ min. Next, place the base in

Solutions tables

Sepia toner
Bleacher

Potassium ferricyanide	50 g
Potassium bromide	50 g
Dissolve in water to make 500 ml	
Dilute 1:9 for use	

Toner (re-usable)

either Sodium sulfide	25 g
or Thiourea*	0.1 g
+Sodium carbonate	50 g
Dissolve in water to make 500 ml	
*Thiourea solution gives off less odor	

Iron toner
Solution A

Potassium ferricyanide	1 g
Sulfuric acid (concentrated)	2 ml
Dissolve in water to make 500 ml	

Solution B

Ferric ammonium citrate	1 g
Sulfuric acid (concentrated)	2 ml
Dissolve in water to make 500 ml	
Mix equal parts of A and B solutions	

Nickel toner
Bleacher

A Nickel nitrate	25 g
Potassium citrate	75 g
Dissolve in water to make 500 ml	
B Potassium ferricyanide	20 g
Dissolve in water to make 500 ml	
Mix equal parts of A and B solutions (acidified with a few drops of citric acid)	

Toner

Dimethyl-glyoxime (saturated in alcohol)	50 ml
Sodium hydroxide (0.4% solution)	50 ml
Add water to make 500 ml	

"Colorvir" dye/toner kit △
Kits contain dyes, toners and pseudo-solarization chemicals. Instructions in kits give the sequence of solutions required for different color effects.

"sensitizing" solution for 45 seconds, then wash it under warm running water. Finally, rinse the diazo film in denatured alcohol, and repeat the procedure to laminate further colors on the base. You use the same method for positive-working developer, except that you use a different "wipe over" sensitizing solution.

Toners

Sepia toner
Choose a fully developed print with a rich range of tones, and bleach it to a straw color. This converts all the black silver into a halide, which you can then tone. After a rinse, redarken silver bromide in sepia using the solution in the table. Toner only affects bleached parts so you can selectively tone any area.

Iron toner
This toner produces a strong, blue image. Start with a print that is slightly lighter in density than normal (iron toner has an intensifying effect). Make up the combined working solution from the formula given in the table, or buy a ready-to-mix pack. Blue toner slowly converts the black silver image to a ferric (iron) salt in one step. Results will have more "body" if you remove the print before it fully tones to a bright Prussian blue. Then wash the print until pale yellow stain disappears (10 min).

Nickel toner
Nickel toner gives a bright pink or magenta image if you use the formula in the table. You must work with separate bleaching and toning solutions. This enables you to achieve a range of partial toning effects. Select an original that is more contrasty than normal, because the process has a slight contrast-reducing effect. After bleaching, fix the image in a 5 per cent solution of hypo (sodium thiosulfate) crystals for 5 min. Then place the print in toner. Finally, wash it for 10 min.

Darkroom data

Access to a darkroom enables you to try out darkroom special effects that involve printing techniques – for example, solarization, using liquid emulsion, and multiple printing. You will need a color enlarger, safelighting, a masking frame, focus magnifier, and also print tanks, trays and graduates. For safety, you should separate wet and dry areas in your darkroom. Keep a notebook to record filtration settings and exposure times – this helps you to repeat results quickly and simply.

Office punch system

Kodak punch system

Registration
The matching of image areas during exposure is an important starting point for several darkroom techniques. The best way to do this is to register images using a punch system. This makes two or more holes near the edge of each sheet of film or paper. These holes correspond to pins which you tape firmly on the enlarger baseboard. You punch the material before exposure, and then locate it on the pins so that the projected image falls in exactly the same place each time. After processing, you can contact print a sequence of these sheets on punched photographic paper, and they will fall into exact register. The simplest registration system is an ordinary office punch and a two-pin board. You can make this yourself, or you can buy a precision Kodak register punch and a tape-down pin bar. Use this system, too, for copy posterization (see p. 116), taping the bar on one edge of a light box.

Posterization
Use this technique to convert a normal image into a picture that consists of flat areas of tone or color. There is no shading or gradation in a posterized print – just abrupt changes from one area of tone or color to another. Make color or density separations, which you register and expose on the same piece of color paper (under the enlarger) or color film (in the camera), changing filters between exposures.

Punch systems
You can buy a good quality office punch and set it into a board. Place the throat level with the board's top surface to keep film level during punching. Make ½ in (1½ cm) high pins from wooden doweling, or cut the heads from nails and file ends down smooth. Fit the pins into a mat-black painted board that is larger than the biggest material you use.

A photographic punch mounted on a baseboard is more precise than the office type. It makes three holes of two different shapes, this helps you to locate punched material on the pins the right way up in the dark. Sets of precision-made pins come with the unit. These attach to the baseboard.

Making density separations
Enlarge your original black and white or color negatives on three register-punched sheets of line film. Posterized results from density separations show different colors in areas which originally differed in tone.

1 Project your original black and white or color negative on the baseboard. Position the register pin bar.

2 Turn on the red safelight and make an exposure test on a register-punched sheet of line or lith film.

3 For three tonally different positives underexpose one sheet of punched line film, expose a second normally, and overexpose a third.

4 Contact print the separations on high-contrast film giving equal exposures, to make negatives ready for printing.

Making color separations
Take a color original and copy or enlarge it on panchromatic lith film, see right. Posterized results from color separations show chosen color variations where there were color differences in the original.

1 In darkness, make exposure tests on strips of lith film through tri-color red, green and blue filters.

2 Still in darkness, punch register holes in a full-size sheet of lith film. Position it over the pins and expose through the red filter.

3 Expose two more sheets through green and blue filters, respectively. Cut a different number of corners off each film to code colors.

4 Contact print each positive on register-punched lith film. If you are using a slide, print negatives to produce positives.

Lith paper

Lith paper, like lith film, is designed for making prints from black and white artwork. Process it in lith developer for a high-contrast black image. You can also use it to make brown prints by grossly overexposing it, and then developing in lith developer diluted 1:1 with water.

Using liquid emulsion

Liquid Light, a ready-made emulsion, has its own two-part priming solution. You must use this with non-porous bases such as glass or ceramics. Coat highly porous materials with a thin layer of varnish diluted 1:1 with naptha. Primed canvas will need a coat of dilute wall paint. You can coat emulsion direct on most papers, cloth and unprimed canvas, under a red or orange safelight. Emulsion must be thick enough — too thin a coating will give only gray tones. Apply emulsion evenly using a swab or paintbrush. Still under safe-lighting, dry the objects carefully, using a hairdryer set on a very low heat.

Shading and vignetting

Use these techniques to emphasize or remove parts of an image. You can use shading to remove a background in order to make your main subject stand out. Have

Vignetting ▽
Focus image on masking frame. Hold cardboard between the lens and frame and sketch your chosen shape on it.

White vignette Insert paper in masking frame. Use red filter to position cut-out surround. Remove filter, and expose image to paper.

Black vignette Vignette as above. With red filter in place, remove negative. Hold dodger over image, remove filter and fog edges.

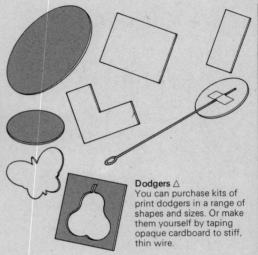

Dodgers △
You can purchase kits of print dodgers in a range of shapes and sizes. Or make them yourself by taping opaque cardboard to stiff, thin wire.

shaped dodgers or use your hands to cover desired areas for parts of the exposure. A shaped vignette will enable you to shade the edges of your picture to white or black. For a white vignette, mask the picture edges during exposure using a piece of opaque cardboard with a hole cut in the center. And for a black vignette, work in the same way, but once you have exposed the negative remove it from the carrier, cover the picture area with black cardboard, and fog edges to white light.

Special chemicals

Name	Type	Purpose	Liquid/Powder
Ilford Ilfospeed	Developer	Speed-enhancing, for black and white paper	L
Kodalith	Developer	For lith paper or film	L/P
Paterson Acuspeed	Developer	Speed-enhancing, for film	L
Solarol	Developer	Solarizing, for film or prints	P
Colorvir	Toning kit	Toners, dyes, and pseudo-solarization chemicals	L
Tetenal Multi-toner	Toning kit	Toners, and pseudo-solarization chemicals	L
Kodak D-8	Developer	High-contrast, for line film	P
Liquid Light	Emulsion	Liquid, for painting on 3D surfaces	L

Special papers

Name	Effect	Type
Autone	Colored-base — colors, metallic, fluorescent	Bromide, fiber or RC
Autone-RC	Colored base — colors, metallic	RC
Kentmere Kentint	Colored-base — colors, metallic	RC, Bromide
Kodak Mural	Rough mat	Fiber-base
Metone	Aluminum base	Bromide-coated
Tura Report Rapid	Warm-tone	Chlorobromide
Tura Photolinen	Rough linen	Bromide-coated
Argenta Linen	Fine or coarse linen	Bromide-coated

New media

During the next few years there will be a dramatic change in the way we produce and view visual images. Both three-dimensional holograms and video, which creates images purely electronically, will alter the way we produce pictures. Methods like color photocopying and laser scanning already allow you to use electronic print reproduction processes for post-camera special effects.

The cost and shortage of expendable materials such as silver and chemicals will play a part in these new developments. Magnetic videotape will shortly be super-seded by solid-state storage systems. And portable video cameras, linked to sophisticated home VTR units, may replace conventional still and movie silver-image systems. You will be able to use these units to store information, reproducing it as a still or moving image. Monitors will be thin, flat and portable and less cumbersome than present home movie equipment. Electronic information storage will enable you to recall a still image in virtually any form for special effects — to change hues, alter contrast, and mix or split images with time-lapse control.

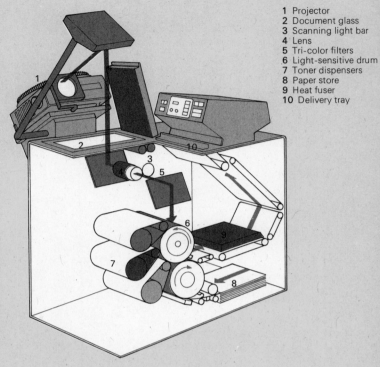

1 Projector
2 Document glass
3 Scanning light bar
4 Lens
5 Tri-color filters
6 Light-sensitive drum
7 Toner dispensers
8 Paper store
9 Heat fuser
10 Delivery tray

Photocopying machines
These machines can be used to manipulate line or color (see pp. 136–141). At present, this electrostatic system does not have an acceptable response to tone, but electronic density synthesis may solve this problem shortly.

Laser light printing system
Traditional printing from color slides demands careful control, but a new system is available which uses the coherent properties of laser light to scan the transparency and by-pass conventional optics.

The lasers, one for each primary color, break up the image into an almost infinite number of pieces of information which are stored in a computer in electronic form. To reconstitute the picture, another set of lasers reconstruct the image on a color negative, or on a regular positive/positive color printing paper.

The machine evaluates a slide placed in the scanner previewer and presents its image on a video display screen. The

Color photocopying machine △
When the light bar scans the original on the document glass the image is projected, via a mirror, to the lens. (Three scans are made for color, through tri-color filters.) The lens focuses the light onto another mirror, which transfers it to the light-sensitive selenium drum charged with static electricity. Positive charges leak away in areas exposed to light. As a result, when toner powder reaches the drum it is only attracted to the areas that represent dark parts of the image. The paper is positively charged to draw the toner image from the metal surface. When the drum reaches the paper, heat fuses the toner with the paper. The finished print emerges in the delivery tray.

previewer incorporates a system of control settings. These are for contrast control, mode control (color posterization, tone posterization or standard), and individual strength characteristics of the three colored lasers. Electronic masking overcomes the problem of excessive contrast when printing from slides.

Laser printing machines make excellent, virtually grainless prints from slides. And the laser system has a number of features which enable you to completely redesign your print. You can display and print the following effects: tone posterization, color posterization, high-contrast positives and negatives, pseudo-solarization, fine-line contour drawings in black and white or color, and simulated screenprints or lithographs. This system requires costly equipment, but is simple to use and produces better results than darkroom work. At present there is only one company which specializes in Laser-printing: Laser Color Labs in West Palm Beach, Florida. Write to them for details of services.

Holograms

Holography is a process of constructing three-dimensional effects without the use of a camera or lens-imaging equipment. The secret of holography lies in its laser light source. Laser light is a coherent light source, consisting of a parallel-sided beam of light of one wavelength only. The light from the laser is split — one beam (the reference beam) goes straight to the light-sensitive emulsion — an extremely fine-grain type coated on glass plates. The other beam lights the subject (the illuminating or object beam). When the object beam, reflected from or scattered by the subject, reaches the emulsion it is out of phase with the reference beam, because it has encountered the subject in its path to the film. This phenomenon causes an effect known as interference. If you light a processed hologram with a special coherent light source, it will mimic the object so exactly that it will appear to be three-dimensional. Subjects are limited to small, inanimate objects unless you have pulse-laser exposing equipment.

How to make your own Transmission Hologram

Making your own hologram is not nearly as costly as you may think. The main outlay is for a small laser, minimum output 1 milliwatt, which will cost about £150 ($300). For a simple set-up using a translucent subject you will also need a beam-spreader (an 8 mm concave lens), surface-silvered mirror, an open, grooved plate holder, modeling clay, a paving stone to absorb vibrations (or suitable shock-proofing construction), and holographic light-sensitive material such as Agfa 10E7S.
Never look directly into the laser beam — it may damage your eyes.

1 Mirror
2 Subject
3 Pinhole
4 Lens
5 Illuminating beam
6 Semi-transparent mirror
7 Laser light
8 Laser
9 Mirror
10 Reference beam
11 Interference pattern
12 Film

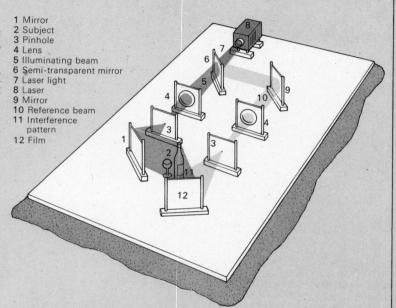

Making a hologram △
Line up the mirror, laser and plate holder on the paving stone, and fix firmly with modeling clay. Position the object as near as possible to the plate holder. Clean the mirror carefully. Cut off the laser beam with a piece of black cardboard. In total darkness or under safelighting, tape the plate to the holder facing the laser, emulsion outward. Wait 5 min for all vibrations to cease, then remove the black cardboard and expose film for about 5 sec. Keep perfectly still, and do not breathe into the optical path during exposure. Then develop and fix the hologram as for standard film with a developer such as D 163, 1+1, for 5 min at 68°F (20°C). After washing, rinse in denatured alcohol to clear the blue dye from the emulsion and help dry the plate. To view the hologram, replace it exactly as it was for the exposure. When you look through the laser-lit emulsion you will see a black and white representation of the object. If the image is patchy it may be due to vibration in the room or air currents. To light an opaque object you will need to use a beam-splitter, such as 2ins (4.6 cm) square glass. Light the image by any coherent light source for viewing.

Working as a professional

A professional photographer needs business skills as well as artistic talent. If you intend to work as a professional, you will have to note the time and expenses involved in every job. And you must keep accurate account books for tax purposes. You may have to employ an assistant or technician, and you will need to invest capital in equipment. If you do not want to make this step straight away, it is often best to start your photographic career as an assistant to an established photographer. You will make important contacts, learn business methods, and have access to equipment you cannot afford.

Markets

Special effects photographs have applications in advertising or record cover work. These pictures are invariably commissioned — you must produce work of a professional standard, and you will need contacts at advertising agencies or in the music business.

If you do not want to specialize to this extent, you can sell your existing work for magazine or book illustration. Another alternative is to place your work with a picture library.

Index

Acknowledgments

Michael Langford would like to thank Andrew de Lory for his major contribution to the photographs in this book. Thanks too for the professional skills of Judith More and Neville Graham, project editor and art editor respectively, and to Joss Pearson for assessing priorities. Tim Stephens of the London College of Printing was a most valuable outside consultant. And appreciation goes to Michael Burman of F. E. Burman Ltd. who coped admirably with the problems of reproducing the strange-looking illustrations.

Dorling Kindersley would like to thank: Andrew de Lory, Tim Stephens, F. E. Burman Ltd., Mike Snaith and Peter Broughton at MS Typesetting, Kay Dixon at Image Bank, Elly Beintema, Jonathan Hilton, Sue Burt, Teresa Cross, Ken Oberg at Kodak, Dave Strickland, Mari Mahr, Lawrence Lawry, Neil Menneer, Pete Truckel, Erik Steen, Bob Carlos Clarke, and Oxford Scientific Films.

Photographic credits
All photographs by Andrew de Lory except for:
Chris Andrews p.137
Nic Barlow p.2
Elly Beintema p.67
Simon Bran p.136b
Al Bridel p. 73
David Buckland p.10bl, p.19
Keith Butcher p.76t
David Carpenter p.62
Bob Carlos Clarke p.15b, p.119, p.120, p.121
John Cleare p.30t, p.31, p.66b
Gerry Cranham p.23, p.27, p.28
A. L. Coburn/George Eastman House p.9tl
John Cooke/Oxford Scientific Films p.83
Simon Cooper p.98, p.99b
Amanda Currey p.124cl
Bob Dainton p. 131
Andy Earl p.79
Calvin Evans p.54b
David Fairman p.105
Dr. Harold Edgerton/MIT, Cambridge, Ma. p.11br
Alfred Gescheidt/Image Bank p.6b, p.61
Ricardo Gomez-Perez p.20b, p.21, p.71, p.92
Hag p.122, p.123
Robert Hallmann p.77
Sam Haskins p.14
Louis Ducos du Hauron/George Eastman House p.9tr
Francisco Hidalgo/Image Bank p.10tl, p.11tr, p.35, p.41, p.48l, p.57
Horvas/Vision International p.85
Michael Langford p.39, p.96bc, p.104, p.130
Lawrence Lawry p.100b, p.110, p. 127
Mari Mahr p.32, p.108t, cr, p.109, p.134t, p.142, p.143, p.144
Neil Menneer p. 52, p.64b, p.97b, p.126, p.139
Lazlo Moholy Nagy/Royal Photographic Society p.9br
Stephen Nash p.124r
Wilf Nicholson p. 36, p.112l

Peter Parks and Stephen Dalton/Oxford Scientific Films p.82
G. I. Ratcliffe p.50t
Oscar Rejlander/Royal Photographic Society p.8tl
Ben Rose/Image Bank p.84
Tim Simmons p.63t
Al Satterwhite/Image Bank p.7
Red Saunders p.93
Carol Sharp p.134b
John Starr/Allsport p.55
Erik Steen p.6t, p.34t, p.70b, p.96bl, p.97t, p.112r, p113
Tim Stephens p.33, p.118, p.125, p.128, p.129, p.132, p.133, p.141
Dave Strickland p.106t, p.107
P. Thurston/Daily Telegraph Library p.66t
Pete Truckel p.135, p.138
Pete Turner/Image Bank p.45
John Wainwright p.136t
Etienne Weil/Image Bank p.72
Chris Alan Wilton p.40b

Jacket (front)
Top row:
L Al Bridel
C Andrew de Lory
R Erik Steen
Bottom row:
Andrew de Lory
Jacket (back)
Andrew de Lory

t=top
tl=top left
tr=top right
l=left
cl=center left
cr=center right
r=right
b=bottom
bl=bottom left
bc=bottom center
br=bottom right

Illustrations by:
Albert Jackson and David Day

Photographic services
Negs
Downtown Darkroom
Paulo Colour